Photography in Boston:
1955-1985

edited by
Rachel Rosenfield Lafo and Gillian Nagler

Photography in Boston: 1955-1985

DeCordova Museum and Sculpture Park, Lincoln, Massachusetts, and **The MIT Press,** Cambridge, Massachusetts, and London, England

This catalogue is published on the occasion of the exhibition *Photography in Boston: 1955–1985,* organized by Rachel Rosenfield Lafo, Senior Curator, DeCordova Museum

DeCordova Museum and Sculpture Park
Lincoln, Massachusetts
September 16, 2000–January 21, 2001

Major funding provided by Polaroid Corporation. Additional support provided by the LEF Foundation, Stratford Foundation, and the Charina Foundation.

Library of Congress Cataloging-in-Publication Data

Photography in Boston, 1955–1985 / edited by Rachel Rosenfield Lafo and Gillian Nagler.
 p. cm.
Catalogue published on the occasion of the exhibition Photography in Boston, 1955–1985.
On t.p.: DeCordova Museum and Sculpture Park, Lincoln, Massachusetts.
Includes bibliographical references and index.
ISBN 0-262-12229-4 (hc : alk. paper)
 1. Photography—Massachusetts—Boston—History—20th century—Exhibitions. I. Lafo, Rachel Rosenfield, 1951– II. Nagler, Gillian. III. DeCordova Museum and Sculpture Park.
TR25.B66 P47 2000
770'.9744'610904—dc21
 00-025882

Contents

We are delighted to collaborate with the DeCordova Museum and Sculpture Park in presenting *Photography in Boston: 1955–1985* to the public. The partnership between Polaroid and the Museum builds on mutual interest in encouraging creative inquiry and experimentation.

Although Polaroid began as a company concerned with developing the field of light polarization, its direction changed dramatically when the idea of creating a one-step dry photographic process challenged the company's founder, Edwin H. Land. It didn't take Dr. Land long to figure out how the process could work, but translating the dream into reality demanded thought, creativity, and continual investigation in the laboratory. This exciting enterprise was on the cutting edge.

Invention and experimentation characterize the very nature of instant photography, and we have been refining it for many years. It is notable that the artists included in this exhibition who used the new technology were accomplices in the experiment, testing the parameters of recently invented films while they visually tested their own aesthetic ideas. They pushed the technological envelope, enabling Polaroid scientists to learn what worked well and what didn't. Additionally, this collaborative exercise nurtured a growing number of artists who relished a chance to work with these instant films and cameras.

What began as a research and development experiment evolved into a corporate philosophy that encourages creativity in all facets of one's life—creativity at home, at play, and in the workplace. *Photography in Boston: 1955–1985* celebrates the creative spirit of a remarkable group of individuals whose imagery serves to inspire us all, as well as the next generation of photographers.

Gary T. DiCamillo
Chairman and Chief Executive Officer
Polaroid Corporation

Preface

With the presentation of *Photography in Boston: 1955–1985,* the DeCordova Museum and Sculpture Park launches the largest exhibition and publication project in its history. *Photography in Boston: 1955–1985* is the first of three exhibitions and catalogues that will consider how art has developed in the Boston area during the latter half of the twentieth century. Forthcoming will be *Painting in Boston* and *Sculpture in Boston.* Together the three are intended to comprise, not necessarily an encyclopedia, but certainly a well-informed perspective on the major players, directions, and social and aesthetic forces operative in the Boston area over the past fifty years.

Our project is more than a millennial look back toward the recent past in the hope of projecting some kind of assurance into the next century and beyond. The second half of the twentieth century is, in fact, the period of DeCordova. The Museum opened to the public in October 1950, and so this exhibition precisely marks the fiftieth anniversary of its operation. Since the DeCordova Museum was founded to promote the appreciation and understanding of modern and contemporary American art among the general public, working with living artists primarily from the New England region, a project to overview the art landscape of the past fifty years also becomes a project of institutional introspection. How has this museum acted upon that landscape?

Any analysis of a period will inevitably reflect the subjectivity of its author. Our venture in assaying the art of our region does not pretend exemption from this rule. It does, however, assert the consistent presence of the DeCordova Museum and its curators' activity on the scene, creatively engaging with many of New England's foremost artists for half a century. Such engagement both informs and entitles the perspective advocated in this series of exhibitions and publications. The project also helps to make the case for the regionally based contemporary art museum functioning as the "collective memory" of a particular historical time and place. Beyond the vague generalizations of American regional stylistic attitudes popular some time ago, there remain distinctions to be made regarding how and why certain artists created what they did where they did. This is the role that DeCordova has set for itself.

That this project is being so successfully and beautifully realized is due to my long-time colleague, Rachel Rosenfield Lafo, senior curator at the DeCordova Museum and Sculpture Park since 1984. She has herself been a major player in shaping the development of art in and around Boston. Special appreciation is also due Polaroid Corporation, the major funder of *Photography in Boston: 1955–1985,* not only for their generous support for this exhibition but also for their major support for artists and photography throughout the period focused on here.

In the end, of course, the opinions expressed in this exhibition and catalogue are those of the curators, the authors, and the Museum. Our hope is that the work presented here may move thinking about photography in Boston beyond a simple checklist of who has been included to a more constructive analysis of what options such a rich and particular and enduring history may provide.

Paul Master-Karnik
Director, DeCordova Museum and Sculpture Park

Introduction

It was Paul Master-Karnik, Director of the DeCordova Museum, who suggested back in 1994 that we take an in-depth look at the history of photography in the Boston area in the second half of the twentieth century. After beginning research on the rich photographic history of this area, I determined to limit the focus of this project to the years 1955–1985. The DeCordova Museum opened to the public in 1950, and it seemed appropriate to relate the time period of this exhibition to the modern period in which DeCordova emerged as a force on the regional art scene.

The thirty-year period chosen for this project encompasses photography's acceptance as an art form, the influence of modernism, and the coalescence of a unique constellation of educational institutions, museums, and technological developments in the Boston area that directly influenced artistic options for photography. This period coincides with the area's growth in the fields of electronics, space research laboratories, computer and software products, biotechnology, genetic engineering, printing and publishing, higher education, and finance. Cambridge, long recognized as a center for education and technology, for example, was the city where Dr. Harold Edgerton invented electronic stroboscopic flash photography in 1930 and Dr. Edwin Land invented instant photography in 1947. Both of these innovations had a lasting impact on the technological development of photography as well as its aesthetics. Minor White's arrival at the Massachusetts Institute of Technology in 1965 to run the Center for Creative Photography and Polaroid Corporation's innovative support of creative photography are further examples of how such developments built upon one another and created a unique regional critical mass in modern photography. The focus of the exhibition is on photographers and institutions active in Boston and surrounding areas, such as Worcester and western Massachusetts, as well as the influence of photographers teaching at the Rhode Island School of Design in Providence, specifically Harry Callahan and Aaron Siskind.

Up until 1955, there were few places in the Boston area to see photography on a regular basis, and even fewer museums collecting or schools teaching photography as a discipline. But in 1955, with the opening of the Carl Siembab Gallery on Newbury Street in Boston, and with the subsequent arrival in Boston of Carl Chiarenza from Rochester, New York, a photography community began to coalesce. There followed in the 1960s and 1970s an explosive growth in the photography field, in the Boston area and elsewhere, resulting in many places to study, exhibit, and see photographs. The 1970s in particular were a time of expansion in photo education, collecting, galleries, and museum activities. By the mid-1980s, many more photographers were active on the regional scene, forming a rich and diverse community. Thus, the thirty-year period from 1955 to 1985 was a time when photography became thoroughly enmeshed in the fabric of the Boston art world.

I selected 1985 as the end date for this project for several reasons. One is that the number of photographers working in Boston has increased exponentially since that date, so much so that to do justice to those photographers a separate exhibition would be necessary. Also, by the mid-1980s, the photography market had slowed down somewhat, grant support had diminished, and a number of galleries and exhibition spaces dedicated to photography had closed. Given these considerations, and the decision not to include digital photography in this exhibition (the first digital camera was marketed in

1984),[1] it seemed logical to end the exhibition in 1985.

As curator of the exhibition, I was responsible for choosing which artists and photographs to include, and for selecting the catalogue essayists. In addition to my own essay, I invited three guest writers to contribute. Kim Sichel, photographic historian and associate professor of art history at Boston University, was asked to write about the period 1955–1970, including not only the significant individuals who were active at that time but also the institutions where photography was taught, exhibited, and collected. My essay, which covers the period 1970–1985, continues this coverage of individuals, galleries, museums, and educational institutions. Noted critic and writer A. D. Coleman was asked to address what was being written about photography during the thirty-year period of the exhibition. Photographer, writer, and teacher Arno Rafael Minkkinen, who has used Polaroid film for his own work, was asked to write about Polaroid Corporation, its technical innovations, artists' support program, and collection. Additionally, he interviewed several artists who used Polaroid film to hear their personal responses to the medium.

In an exhibition of this scope, it would be impossible to include the work of every photographer who was present on the scene between 1955 and 1985. I chose to focus on artists who have created a significant body of photographs, and did not consider artists who primarily work in other media but have at times used photography in their work. Some well-known photographers, such as Walker Evans, lived too far out of the geographical focus of the exhibition to be included, though their work was without question extremely influential on photographers in this area. Others, such as Mike and Doug

Starn, Laura McPhee, and Abelardo Morell, were just getting their start in the mid-1980s, and in my assessment had not yet begun their mature work. This said, the exhibition offers a comprehensive look at a thirty-year period in Boston's photographic history. Coming as it does at the turn of the millennium, this investigation could and should be the foundation for other studies of the photographic history of the region.

Rachel Rosenfield Lafo
Senior Curator, DeCordova Museum and
Sculpture Park

1. See Keith F. Davis, *An American Century of Photography: From Dry-Plate to Digital* (Kansas City: Hallmark Cards, 1995), 453. Davis notes that artists such as Nancy Burson and Peter Campus were using digital technology in their work in the 1970s.

Acknowledgments

An exhibition and catalogue of this magnitude could not have been achieved without the help of many individuals and organizations. On the DeCordova Museum staff, I would like to thank Paul Master-Karnik, Director, and Nick Capasso, Associate Curator, for their advice and encouragement. I am most indebted to Curatorial Intern Gillian Nagler, who has assisted me with this project since January 1999. Her excellent research and communication skills and amazing resourcefulness were always in evidence as she worked on editing the catalogue text and coordinating loan, photography, and reproduction requests. I would also like to thank Sue Atwater, Curatorial Assistant, for ably providing additional administrative support. Lynn Traub, Registrar, expertly coordinated the shipping and insurance of the over 200 photographs included in the exhibition. Brad Gonyer, Preparator, and Kevin Bird, Assistant Preparator, undertook the enormous job of matting, framing, and installing the exhibition. Marc Teatum, Staff Photographer, is to be thanked for his patience in photographing many of the images for the catalogue. Corey Cronin, Director of Marketing, played an important role in promoting the exhibition. Without the assistance of Melissa Kane, Director of Development, and Marie Nunn, Assistant Director of Development, essential funding for this exhibition would not have been secured. I would also like to thank Claire Loughheed, Director of Education, and Laura Howick, Museum Educator, for planning the educational programs for this exhibition.

Over the five years that I have worked on the project, I benefited from the assistance of many interns. These include graduate students Mary Louise Hoss, who compiled the information for much of the chronology and did a great deal of background research, and Rebekah Burgess and Sarah Miller, both of whom did much research in the field. Other interns who assisted with this project are Angela Koester (currently Assistant to the Director of the DeCordova Museum) and Ellie Bronson.

Since the inception of this project, I have been fortunate to have the advice of Gus Kayafas, photographer, DeCordova Trustee, owner of Palm Press, Inc., and an individual who has been part of the local photographic scene since the mid–1960s. Gus studied and taught with Minor White and Harold Edgerton, went to graduate school at the Rhode Island School of Design where he studied with Harry Callahan and Aaron Siskind, and shaped the photographic programs at the Massachusetts College of Art. I greatly appreciate Gus's willingness to share his archival materials, collection, and knowledge with me. Other individuals who shared archival materials with me are David Akiba, Karl Baden, Chris Enos, Stephen Jareckie, Rodger Kingston, Wendy Snyder MacNeil, Arno Minkkinen, Rosamond Purcell, Daniel Ranalli, Sheron Rupp, Willard Traub, and Kelly Wise. I am grateful to John Jacob and the staff at the Photographic Resource Center for allowing me to conduct research in their library and providing me with past copies of *Views*. Branka Bogdanov, video producer for the Institute of Contemporary Art in Boston, kindly lent me a copy of her videotape on the "Boston School."

Beginning in 1994, I started to interview photographers, curators, collectors, and gallery owners about their roles in the time period 1955–1985. I'd like to thank those artists included in the exhibition whom I had the opportunity to interview. Additionally, the following people who are not represented in the exhibition were kind enough to allow me to interview them: Kelly Wise, Carl Siembab, Howard Yezerski, Brent Sikkema, Dennis Purcell, Gus

Kayafas, Robert Klein, Cliff Ackley and Anne Havinga, Stephen Jareckie, Barbara Marshall, Don Perrin, Barbara Hitchcock, Jock Reynolds, and Eelco Wolf.

I am deeply grateful to Polaroid Corporation for their generous funding of this project. In particular, I would like to acknowledge Gary T. DiCamillo, Chairman and Chief Executive Officer, Anne M. McCarthy, Vice President, Corporate Communications, and Barbara Hitchcock, Director, Cultural Affairs, for their support. Barbara Hitchcock was particularly helpful in providing advice and information about the Polaroid Collections. I would also like to thank the LEF Foundation, the Stratford Foundation, and the Charina Foundation for additional funding.

The DeCordova Museum is pleased to embark on this first copublishing venture with the MIT Press, and I thank Roger Conover, Acquisition Editor for Architecture and Design Arts, for his interest in this project, Matthew Abbate for his sensitive editing, and Jean Wilcox for her handsome design. I am most grateful to Kim Sichel, A. D. Coleman, and Arno Minkkinen for contributing their insightful essays to this publication.

The photographs in the exhibition are borrowed from many sources. I am indebted to the photographers who have lent us their work. In addition, I would like to thank Arlette and Gus Kayafas, Jude Peterson, and John Pijewski for lending works from their personal collections. I'd like to acknowledge the following institutions and their staff for lending work to the exhibition, answering research questions, and/or providing photographs: LIGHT Gallery: Fern and Tennyson Schad; Harvard University Art Museums: Deborah Martin Kao and Jenna Webster; Polaroid Collections: Barbara Hitchcock and Micaela Garzoni; Museum of the National Center of Afro-American Artists: Barry Gaither; Worcester Art Museum: David Acton and Maura Brennan; MIT List Visual Arts Center: Jill Aszling; Mount Holyoke College Museum of Art: Wendy Watson and Linda Best; Boston Public Library: Sinclair Hitchings and Aaron Schmidt; Alpha Gallery: Joanna Fink; Matthew Marks Gallery: Jeffrey Peabody, Stephanie Dorsey, and Ellie Bronson; the Lotte Jacobi Archives, University of New Hampshire: Gary Samson; and Pace/MacGill Gallery. I am also grateful to the following institutions and individuals for providing photographs, reproduction rights, and research information: Addison Gallery of American Art: Allison Kemmerer; Bell Gallery, Brown University: Kate Irwin; Fitchburg Art Museum: Anja Chavez; Art Gallery, University of New Hampshire: Anne Goslin; The Ansel Adams Publishing Rights Trust; The Harold and Esther Edgerton Family Foundation; Aaron Siskind Foundation: Anne Coleman Torrey; Minor White Archive at Princeton University: Peter Bunnell; Fogg Art Museum: Elizabeth Gombosi; Worcester Art Museum: Nancy Swallow; Commerce Graphics, Ltd., Inc.; and Anita Petricone, Ada Robinson, and Alan Shwachman.

RRL

Photography in Boston:
1955-1985

Photography in Boston, 1955–1970:

Kim Sichel

Science and Mysticism

We can instantly recall it: the drop of milk splashing against a red and shadowy background, frozen as a white, unworldly, porcelain crown by the camera and strobe. It is an image of intensity and subtlety, of show and substance, of beauty and precision. It surprises and delights us, not least because it rewards our hope that art and technology can come together with a lightness of touch. The photograph can stand for the man.

Citation of Harold Edgerton for the Eugene McDermott Award of the Council for the Arts at MIT[1]

Camera accepts everything within vision and in turn regenerates us by its two inherent powers: the power to record and to metamorphose. How astounding is camera! With its unique ability to register continuous value or tone, camera can sanctify even the ugly and the dead, clarify the ordinary, and, in a moment, turn a hundred-and-eighty degrees to play iconoclast.

Minor White, *Be-ing without Clothes*[2]

1. Cited in Gus Kayafas, ed., *Stopping Time: The Photographs of Harold Edgerton* (New York: Harry N. Abrams, 1987), 126.

2. Minor White, ed., *Be-ing without Clothes* (New York: Aperture, 1970), 11ff.

If there is a particular association between New England and photography, it centers around two separate but interpenetrating realms: the scientific explorations of the medium at the Massachusetts Institute of Technology and radiating outward throughout the region, and the mystical and formalist impact of an influential group of area teachers and photographers. These realms met in unexpected ways: the scientific community's work shared many artists' wonder at nature's beauty, while the artists conducted their personal explorations through a series of highly detailed and crafted technical innovations.

Boston and Cambridge institutions hosted an impressive series of technical innovations: most notably Dr. Edwin Land's invention of the instant photographic process and Dr. Harold Edgerton's development of stroboscopic photography. Artists working in tandem with science expanded these technical innovations into formally beautiful statements, including not only Edgerton's elegant photographs but Ansel Adams's early experiments with the Polaroid process, Gyorgy Kepes's experimentation with light, Berenice Abbott's scientific photography, and Bradford Washburn's cartographic landscapes. These images concentrated on detail, and revealed the beauty that light could craft in speed, movement, or explosion. Although created primarily as scientific tools, their close attention to detail, their often microscopic imagery, and the wonder they reveal at the natural world created a powerful aesthetic. Edgerton, the figure who wrote most eloquently about these processes, convinced a very broad audience that science was beautiful, and that it held a quality of magic or wonder.

This close attention to detail, beautiful printmaking, frequent close-up imagery, and a sense of the marvelous in nature were shared by the art pho-

tography teachers who had the greatest impact on Boston photography. In an extension of his teachings and writings in Rochester, Minor White initiated a photography program at the Massachusetts Institute of Technology that actively sought to include a mystical or meditative quality in beautifully crafted and closely observed views of nature. In Providence, Harry Callahan, followed ten years later by Aaron Siskind, provided a photography program at the Rhode Island School of Design that similarly emphasized rigorous looking, and a strict and formal organization of natural images (often seen at very close range). Although they differed from the original utopian Bauhaus ideals of the Chicago Institute of Design, Callahan and Siskind brought from Chicago a rigor of looking that in many ways paralleled close scientific observation and a wonder at the beauty of the natural world.

A third important early strand in the Boston photographic world was the photojournalist attempt at honest observation brought by Jules Aarons and Irene Shwachman, through the lens of the Photo League. Such street photography provided a counterpoint to the views of Minor White's *Aperture* magazine and its impact on Boston. In much writing about Boston the work of Aarons and Shwachman has been downplayed, as it fits less than neatly into the formalist concerns of many photographers, but their work and their ideas proved seminal in the early photographic activities in the city. Other important documentary photographers active in the area include Steven Trefonides and Jerome Liebling.

Another vital element was the impact of institutions on the emergent photography world. More than perhaps any other area, the Boston region allowed photographic practice into its institutions, early and publicly. Callahan's Rhode Island School of Design

3. For a concise description of Edgerton's accomplishments, see Marta Braun, "The Expanded Present," in Ann Thomas, ed., *Beauty of Another Order: Photography in Science* (New Haven: Yale University Press and National Gallery of Canada, Ottawa, 1998), 183–184. The most comprehensive discussions of Edgerton can be found in Kayafas, ed., *Stopping Time*, which has an essay by Estelle Jussim and also includes notes by Gus Kayafas, Edgerton's student and later research affiliate in the MIT Stroboscopic Light Laboratory. Also see Douglas Collins, *Seeing the Unseen: Dr. Harold Edgerton and the Wonders of Strobe Alley* (Cambridge: MIT Press, 1994).

4. The 1950s were particularly marked by his deep-sea photography collaborations with Jacques Cousteau, including more than 13,000 images of the Deep Scattering Layer, a series of false bottoms of the ocean floor, and Edgerton's development of a sonar device for use in deep-sea photography. In Collins, *Seeing the Unseen*, 59–61.

5. Harold Edgerton, "Foreword," in *Stopping Time*, 8.

6. Harold E. Edgerton and James R. Killian, Jr., *Flash! Seeing the Unseen by Ultra High-Speed Photography* (1939; Boston: Charles T. Branford, 1954).

7. Ibid., 11.

8. Ibid., 9.

9. Estelle Jussim, "Astonishments and Marvels," in Kayafas, ed., *Stopping Time,* 12.

10. Cited in ibid.

11. Edgerton and Killian, *Flash!*, 21.

12. Jussim, "Astonishments and Marvels," 21.

program, White's photography program at MIT, Carl Chiarenza's promotion of photography in shows and writings at Boston University, and the scientific laboratory work of Edgerton, Kepes, and others at MIT implicated the most powerful institutions in the region in the growing impact of the medium. Beginning in the 1950s and continuing into the 1970s, public photography exhibitions were held at Polaroid, the Museum of Fine Arts, MIT, the Institute of Contemporary Art, the Addison Gallery, DeCordova Museum, and at Carl Siembab's early and important photography gallery on Newbury Street.

Scientific Beauty In 1931, Harold Edgerton first published the results of his electrical stroboscopic research. His sequential flash device, a stroboscope, emitted sixty ten-microsecond flashes per second.[3] First developed to study the patterns of movement of synchronous motor blades, the stroboscope could be connected to a camera to release the shutter each time the flash went off. Thus extremely fast images of movement could be chronicled, stilled into a frozen image. Edgerton's photographic experiments lasted at MIT from his doctoral work (Ph.D. 1931) through his entire career, and he worked with the active support of the university. His students, the research he pursued for the university, and his partnerships were an intrinsic part of the development of stroboscopic photography.[4]

Light was at the center of his interests from early childhood: he began experimenting with photography as a child and made his first electrical flash lamp in 1928.[5] Edgerton's scientific discoveries found a popular audience in his 1939 book *Flash! Seeing the Unseen by Ultra High-Speed Photography*.[6] The scientist used two principles, speed and light, to create his views. Flashes, with the stroboscopic cam-

era, could take exposures shorter than 1/50,000 of a second (and eventually as short as 1/100,000,000 of a second), making visible the invisible.[7] Edgerton realized that "good experiments revealed something previously unknown" and that "seeing the unseen" inspired not only himself but many others.[8] Historian Estelle Jussim sees in these images "a masterful scientific realism touched by wit."[9]

Edgerton possessed two qualities that helped to popularize his experiments: a humorous down-to-earth presentation, and an extraordinary sense of the beauty of certain images. Curators from Steichen onward have recognized that they "not only opened a new vista from the scientific standpoint but they were also a new art form."[10] Edgerton and his co-writer James Killian remained cagey about the artistic effects, preferring to honor the notion of craftsmanship:

Much fatiguing gibberish has been spoken about the esthetics of photography, and the issue is still joined as to whether photography is, or is not, an art form. . . . But there are craftsmanship and esthetic motivation in science, and they inevitably appear in these high-speed pictures.[11]

By the end of his career, Edgerton's inventions included the freezing of high-speed motion, superimposition of motion within a single photograph, high-intensity photography, close-up microphotography, strobe images made without a camera, and underwater imagery.[12] His images of hummingbirds, drops of milk splashing, bullets penetrating objects (figure 1.1), and golf clubs in motion combine poetry, science, movement, and humor.

Edgerton's most famous image, of a drop of milk splashing into a crown of droplets, captures the scientific event of a liquid hitting a solid surface. But

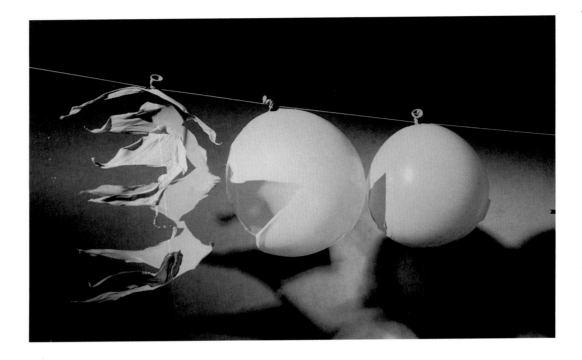

1.1 **Harold Edgerton** *Bullet through Balloons,* 1959

he made many photographs of milk splashing; despite his disclaimers, it was his aesthetic sense that led him to choose the one to publish. Jussim calls this kind of decision "the appearance of an event that tells him that this is the way nature *should* look."[13] One 1957 color photograph, *Milk Drop Coronet on Red Tin,* shows in clear and minute detail the beautiful abstract forms present in nature (plate 1); more than just a pleasing arrangement of forms, the image captures a sense of wonder in natural phenomena. Although it would be presumptuous to call this a regional style, this quality is one that Edgerton's art photography colleagues in Boston would share.

If stroboscopic photography was the earliest photographic invention to play a significant role in Boston from the early 1930s, instant photography

transformed the medium in the late 1940s. Edwin H. Land invented an instant photographic process in 1947 and founded the Polaroid Corporation. In 1948, he hired Ansel Adams as a consultant to test his new films, realizing that he wanted not only a technological tool but one that would be used by artists. In the journal of the Royal Photographic Society in 1949, Land wrote:

The purpose of this investigation is essentially aesthetic, although the realm of the investigation is, of course, scientific and technical. The aesthetic purpose is to make available a new medium of expression for numerous individuals who have an artistic interest in the world around them.[14]

Adams created landscape images (figure 1.2) with the new materials that adhered to his rigorous for-

13. Ibid., 33.

14. Cited in Richard W. Cooke, "Polaroid Corporation: Helping Artists Explore New Photographic Frontiers," *Art Today* 6, no. 1 (1991): 26.

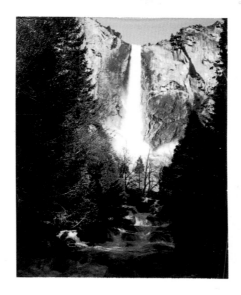

1.2 **Ansel Adams** *Cascades*, 1956 (Polaroid PolaPan Land Film Type 53; The Polaroid Collections)

15. Gyorgy Kepes, "The Discipline of Photography," *Positive* 1 (1982): 21.

16. Gyorgy Kepes, introduction to Kepes, ed., *Education of Vision* (New York: George Braziller, 1965), ii.

17. "Gyorgy Kepes," in *The New Spirit in American Photography* (Urbana: Krannert Art Museum, University of Illinois, 1985), n.p.

18. Gyorgy Kepes, *Language of Vision* (Chicago: Paul Theobald and Company, 1944).

ideas. Foremost among these was Gyorgy Kepes, a Hungarian-born artist who founded a program of visual education at MIT's School of Architecture. A member of the Hungarian avant-garde, Kepes had worked with László Moholy-Nagy in Berlin, then followed Moholy-Nagy to the New Bauhaus in Chicago, where he taught the Light and Color Workshop from 1937 to 1943. Interested in the role of light as an expressive medium, Kepes wrote that "there is an old dialogue between man and light, and in it light plays three major roles: cognitive, aesthetic, and symbolic."[15] He also realized that the social world and the physical (environmental) world included a third element, which he termed "our inner chaos—individual inability to live in harmony with oneself."[16] His work with light as a creative medium expanded beyond camera photography to experimental camera-less techniques, to painting, to light installations, and to public art.

Kepes's MIT program followed one based on the Bauhaus foundation course, and employed everything from straight photographs to abstract texture studies, solarizations, cutouts, and other experimental projects.[17] He continued to experiment with photograms, in particular, throughout his career, from his first experiments with them in Budapest in the late 1920s. He experimented as well with the *cliché-verre* process (in which an image is etched on a glass plate and printed on photographic paper). Unlike many of his Boston colleagues', his work was often abstract, but it, too, had a strong interest in science and technology.

In fact, the continuities between art and science were at the core of Kepes's beliefs, which he integrated into his work and his teaching alike. His first and enormously influential book *Language of Vision* (1944)[18] represented "an analytical and inclusive

mal conventions; the early Polaroid images he made have a magical light quality that other photographers in the area admired and that appeared in Polaroid work by the younger experimenters as well. In 1963 Adams published a handbook on Polaroid processes. Other photographers who used the new processes in conjunction with Polaroid during its first years included Paul Caponigro, William Clift, Carl Chiarenza, and Nicholas Dean.

If Land's inventions and Edgerton's experiments created a scientific body of activities with an aesthetic component, other photographers began with artistic issues and enlisted science to further their

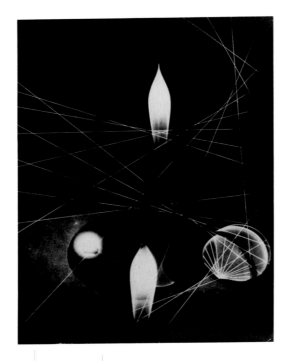

1.3 **Gyorgy Kepes** *Untitled*, 1957

19. Judith Wechsler in *Gyorgy Kepes: The MIT Years, 1945–1977* (Cambridge: MIT Press, 1978), 11.

20. Quoted by Wechsler in ibid., 12. See Gyorgy Kepes, *The New Landscape in Art and Science* (Chicago: Paul Theobald and Company, 1956).

21. The series was published in New York by George Braziller, beginning in 1965.

22. Anne Hoy, "Chronology," in *Gyorgy Kepes: Light Graphics* (New York: International Center of Photography, 1984), n.p.

23. For a discussion of Abbott's scientific work, see Julia van Haaften, "Science," in *Berenice Abbott Photographer: A Modern Vision* (New York: New York Public Library, 1989), 57ff.

24. Three further physics textbooks, with illustrations by Abbott and text by E. G. Valens, were published by the World Publishing Company, Cleveland, Ohio. They were *Magnet* (1964), *Motion* (1965), and *The Attractive Universe* (1969).

approach to design."[19] When he arrived at MIT in 1945, he began to study the collaborations between art and science more directly, and the university both promoted and nurtured his explorations. In 1951 he organized an exhibition titled *The New Landscape* combining abstract images with those of scientific phenomena such as photo and electron micrographs. Its subject was the "new frontiers of the visible world . . . until then hidden from the unaided eye."[20] His seminars and interests in the collaborations between artists and scientists culminated in the Vision + Value series that he edited in the 1960s.[21]

In 1967, Kepes founded the Center for Advanced Visual Studies at MIT, where he continued to explore the use of light as a creative medium for artists and scientists working in collaboration, often in the public art arena. He had returned to painting in 1951,

but light and photographic vision always played a seminal role in his ideas, and the interaction between science and nature continued to dominate his thinking. Kepes's photographs not only emphasize the structural beauty of light imprinted on photographic paper, but convey the magic of science as well. In photograms from the late 1930s and around 1950, in particular, he moves away from the more geometric rigor of the Bauhaus period work to record light more calligraphically, often with what curator Anne Hoy calls "an almost Oriental simplicity and serenity."[22] Compositions emerge from the simplest of elements; *Untitled* (figure 1.3), for example, consists of string intertwined with two flames in a spare and elegant organization of forms.

Edgerton and Kepes found their dual interest in aesthetics and scientific inquiry nurtured by the cultural atmosphere of MIT. Berenice Abbott, too, explored the possibilities of scientific imagery in Boston during these years, in her work for the Physical Science Study Committee in Watertown (1958–1961), a group of MIT scientists creating a new secondary school physics textbook.[23] *Physics* was published in 1960, illustrated with her studies of physical phenomena, and other books followed.[24]

Abbott felt strongly that science was the modern issue that most needed photographic attention, and focused on science in her work from 1939 to the 1960s. She served as picture editor for *Science Illustrated* in the 1940s, and developed a process of direct photography onto large negatives to avoid grainy reproductions. Whereas Kepes explored the abstract beauty of a collaboration between art and science, and Edgerton chose the most perfect forms to express the movement of objects through space, Abbott believed that the scientific subject should govern the outcome of the collaboration: "Here in

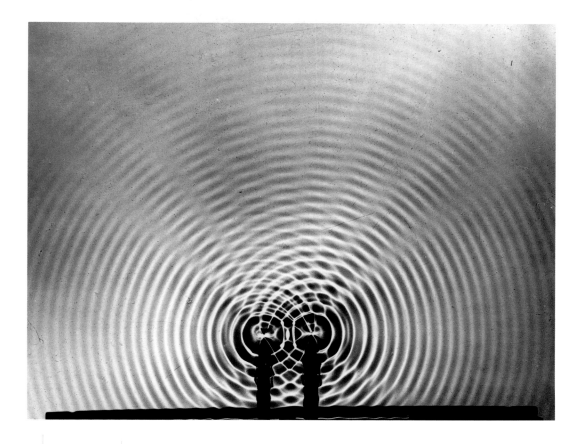

1.4 **Berenice Abbott** *Interference of Waves,* 1958–1961

25. Berenice Abbott, "The Image of Science," *Art in America* 47 (Winter 1959): 76–79, reprinted in van Haaften, "Science," 59.

26. Berenice Abbott, "Photography and Science," unpublished statement, 1939, reprinted in van Haaften, "Science," 58.

27. Berenice Abbott, caption for "Wave-Forms," in Hank O'Neal, *Berenice Abbott: American Photographer* (New York: McGraw-Hill, 1982), 60.

physics is primal order and balance; its universal implications extend limitlessly. Both scientists and artists are humble before its reason and proportion. Both try simply and faithfully to express the subject. Both must know above all else how to let the subject speak for itself."[25] She believed strongly that photography, as a child of the industrial revolution, was the medium most effective at explaining science, writing, "there is an essential unity between photography, science's child, and science, the parent."[26]

Although she recorded balls bouncing and pendulums swinging, Abbott's most striking images are her records of water and light waves. Her wave pictures are photograms in motion; they record the light rippling across water in a tray when the water is set in motion. After determining the distance from the water needed for the paper to record the waves legibly, she struggled with the light source and "finally devised a system of putting a pinhole over the light source."[27] Despite her insistence that the scientific principles should speak for themselves, images such as *Interference of Waves,* with two intersecting sets of circular waves, display the poetic beauty in abstract physical properties (figure 1.4).

A fourth photographer enriches the tradition of scientific photography in Boston in a different way. While Edgerton and Abbott photographed microscopic natural wonders, Bradford Washburn pho-

tographs mountains at the largest possible scale. Washburn was the founding director of Boston's Museum of Science from 1939 to 1980, but he is also a cartographer and expert on Alaskan mountains and glaciers. He uses an 8 by 10 inch view camera and often photographs from airplanes to obtain the most comprehensive views possible of the mountains he records. Often taken from open airplane doors, his photographs document the details of the world's great peaks, for use by climbers and scientists. His oblique aerial views permit a photographic mapping of Mount McKinley, Mount Everest, and other peaks. Images such as *McKinley's Great Shadow* (plate 7) combine dark dramatic shadows with white peaks, and reveal such exquisite detail that the texture of soft snowdrifts, cracks in the harder ice texture, and the shape of the crevasses are clearly visible.

Although the presence of Edgerton, Kepes, Abbott, and Washburn in the 1950s and 1960s illuminates one of Boston's most important contributions to photography—the pedagogy and practice of scientific photography in the university environment—their work cannot be dismissed merely as an isolated series of technological projects. All of these photographers, in their own ways, explored science and believed passionately in teaching their findings to their students. Furthermore, they each found an element of poetry and aesthetics in science, and their wonder at the natural world drove their work. It is this combination of poetry and a reverence for natural forms that links them with the group of art photographers who soon emerged in the educational and artistic photography world in Boston.

The Street and Its Impact Among the most important figures in the early 1950s were two photographers who came from the tradition of street photography. Jules Aarons, now an astrophysicist emeritus at Boston University, first studied photography in Province-town with Sid Grossman, who, with Aaron Siskind, was a member of the Photo League. Aarons and Irene Shwachman both followed the tradition of documentary photography that had emerged in the 1930s, and adapted it to Boston and to a 1950s sensibility. Aarons began photographing the streets and inhabitants of Boston's West End neighborhood, explaining, "I wanted to do in Boston what Helen Levitt, Aaron Siskind and Leon Levinstein were doing in New York. Photographing areas which were going to disappear."[28] He documented the mixed cultures of the West End, including African-American, Irish, and Jewish populations, in the years before the Redevelopment Authority razed the neighborhood in 1957 and 1958. Aarons's work in Boston, Europe, and South America has an immediacy and graphic strength similar to that of Aaron Siskind's 1930s work for the Photo League,[29] with an additional leavening quality of humor. He printed his own photographs, and the graphic quality of black and white was important to him. Aarons's beautiful graphic compositions and strongly contrasting printing style are evident in images like *Indian Boy, Quito, Ecuador* (plate 15). In this image, a pensive boy is silhouetted against a wall, his luminous eyes and tilted hat in strong juxtaposition to the tactile pattern of the masonry behind him.[30] Despite his belief in the goals of the Photo League, these images were formalist in one sense: Aarons had little extended contact with his subjects. In fact, he termed some of his images "sneaky photography," explaining that he used a Rolleiflex camera so that others would not notice him. "Having a waist-level camera made it easy to photograph without being too obvious. In

28. Jules Aarons, conversation with Kim Sichel, reprinted in Kim Sichel, *Black Boston: Documentary Photography and the African American Experience* (Boston: Boston University Art Gallery, 1994), 10.

29. The Photo League, a group of politically active photographers in New York, was founded by Sid Grossman and Sol Libsohn. Aaron Siskind's feature group study, the "Harlem Document" (including work by Harold Corsini, Morris Engel, and Jack Manning), was the most complete of the League's studies of urban life.

30. This image was included in the DeCordova's 1968 photography exhibition *Photography, U.S.A.*

many cases it was possible to mingle with the group involved, children and adults, and take photographs without their knowledge."[31]

Aarons exhibited his photographs in Boston very early, at MIT in 1949, at the Institute of Contemporary Art in 1951, and as the subject of the first photography show at the DeCordova Museum in 1951. He also served as a consultant to the DeCordova in the early 1950s, curated several shows, and taught photography at the museum.[32] He showed repeatedly with Carl Siembab at his galleries on Newbury Street throughout the 1960s and 1970s, in addition to publishing his photographs in the *Boston Globe* and other area newspapers.

Irene Shwachman became intimately involved in the Boston photography scene soon after she met Jules Aarons. He encouraged her to send her color abstract work to the Museum of Modern Art, where it was included in the 1951 exhibition *Abstraction in Photography*. In 1959, she assisted Carl Siembab in developing a photography exhibition program at his gallery. Her main interest, however was street photography. During the same year, Shwachman met Berenice Abbott and was enormously affected by her 1930s documentary project "Changing New York." She decided to attempt a similar project in Boston and photographed the city from 1959 to 1968, calling her work "The Boston Document."[33] In her description of the project she commented, "Well aware of the work of Eugène Atget in Paris and Berenice Abbott in New York, I wanted to show the upheaval caused by urban renewal, and the quality of Boston."[34]

The "Boston Document" eventually totaled over two thousand negatives, and from about 1960 to 1962 Shwachman incorporated this personal project into the work that she did for the Boston Redevelopment Authority, finding an overlap between her goals and those of her employers. "They were especially interested in alleys and access to buildings crammed into them, in industrial sites, in groups of buildings to be considered for rehabilitation or demolition, in play areas, the elevated tracks, blocks of stores."[35] Shwachman, like Aarons, paid special attention to the African-American community, photographing in Roxbury and for Freedom House, a Roxbury community and cultural center founded by Muriel and Otto Snowden. Her documentary images highlight the vibrant community of individuals and their neighborhoods, as in *Richman Bros., Washington St.* (plate 17), recording a storefront whose sign suggests the threat of impending change in the neighborhood.

Although Aarons's and Shwachman's photographs stem from the 1930s documentary tradition of seemingly transparent and nonjudgmental photography, they betray their decade by the more personal and emotional interaction between subjects and photographers. In Aarons's work, in particular, this is also reflected in dramatic printing tones. Their photographs reflect the passion both felt for their city. Other documentary photographers in the 1950s include Steven Trefonides, a painter and photographer who would become an important figure in bringing together photography enthusiasts in the late 1950s. His photographs were included in one of the first photographic exhibitions in Carl Siembab's gallery, along with those of Jules Aarons. Trefonides continued to explore urban street photography into the 1970s, as can be seen in *Washington Street* (plate 18), a geometrically composed image of a vendor looking out of his booth. Its windows reflect the passing people and windows opposite, in a tripartite composition that recalls the graphic photojournalism of Henri Cartier-Bresson.

31. Jules Aarons, statement, in Sichel, *Black Boston*, 33.

32. Among the exhibitions Aarons curated at the DeCordova was *New England: A Photographic Interpretation* (1952).

33. Much of this material is now on deposit at Northeastern University: Freedom House Collection, Archives and Special Collections, Northeastern University Libraries.

34. Irene Shwachman, "The Boston Document," unpublished statement, Freedom House Collection, Archives and Special Collections, Northeastern University Libraries; reprinted in Sichel, *Black Boston*, 10.

35. Shwachman, "The Boston Document," reprinted in ibid., 11.

36. Walker Evans, of course, was the other great documentary photographer working and teaching in New England. He lived in Old Lyme and taught at Yale University, but Connecticut lies outside the geographical parameters of this exhibition.

37. Alan Trachtenberg, "How Little Do My Countrymen Know," in *Jerome Liebling Photographs* (Amherst: University of Massachusetts Press, 1982), n.p.

38. Lewis Mumford, "Jerome Liebling: The South Bronx," *Massachusetts Review* (1978): 3.

39. Eugene Richards, *Dorchester Days* (Wollaston, MA: Many Voices Press, 1978).

40. For an insightful historical overview of the changes from the German Bauhaus to the New Bauhaus in Chicago, see Abigail Solomon-Godeau, "The Armed Vision Disarmed: Radical Formalism from Weapon to Style," in her *Photography at the Dock* (Minneapolis: University of Minnesota Press, 1991), 52–84.

41. For an overview of the Institute of Design, see *The New Vision: Forty Years of Photography at the Institute of Design* (Millerton, NY: Aperture, 1982).

42. The school's catalogue for 1939–1940 stated that the student must "strike down to bed rock and build upward for himself, within himself, gaining that happy status of self-expression and experimentation which is the true science of creative achievements." Quoted in ibid., 24.

Finally, Jerome Liebling was an important Photo League documentary photographer who came to teach at Hampshire College in Amherst in 1970. Although he was not active in New England in the years before 1970, the intensity of his documentary vision shares much with Aarons and Shwachman.[36] As Alan Trachtenberg writes, "Liebling often draws his subjects from the lexicon of documentary photography . . . yet employs a personal vocabulary in depicting them."[37] His projects in this period include *South Bronx, Charlotte Street* (plate 16), a series of studies of figures in devastated urban settings that evoke more universal than local misery. As Lewis Mumford wrote about Liebling's project, "The empty spaces tell us more about the lives people have led than the solid walls that remain. Now that the ground has been cleared, even of decent durable buildings, we know the worst."[38]

The personal connection that these photographers had with street life would continue and intensify in photographic work of the 1970s, particularly in the photographers of the group Voices, including Melissa Shook, Jerry Berndt, Roswell Angier, and Eugene Richards, whose *Dorchester Days* (1978) seems like the tragic underside of Shwachman's "Boston Document."[39]

Personal Voices If Aarons and Shwachman traveled the city streets for images that reflected the transitions of their decade, many of the teachers and photographers in Boston chose another, more interiorized path. Minor White, Harry Callahan, and Aaron Siskind, the three great teachers of the Boston region, looked primarily to natural forms rather than urban subjects, finding intimate expressions of beauty that seem to parallel the discoveries of scientific photography in the area. Although White and Callahan were very different people with dramatically different teaching styles—Callahan, at the Rhode Island School of Design from 1961, was an almost silent mentor to his students, whereas White presented a particular method that some loved and others hated—they both sought rigorous expressions in nature and valued expressive printing techniques. Paul Caponigro and Carl Chiarenza, along with many of White's students from MIT, developed these ideas into a powerful regional imagery.

When Harry Callahan arrived at the Rhode Island School of Design in 1961 from Chicago's Institute of Design, he had spent fifteen years in an institution based directly on the Bauhaus model. But although he taught a rigorous formal program, the political meanings of the original German Bauhaus were absent.[40] He continued his meticulous studies of the forms inherent in nature until he stopped teaching in 1977, and photographed the same subjects until his death in 1999.

The Institute of Design, although an art school, offered an eclectic mix of science, art, and social studies.[41] Photography, from the beginning, held a place equal to sculpture and painting in its curriculum. It Americanized the German tradition through two transformations. First was the incorporation of technology as a natural rather than a political right (Americans had Ford automobiles, not World War II tanks, in their collective memories). Second was the strong belief in self-expression, a common stance in the postwar, post-nuclear bomb, post-Holocaust decade of the 1950s.[42] Callahan epitomized the best of this self-expression.

As a teacher, both in Chicago and in Providence, Callahan taught by example rather than rhetoric, and his personal standards for excellent printmaking and the full exploration of series had a big impact on his

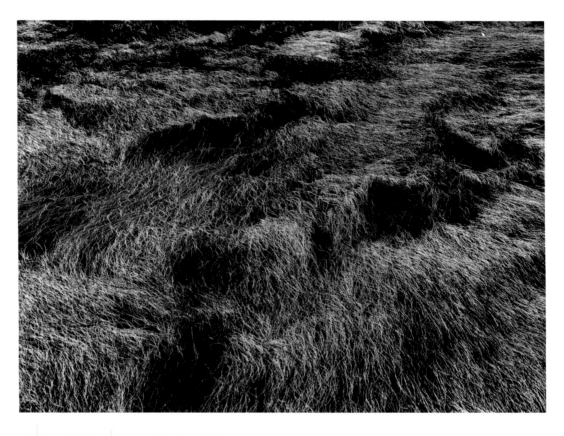

1.5 **Harry Callahan** *Horseneck Beach*, c. 1965

43. Quoted in ibid., 39.

44. Ibid., 14.

45. *Photographs: Harry Callahan,* El Mochuelo Gallery Monograph no. 1 (Santa Barbara, CA: Van Riper and Thompson, 1962), n.p.

46. For an overview of Callahan's work in New England, see Diana L. Johnson, "A Conversation with Harry Callahan," in *Callahan in New England* (Providence: Brown University, 1994), 6–15.

47. Harry Callahan, in ibid., 6.

students. Arthur Siegel wrote: "In many ways Harry is a very simple person: his photography is simple and his themes sophisticated. He wasn't a reader or an intellect, but a fantastic, creative photographer. Harry is smart in his simple-minded way. He is not innocent."[43] Callahan's ultimate teaching method was to step back and let students find their own path. He wrote, "And in the end how can anybody tell anybody else how to be an artist? This is what really boils me. All of these teachers thinking they're great educators."[44] Callahan taught wordlessly, by example, the perfection he sought in his own work inspiring a whole generation of photographers to try the same path. The closest he came to a credo was the 1962 statement: "I do believe strongly in pho-

tography and hope by following it intuitively that when the photographs are looked at they will touch the spirit in people."[45]

Of the work that Callahan pursued after arriving in New England, the series of studies of Horseneck Beach and the streets and houses of Providence stand out as pathbreaking, extending his formal vision to a sustained and meticulously viewed love affair with the landscape of New England.[46] He had been studying the details of nature since his first contact with Ansel Adams in 1941. Realizing that Adams's contact prints of close-ups were a method he could apply, he "got to photographing weeds and stuff."[47] The combination of Bauhaus-inspired formal compositions and the straight photographic tradi-

1.6 **Aaron Siskind** *Lima 89 (Homage to Franz Kline)*, 1975

tion gleaned from Adams, Weston, and their genera-
tion gives Callahan's work its distinctive quality of
formal detail yet emotional distance. His work is not
impersonal, however; as John Szarkowski puts it,
"for him, the problem was located at the point where
the potentials of photography and his own private
experience intersected."[48]

The Horseneck Beach photographs illuminate
Callahan's close attention to detail, and the emotions
that can be quietly expressed through landscape: "For
years the ocean was important—I can't even explain
it or describe it. Just walking along the beach and
being there, when there were people and when there
weren't any people."[49] In *Horseneck Beach* (figure
1.5), for instance, the overall pattern of beach grass
fills the frame from corner to corner in a delicate
series of patterns. Callahan's years in Providence also
marked his most sustained experiments to date with
color (plate 20), in studies of the brightly painted
houses of the Benefit Street section of the city.

In 1951, knowing of Aaron Siskind's Photo
League work in the 1930s, Callahan hired him to
teach documentary and socially concerned art at the
Institute of Design. Siskind taught there for nine-
teen years, directing the program after Callahan's
departure, and in 1971 eventually followed him to
the Rhode Island School of Design, then offering the
only graduate program in photography on the East
Coast. The program that they developed in Chicago,
and subsequently brought to RISD, "stressed a con-
cern with composition . . . and the creative use of
the picture frame to transform subject matter and
objects into expression."[50] Callahan has commented
that the Rhode Island School of Design was a more
traditional school. Siskind's teaching style in both
places differed from Callahan's. He was always more
involved emotionally with the individuals in the pro-

gram.[51] As a former RISD student of theirs, Neal
Rantoul, has written, "Aaron always interpreted the
responsibilities of teaching as a serious commitment
to individual development through photography. . . .
He would calculate whom he needed to work closest
with based upon how much psychological or emo-
tional trouble they were in."[52]

Siskind was an active part of the group of New
York abstract expressionist artists in the 1940s
before moving to Chicago to teach in 1951, yet his
decades of summers in Martha's Vineyard contributed
a New England facet to his work long before he set-
tled here permanently. Siskind's work of the 1940s,
especially the seaweed and rock details of Martha's
Vineyard, displays the emotive quality of simple nat-
ural shapes.[53] Siskind's biographer Carl Chiarenza
sees such images as linking "contemporary, personal,
social and international problems with the grand
struggles of history and mythology," like the con-
cerns of the abstract expressionist painters
befriended by Siskind.[54]

Siskind came permanently to New England only
in 1971 at the age of sixty-seven, after retiring from
the Institute of Design. His impact on his new
teaching environment, however, was enormous. As
Chiarenza states, "Siskind, without design or intent,
had become a spokesman for the artist-photogra-
pher."[55] He taught at RISD for five years, maintain-
ing his energetic teaching style, and retired in 1976.

Among his most powerful work during these
years is the series *Homage to Franz Kline*, made
between 1972 and 1976. Siskind had first thought of
a photographic homage to Kline on a 1961 trip to
San Luis Potosí in Mexico.[56] He developed the series
while in Rhode Island, incorporating photographs
from Jalapa (Mexico), Rome, Lima, and Boston, such
as *Lima 89 (Homage to Franz Kline),* in which paint

48. John Szarkowski, *Harry Callahan* (New York: Museum of Modern Art, 1976), n.p.

49. Harry Callahan, in Johnson, "A Conversation with Harry Callahan," 9.

50. Charles Traub, "Photographic Education Comes of Age," in *The New Vision*, 59.

51. Other members of the Rhode Island School of Design faculty in those years included Bert Beaver, Paul Krot, and Dick Lebowitz.

52. Neal Rantoul, "The Heyday of Photographic Education," *Art New England* 6 (February 1985): 7.

53. Carl Chiarenza, *Aaron Siskind: Pleasures and Terrors* (Boston: New York Graphic Society, 1982), 52.

54. Ibid., 63.

55. Ibid., 181.

56. Ibid., 188.

drips and marks form a strong L-shape against a scratched wall (figure 1.6). These close-up details of graffiti and paint marks on walls are not abstract photographs in the tradition of Kepes's photograms. Instead, they elicit an emotional response from a lyrical and close reading of the details of the quotidian world. Whether representing seaweed in Martha's Vineyard or Mexican graffiti, Siskind's photographs occupy a dual space, in the natural world and in human emotions. As Thomas B. Hess put it, "he talks to us through our humanity—through his feel for the tragic."[57]

Minor White and Company The most charismatic teacher in the United States during these years was Minor White, who came to MIT in 1965 from Rochester.[58] Long the editor of *Aperture* and a major voice in the definition of art photography during the 1950s and 1960s, White had an enormous impact in Boston. He combined formal experimentation and mysticism, and engaged whatever philosophical method opened his own mind or those of his students. This was a strong contrast to Callahan's reticence and Siskind's blustering raconteur style. Shaped by his years in California and in Rochester, White, too, came to Boston toward the end of a long career. But his mark is impressive, for the students whom he either mentored or pushed into an opposite direction from 1965 to 1976, and for the series of exhibitions and publications that he formulated while at MIT. White was particularly attracted to the idea of teaching students who were committed to science:

In moving to MIT, the whole objective changed from teaching future professionals to using photography as a way of teaching technologically and scientifically minded

people something about seeing creatively. The key phrase was: "We are trying to provide an opportunity for our scientists, our engineers, and our humanists to observe creativity in some other field than their own."[59]

He developed a photography program at MIT—the Creative Photography Laboratory—and curated numerous exhibitions for its gallery. He also organized four enormously influential shows at the university's Hayden Gallery: *Light*[7] (1968), *Be-ing without Clothes* (1970), *Octave of Prayer* (1972), and *Celebrations* (1974).[60] During these years he continued to edit *Aperture* and worked on and published his monograph *Mirrors, Messages, Manifestations*. His principal colleague at MIT was Jonathan Green, a historian and photographer who taught, collaborated on several exhibitions, and wrote together with White in some of his projects.

White's charisma was both powerful and dangerous. Among those who knew him best was Peter Laytin, a good friend who came to Boston in 1971 to be an assistant to White in his Arlington home. As Laytin noted of his friend and colleague: "The man had an aura. There was something unique about his physical presence. . . . Because of that strong ego, his inaccessible personality, his religious background, his assumed homosexuality, and his avant-garde teaching methods, a myth arose."[61] White's interest in spirituality, in Catholicism, in eastern religions such as Buddhism and Sufism, and in the philosophy of G. I. Gurdjieff strongly affected his teachings. Jonathan Green writes that "the major role that Minor saw himself playing at MIT was the role of the humanist or perhaps even more spiritualist in the midst of technology."[62] Green also recalled that White included sensitivity training and group therapy in his teachings. The "Creative Audience"

57. Thomas B. Hess, introduction to *Places: Aaron Siskind Photographs* (New York: Light Gallery/Farrar, Straus and Giroux, 1977), 11.

58. For comprehensive monographs on Minor White, see Peter Bunnell, *Minor White: The Eye That Shapes* (Princeton: The Art Museum, Princeton University, 1989), and *Minor White: Rites & Passages*, with biographical essay by James Baker Hall (New York: Aperture, 1978).

59. Paul Hill and Thomas Joshua Cooper, "Minor White 1908–1976," *Camera* (March 1977): 35.

60. For a clear discussion of Minor White at MIT, see Linda Benedict-Jones, "Minor White at MIT 1965–1976: Contributions and Controversy," in *Positive* (Cambridge: Creative Photography Laboratory, MIT, 1980), 15.

61. Peter Laytin, interview with Linda Benedict-Jones in ibid., 16. Laytin was assistant professor at MIT's Creative Photography Lab in 1976–1977 and also served as co-director of the Lab and curator of the gallery there.

62. Jonathan Green, interview with Linda Benedict-Jones in ibid., 18.

classes he taught, the center of his curriculum, had more to do with looking at photographs than making them, and were a source of inspiration to some and irritation to others. He used various techniques to increase the sensory perception of his students, making them move, read works of Eastern and Western philosophy, and meditate, all in the hopes of destroying conventional modes of vision.[63]

Both as a teacher and as an editor of *Aperture* from 1952 to 1975, White was one of the most important supporters of artistic, expressive photography in the 1950s and 1960s. As Green writes, two major ideas dominated *Aperture*. "The first was that photographs could be 'read.' The second was that photography could serve as a fitting medium for psychological and spiritual contemplation."[64] Green summarizes *Aperture's* premises about "reading" photography: subject matter alone does not constitute the entire meaning of a photograph, photographs are related to other arts, they have "similes, metaphors, symbols, and forms" relating both to the external world and to the photographer, photographs can be new experiences, and accidental prints may uncover new meanings.[65] Of White's spiritual quest he writes: "White was looking for the Tao of photography: the way to see clearly beyond the superficial, the intellectual, the pictorial."[66]

White's more scientific colleagues such as Edgerton had no vocabulary for aesthetics in photography, and his fellow art school teachers Siskind and Callahan were more intuitive and less verbal about the developments they taught and experienced themselves. White never hesitated to write or speak, sometimes extravagantly, sometimes eloquently, and if he engaged sometimes dubious methods to elicit artistic expression, his aim was to extract it from himself and his students at all costs, for better or for worse. White's commitment to photography as a means of emotional expression marks his philosophy as a direct descendant of Alfred Stieglitz's belief in the "idea" of photography, and White taught or published almost everyone who became an important art photographer during these decades.

White's exhibitions at MIT, along with the publications that accompanied them, are unique to his time in Boston. He wrote of this new impulse: "As I get older and [get] more knowledge, I find myself using photography as a medium for something else. . . . And that started very quickly after I arrived at MIT. The shift from RIT to MIT happened just at a time when I was ready to do that."[67] These exhibitions were based on abstract themes. The sequencing of the images, on the wall and in the publications, was as important as the individual images themselves. In *Celebrations*, the last of the four exhibitions, White encapsulates his goals in creating them:

Light[7] celebrated the equivalent role of light in photographing the sacred. *Be-ing without Clothes*, which followed, celebrated the human body and the theme: neither nude nor naked, but divine. The third show, *Octave of Prayer*, attempted to look for the place of photography in the esoteric ritual. *Celebrations*, while pointing up the interrelatedness of the three previous themes, perhaps suggests something of the potential unification of art, science and the sacred.[68]

The exhibitions explored various spiritual subjects in conjunction with photography, and were assembled by narrowing down hundreds of entries to the sequences and images that White found most compelling.[69] *Light*[7] (1968) opens with a portrait of Alfred Stieglitz, and White writes that "Seven Levels Of Light Illuminate the mind and cast shadows on

63. James Baker Hall in *Minor White: Rites & Passages,* 111.

64. Jonathan Green, *American Photography: A Critical History, 1945 to the Present* (New York: Harry N. Abrams, 1984), 71.

65. Ibid., 72.

66. Ibid., 79.

67. A. D. Coleman, "The Marvelous Mentor: An Interview with Minor White," *Camera* 26 (August 1981): 38.

68. Minor White, ed., *Celebrations* (Millerton, NY: Aperture, 1974), 49.

69. White had first published a similar project in an early *Aperture* issue, *The Way through Camera Work. Aperture* 7 (1959).

the psyche," later suggesting that the exhibition's title suggests "*levels*—as well as Light to the seventh power."[70] He defines each level separately, ending with "images which lead us to our Creator," the seventh level.[71] *Be-ing without Clothes* (1970) offers some clues about White's means of choosing and sequencing the images. He writes:

During the preliminary reviews of work submitted for selection, two strong modes or gestalts crystallized: (1) the search for the ideal, including both the affirmation and the denial of the search. (2) The family seeking an honesty of being: warm, organic, and by touch affirming its existence.[72]

A study of Sir Kenneth Clark's *The Nude: A Study in Ideal Form* helped him to define the idea of this exhibition, "ultimately neither nude nor naked."[73] *Octave of Prayer* (1972) continues the explicit reference to Stieglitz, when White writes that *Camera Work* represents the first "history of conscious prayer in photography" and places his own work into its tradition. He also crafts a link to scientific endeavor: "Intensified concentration is common to all creative people. Scientists, artists, philosophers name this degree of concentration Creativity; the devout call it Meditation."[74] *Celebrations*, the final exhibition from 1974, has a preface by Gyorgy Kepes, who writes, "CELEBRATION, for me, means the expression of the climactic aspect of life."[75] Various sequences include celebrations on stage, natural celebrations, and children.

Although these linked conceptions of photography, creativity, and spirituality are central to White's work, few if any of his own photographs were included in the exhibitions. His own work during these years was nurtured by the inspiration he found

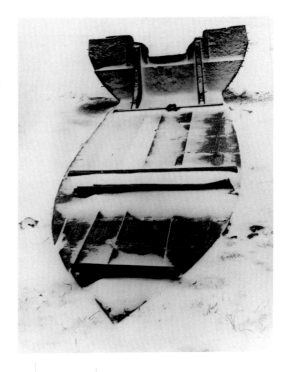

1.7 | **Minor White** *Essence of Boat*, 1967

in teaching a program of his own invention. He traveled less often than before, but journeyed to Maine, Vermont, and Nova Scotia during these years. A trip to Acadia National Park's Schoodic Peninsula in Maine, for instance, resulted in a series of close-up rock studies. Dreamlike qualities emerged from his intermingled still lifes and landscapes such as *Essence of Boat* (figure 1.7).

Although White included the work of dozens of photographers in his exhibitions and publications, he had a particularly close relationship with several younger photographers in Boston, and his ideas deeply inflected their work. These included Gus Kayafas, who came to MIT in 1965 as a freshman and worked with White until the latter's death,[76] Peter Laytin, and Jonathan Green. Other close colleagues included Carl Chiarenza and Paul Caponigro.

70. Minor White, ed., *Light⁷* (Cambridge: MIT Press, 1968), 12, 68.

71. Ibid., 70.

72. White, ed., *Be-ing without Clothes*, 11.

73. Ibid., 13. White referred to Sir Kenneth Clark, *The Nude: A Study in Ideal Form* (Garden City, NY: Doubleday, 1959).

74. Minor White, ed., *Octave of Prayer* (New York: Aperture, 1972), 15.

75. Gyorgy Kepes, preface to White, ed., *Celebrations*, 3.

76. Kayafas recalls that he and Jim Stone were the first people to receive photography degrees from MIT (Gus Kayafas, interview with Nick Capasso and Rachel Rosenfield Lafo, March 7, 1994).

Caponigro's early work resonated strongly with White's, and he would become a seminal figure in the Boston photography scene.

Caponigro studied for one year at the Boston University School of Music before being drafted into the army. In 1954 in San Francisco, while in the army and concurrently studying West Coast photography, he met Minor White, shortly before White moved to Rochester. He journeyed to Rochester in 1957 to be the older photographer's assistant for several months. In 1959, White traveled across the United States with Caponigro, who helped him teach workshops along the way. On returning to Boston, Caponigro met another of White's students from Rochester, Carl Chiarenza, and shared an apartment with him. He also discussed photography regularly with Irene Shwachman. Through Chiarenza, he taught at Boston University and in private workshops at his Newbury Street studio, where William Clift and Marie Cosindas were among his students.[77] Caponigro also was one of the group of photographers who, along with Ansel Adams, experimented with Polaroid materials.

Caponigro shares some of White's concerns, combining an intense interest in "photography, music, and spiritual awareness."[78] Caponigro also searches for self-expression and a depth of meaning through photography, although his interest in G. I. Gurdjieff's philosophy, based on Eastern religions but applied to the modern world,[79] predates that of White, who discovered it only in later years. Although he acknowledges the importance of Minor White's work for his early work, Caponigro's is less dramatic, more peaceful, and more centered. If White photographed as an act of searching, Caponigro's photographs seem to imply moments of resolution rather than conflict (although his best-known image, of running white

deer, is full of movement). Natural forms dominate his compositions. He writes, "Photography is a medium, a language, through which I might come to experience directly, live more closely with, the interaction between myself and nature."[80] A recent critic, Andrew Dykas, has written, "That's the thing about Caponigro's photography: it's autobiographical. Trees, apples, stones, and clouds all take on *his* identity, or perhaps he takes on their spirit."[81]

Yet the technical virtuosity of his prints is also an important element; Caponigro is a printmaker in the grand tradition of Ansel Adams and Edward Weston. Caponigro himself acknowledges the validity of both mysticism and technique in recounting a conversation between Minor White and Ansel Adams in 1959:

Standing between two glasses of vodka being held, respectively, by Minor and Ansel at a cocktail party, I overheard Minor ask Ansel in a playful yet probing tone if he was still practicing the Zone System. Ansel responded, "Well, of course, and I understand that you are now practicing the Zen System." With this exchange they aired their quiet conflict simply and with good humor. I felt released from any need to take a side. For me both ways could dovetail, and the degree to which one delved into it was a personal matter.[82]

New England plays a big part in Caponigro's work. Born in Boston, he has consistently returned to the New England landscape. After many years in New Mexico, he has recently been living on the coast of Maine. The landscape, whether in Ireland, New England, or New Mexico, plays an important role in his work; when man-made objects form the subjects of his pictures they tend to be very old and mystical, such as the rocks of Stonehenge or the posed megaliths of Ireland. Caponigro tries to make photographs

77. Paul Caponigro, interview with Rachel Rosenfield Lafo, July 17, 1995.

78. Marianne Fulton, *The Wise Silence: Photographs by Paul Caponigro* (Boston: New York Graphic Society, 1983), 174.

79. "Gurdjieff (1872–1949) espoused a philosophy based on ancient mysteries and Eastern teachings to which he brought his own unique insights into the problems of modern man, and through which he taught his followers to recapture spiritual harmony" (Fulton, *The Wise Silence*, 179).

80. Paul Caponigro, quoted in ibid., 182.

81. Andrew Dykas, "Music in Silver: The Photography of Paul Caponigro," *Photo Techniques* (March/April 1996): 30.

82. Paul Caponigro, *Seasons* (Boston: New York Graphic Society, 1988), 90.

1.8 **Paul Caponigro** *Branches*, 1966

83. Steve Anchell, "Transcending Technique: An Interview with Paul Caponigro," *pic: The International Showcase for Photographers* (November 1994): 1.

that illuminate the connections between the natural exterior world and interior worlds, writing, "Self-awareness should be a very important part of the overall creative process—part of the living process . . . I don't want merely a temporal thing, I want the greater internal spaces, the vast dimensions that surround these objects."[83] He began searching for this quality while working in the Boston area in the 1960s. His first *Aperture* publication features views of Mount Auburn Cemetery in Cambridge (1958). Less directly mystical yet still a meditation, a photograph made in Nahant, Massachusetts (1965), frames rocks, barnacles, their reflections in still water, and the symmetry that arises from the doubled imagery

in its silvery light. Forms can become almost abstract, as in *West Hartford, Connecticut* (plate 6) and *Branches* (figure 1.8). In both images, undulating geometry suggests the infinity of natural forms.

Carl Chiarenza is another White student who has made a very important mark on Boston. An introspective photographer who also had strong early ties to White, Chiarenza spearheaded a series of important exhibitions, critical writing, and historical activities over a period of twenty-five years or more. Chiarenza first began studying photography with White and Ralph Hattersley at the Rochester Institute of Technology, graduating in 1956, then went on to graduate school in journalism at Boston

1.9 **Carl Chiarenza** *Sulfite Moonscape, 1962*

University, where his master's thesis work was a photojournalistic essay on Boston City Hospital, indebted to W. Eugene Smith in style.

Chiarenza's dark, intense, and abstract photographs reveal an affinity with White's. Although not overtly mystical like White, he acknowledges a magic in photography: "I am captive to the photographic process. For me it is magical-alchemical. Each step in the making of a picture is guided by intrigue, the intrigue that comes from watching the real and unreal interact."[84] Unlike Caponigro, whose poetry comes in the light gray tones of the print, Chiarenza experiments with the mysteries of black. His photographs resemble dream landscapes, and images such as *Sulfite Moonscape, 1962* (figure 1.9)

create an imaginary topography. As Jussim writes, "This tension between unreality and reality demands resolution, an equilibrium which only the viewer can establish and which requires contemplation to achieve."[85] Chiarenza often cites the painter William Baziotes in formulating ideas about his images:

It is the mysterious that I love in painting.
It is the stillness and the silence.
I want my pictures to take effect very slowly, to
Obsess and to haunt.[86]

Chiarenza has been a writer and teacher, as well as a photographer and exhibition organizer, throughout his career. He has published both essays and pho-

84. Carl Chiarenza, preface to *Chiarenza: Landscapes of the Mind* (Boston: David R. Godine, 1988), 9.

85. Estelle Jussim, in *Chiarenza: Landscapes of the Mind*, 32.

86. William Baziotes, "It Is," Autumn 1959, quoted in Chiarenza, preface to *Landscapes of the Mind*, 12.

tographs in *Aperture*. He began teaching photography courses at Boston University, then studied for his Ph.D. at Harvard (1973), where he wrote his dissertation on Aaron Siskind's photographs. Chiarenza taught photographic history at Boston University from 1964 until 1986, when he became Fanny Knapp Allen Professor of Art History at the University of Rochester. He also served as the Boston correspondent for *Contemporary Photographer* from 1963 to 1964, becoming the associate editor in 1965 and editor in 1967. His first "Notes from Boston" reveals a cogent view of the city's photographic activities, with discussions of Carl Siembab's exhibitions of Eugene Meatyard, William Davis, and Edward Weston.[87] An essay from the next year provides an overview of academic sponsorship of photography in New England.

In 1958 Chiarenza organized the Image Study Gallery at Boston University, where he exhibited the work of Minor White, Nathan Lyons, and Paul Caponigro, among others. He was also a central figure in the early photographic gatherings around Carl Siembab's gallery on Newbury Street. In 1971, along with Don Perrin and others, he founded Imageworks, a Cambridge-based organization similar to the Visual Studies Workshop in Rochester. It lasted only a few years, but its successor, the Photographic Resource Center, became an important regional nexus for workshops, exhibitions, newsletters, and publications.

The Association of Heliographers In addition to their strong links to White, Chiarenza and Caponigro were part of a short-lived organization of like-minded photographers, the Association of Heliographers. Formed in Boston in 1963, this consisted of Caponigro, Chiarenza, William Clift, Marie Cosindas, Nicholas

Dean, Paul Petricone, and Walter Chappell, of whom all but Chappell were Boston-based. Although the Bostonians withdrew from the organization soon after its move to New York later that year, it was one of the earliest cooperative photography groups in the country. An exhibition at Lever House in New York illuminated a common ground among these Boston photographers, one that melds the scientific fascination with light stemming from MIT with the mystery and love of nature emanating from such figures as White and Callahan. As Margarett Loke writes in a review of a reassembly of this show in 1998, "the Heliographers—who believed in the camera's ability to transcend the subject and to register emotional responses to it—had an eye for nature as mystery."[88]

Marie Cosindas, another member of this circle, had made her first photographs on a trip to Greece in 1959. During the early years of Carl Siembab's gallery, she rented a portion of his space for her studio. A commercial artist and painter, she studied photography with Caponigro in 1960 and in 1961 worked with Ansel Adams in California, then participated in Minor White's photography workshop in 1963–1964. In 1964–1965 she operated a gallery on Martha's Vineyard, the Cosindas Gallery, where she met Siskind and Callahan.

Unlike White, Chiarenza, or Caponigro, Cosindas did not make landscape photographs but concentrated on still life imagery and portraits. Cosindas made extraordinary images using the Polaroid large-scale camera, and began testing Polaroid's color film in 1962. She is still a consultant for Polaroid. She creates emotionally charged images, both in portraiture and in her "rich, congested, and yet delicate and orderly" assemblages or still lifes.[89] Her portraits include unknown people like young sailors, along

87. Carl Chiarenza, "Notes from Boston: Three Recent Shows at the Carl Siembab Gallery," *Contemporary Photographer* 4 (Spring 1963): n.p.

88. Margarett Loke, "From a Vanished Cooperative, Nature in Abstract," *New York Times,* March 6, 1998, p. E43.

89. Tom Wolfe, "Miss Aurora by Astral Projection," in *Marie Cosindas Color Photographs* (Boston: New York Graphic Society, 1978), 12.

with portraits of famous people. Cosindas's artistic intentions strongly shaped the portraiture process, and images such as *Ellen* (plate 14) are self-conscious in their reference to painting. In this portrait, author and fellow sitter Tom Wolfe sees a strong reference to Gustav Klimt.[90]

These color images have an extraordinary painterly quality as well. As Edwin H. Land wrote, "When we look at her photographs, we are almost embarrassed by the intimate revelation of a stranger. It is clear that she could not work without beauty as one of her tools. What else she uses will remain as mysterious as art itself."[91] Cosindas pioneered the use of Polacolor color film in particular and color in art photography generally. For color is an important expressive tool, and she deliberately courts its painterly quality. John Szarkowski told her, upon first seeing her photographs, "I don't mean to sound blasphemous—but they look like paintings." "I know they do," she replied.[92] Despite this, Szarkowski gave her a one-woman exhibition at the Museum of Modern Art in 1966.

Another member of the Association of Heliographers was William Clift, who also studied with Caponigro. With a strong compositional sense for western landscape, Clift clearly works in the tradition of Ansel Adams, Edward Weston, Paul Caponigro, and other clear-sighted viewers of the distant. Clift participated in the Polaroid experiments, making a series of limpid New England landscapes. For example, his *Kings Chapel Burial Ground, Boston* (plate 4) reveals the mystical strain common to Caponigro, combined with a graphic patterning not dissimilar to landscapes by the German photographer Albert Renger-Patzsch. Nicholas Dean, another Heliographer, also studied the American landscape with Adams and Minor White. He was the first to

organize a photo presentation, "West Coast Photography," at the Boston Arts Festival in 1958, and worked for Polaroid from 1956 to 1966 as a technical specialist in Dr. Land's laboratory. His studies for Polaroid include *Ice, Route 128* (plate 9), a dreamy landscape of ice with a visible link to Caponigro's and White's landscapes.

A final member of the Heliographers was Paul Petricone, whose abstractions of nature (plate 8) also show the influence of White, with whom Petricone studied.

The Boston Scene In the summer of 1963, Anne and Carl Chiarenza wrote a historical overview of the years since Carl Siembab's gallery first opened in 1955, giving credit to what they termed "an almost messianic impulse to bring together the photographer and his potential audience."[93] Carl Chiarenza's first editorial in 1967 for the journal *Contemporary Photographer* pays homage to the gallery's reopening.[94] Many groups gathered as photography became known in the late 1950s and the 1960s, but Siembab's gallery was the most prominent and by far the most important source of support for the photographers in Boston. The gallery leaned at first toward documentary photography, exhibiting projects by Jules Aarons (Boston's West End) and Steven Trefonides (Boston's Hebrew Home for the Aged). Another of the city's early photojournalists, Irene Shwachman, collaborated in planning photography exhibitions for Siembab's space, largely out of frustration at the lack of venues for photography in Boston; in 1959 it would become the first gallery in Boston to show only photography.[95] Shwachman was instrumental in sharing her knowledge of the medium with Siembab. In 1959 Aaron Siskind had an exhibition there; that first season

90. Jeffrey Simpson, "Profile: The Artful Marie Cosindas," *Polaroid Close-Up* 14 (April 1983): 41.

91. Edwin H. Land, quoted in press release for *Marie Cosindas Photographs Then and Now*, Fitchburg Art Museum, 1997.

92. Cited in Wolfe, "Miss Aurora by Astral Projection," 8.

93. Anne and Carl Chiarenza, "The Closing of the Siembab," *Contemporary Photographer* 4 (Fall 1963): 9–11.

94. Carl Chiarenza, editorial, *Contemporary Photographer* 5, no. 4 (1967): n.p.

95. Lee Lockwood, "Profile, Carl Siembab," *American Photographer* 3 (December 1979): 59. Also see *A Photographic Patron: The Carl Siembab Gallery* (Boston: Institute of Contemporary Art, 1981), n.p.

also included Aarons, Berenice Abbott, Eugène Atget, John Brook, Caponigro, Nell Dorr, Lisette Model, Trefonides, and Brett Weston.

When Siembab met Caponigro and Chiarenza at Trefonides's gatherings of photographers, they "significantly influence[d] the aesthetic direction the gallery was to follow in photography."[96] Its emphasis subsequently turned from documentary toward art photography, with proper homage paid to the beauty of the photographic print. Siembab also became very friendly with Minor White. The gallery at 161 Newbury Street soon became a gathering place for Boston's photographers, and exhibited Boston work such as that of John Brook, who participated in a 1959 group show. He created highly romanticized fantasy landscapes and nudes, as well romantic portraits of artists (plate 13).[97] The gallery closed in 1963 because of the failing health of Siembab's wife, but reopened in 1966. Siembab showed most of the major photographers during these years, finally closing his gallery only in 1983, after the more efficient business methods of New York's Witkin Gallery and Light Gallery lured away much of his business.

By 1963 Siembab had exhibited the work of many photographers, including Alfred Stieglitz, Dorothea Lange, Andreas Feininger, Nathan Lyons, Minor White, Wynn Bullock, Carl Chiarenza, Eugene Meatyard, and Harry Callahan, besides those mentioned above. The new gallery at 133 Newbury Street showed, in addition, Imogen Cunningham, Chester Michalik, Nicholas Dean, Ansel Adams, Frederick Evans, and Jerry Uelsmann. At 162 Newbury Street, where Siembab moved in 1970, the gallery presented solo shows by Art Sinsabaugh, Paul Petricone, and Margaret Bourke-White, and in the years after 1970 many more contemporary artists were exhibited. Although Siembab never publicly theorized about

photography, preferring to show work he admired and let it speak for itself, a 1971 interview with Robert Brown of the Archives of American Art reveals a strong view on the importance of art photography that uncannily forecasts the present role of the medium:

I have a fantastic, in fact, fanatical belief in the integrity of photography as an artistic medium. I also strongly believe that it will be the most important medium in the coming generation. Perhaps not in the form that we know it now. Perhaps in another form, in an electric form, or whatever. But I think most of our artistic experiences will come through some photographic means.[98]

These years on Newbury Street served as a magnet for other photographic studios as well, including the commercial architecture studio of Paul Caponigro, Marie Cosindas's studio, and John Brook's portraiture studio. The early 1960s also mark the first sustained institutional attention to photography among Boston museums. There had been isolated activities, such as the 1924 gift of twenty-seven Stieglitz photographs to the Museum of Fine Arts, the Harvard Society of Contemporary Art's *International Photography* show in 1930, and the photography acquisitions from 1934 onward of the Addison Gallery of American Art. During World War II, the Institute of Contemporary Art presented two photography shows, *Wings over America* and *Our Navy in Action*. Two exhibitions of Jules Aarons's work in 1951, at the Institute of Contemporary Art and the DeCordova Museum, were followed by a group show in 1952 at the DeCordova, *New England: A Photographic Interpretation*. Not until Nicholas Dean organized *West Coast Photography* for the Boston Arts Festival in 1958 was there another major

96. Lockwood, "Profile, Carl Siembab," 61.

97. In 1958, Brook had an exhibition at the DeCordova Museum entitled *The Loved and the Lonely*. He wrote about his landscapes, "For me, photography is merely an extension of other things in my life. It is very, very closely connected with my emotional life—my fantasy life." Cited in "Interview with John Brook," *Aura* (June 1976): 6

98. Robert Brown, unpublished interview with Carl Siembab, July 1, 1971, Archives of American Art.

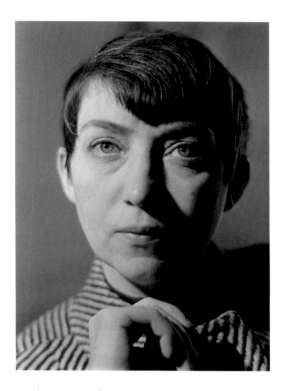

1.10 **Lotte Jacobi** *Berenice Abbott, New York City*, c. 1943

99. Nicholas Dean, "Down in the Depths at the Boston Museum," *Contemporary Photographer* 5 (Winter 1964): 3–5. The museum's annual reports, however, list nine exhibitions of the Stieglitz images between 1932 and 1965 (in 1932, 1935, 1939, 1940, 1942, 1946, 1954, 1964, and 1965).

100. Ackley was appointed curatorial assistant in the Department of Prints and Drawings in 1966, and began to acquire photographs for the museum in 1967.

photographic exhibition. Lotte Jacobi, a well-known German-born photographer who had moved from New York to New Hampshire in 1955, had important exhibitions at the Currier Gallery in 1959 and at Brandeis University in 1960. In addition to her experiments with photogenic drawing, she produced a remarkable series of portraits of artists, including those of Berenice Abbott (figure 1.10), Paul Caponigro (figure 4.3), and Minor White (plate 12).

Except for the Addison Gallery and the DeCordova Museum, most area museums paid little attention to photography until the early 1960s, when the Worcester Art Museum began acquiring and exhibiting photographs. The Museum of Fine Arts was lambasted in a furious article by Nicholas Dean, who termed its collection "almost totally inaccessi-ble to the general public." Dean urged the museum to acknowledge its photographic masterpieces, such as its treasure trove of Stieglitz photographs.[99] In 1966, the Museum of Fine Arts appointed a photography advocate in its Prints and Drawings Department in the person of Clifford Ackley,[100] and Harvard hired Davis Pratt as curator of still photography at the Carpenter Center the same year.

The years from 1955 to 1970 nurtured a vibrant growth in photographic activity in Boston, and witnessed major changes in the national perception of the medium. Photography gradually became recognized as an academic, scientific, and studio discipline, it slowly entered the art market, and it began to work its way into museum collections. From the early 1970s, the slow growth would become an explosion, and the three discernible strands of Boston photography would turn into a kaleidoscope, incorporating dozens of exhibition spaces, galleries, collections, artists' communities, and university programs, each with a different theoretical bent. Even in this explosion of activity, however, there remain certain reminders of Boston's early commitment to science, to mystical or intuitive photography, and to the street—in the current burgeoning experimentation with new processes both digital and silver-based, in the introspective Boston School photographers of the 1980s, and in the tradition of photojournalism that is still strong in the region.

Photography in Boston, 1970–1985:

Rachel Rosenfield Lafo

Expansion and Experimentation

Photography permeates the social fabric, the media and cyberspace, our very dreams. And it is the most omnipresent of all art forms.

Roberta Smith, *New York Times*[1]

The comment above was written in 1999, a testament to the enormous influence photography has had on our lives and culture. Photography is embedded in the information age so inextricably that it seems impossible to imagine how we ever lived without it. Of course, the writer is referring to photography used in advertising, scientific applications, and the media, as well as fine art photography. Photography's growing appreciation as an art form is tied to its pervasive use in other areas of life. Keith Davis postulates that the photograph was able to achieve greater artistic status only when the public did not rely as much on still photography for information purposes. He suggests that the "dramatic advances in communication and information technologies" and the growing importance of televisions in the daily lives of Americans were also factors.[2] In any case, by 1970 a diverse and active photographic community had blossomed in cities across the United States, including Boston. Departments of photography opened or expanded in colleges, universities, and art schools, and photographic history and criticism were increasingly accepted as valid disciplines for study. Museums throughout the country began to pay increased attention to the collection and exhibition of photographs; existing art galleries, both commercial and alternative, started to incorporate photography into their exhibition schedules; and new galleries devoted to photography opened.

The 1970s was also a decade of expansion for photography in the art market. Prices for photographs increased rapidly, and avid collecting ensued. Sotheby's auction house in New York City decided "to hold a series of regularly-scheduled photography sales to gauge whether a market could be developed in America."[3] The events were wildly suc-

1. Roberta Smith, "Gazing in a Mirror: The Omnipresent Camera," *New York Times*, September 10, 1999, p. 35.

2. See Keith F. Davis, *An American Century of Photography: From Dry-Plate to Digital* (Kansas City: Hallmark Cards, 1995), 388.

3. Beth Gates-Warren, "Twenty Years of Photographs at Sotheby's," *Photographs*, Sale 6684, April 7 and 8, 1995, Sotheby's, New York, 1995. (The market peaked in 1980, then fell off, and began to revive again in 1983.)

cessful. It was also a decade when the number of photographic books, exhibition catalogues, and portfolios published increased enormously, and self-published artists' books became a popular art form.[4]

By the mid-1970s, a growing number of colleges and universities in and around Boston began to offer photography courses or initiate photography departments. Aaron Siskind joined Harry Callahan on the faculty of the Rhode Island School of Design in 1971, and Jerome Liebling arrived at Hampshire College in Amherst, Massachusetts, in 1970 as one of the founding faculty members in the area of film and photography. Other schools where photography courses or programs started or broadened included Wellesley College, Boston College, Boston University, Brandeis University, Tufts University, the University of Massachusetts, Boston, the School of the Museum of Fine Arts, Massachusetts College of Art, the Art Institute of Boston, and the New England School of Photography.

These educational institutions not only taught the practice of the medium but also sponsored educational symposia and lecture series on photographic topics. The history and criticism of photography became a subject for independent study. Carl Chiarenza began to teach a course in photographic history at Boston University in 1964, and in 1970 William S. Johnson began offering courses in the history of photography at Harvard University. Eugenia Parry Janis, who taught at Wellesley, and Estelle Jussim, Associate Professor for Film and Visual Communications at Simmons College, both taught the history of photography and wrote about the medium. In 1976, Pamela Allara began to teach a course in photographic history (which Carl Chiarenza helped her design) at Tufts.

While the generation that learned photography in the 1940s and 1950s were often self-taught, those educated in the 1960s and later were much more likely to have received degrees from undergraduate and graduate photography programs. When these new academic programs required new faculty, practicing photographers filled the jobs. According to Lewis Baltz, "It is probable that teaching had supplanted commercial or magazine work as the 'other' work of most serious photographers by the 1970s."[5]

The 1970s also marked a period of increased activity by Boston area museums in the exhibition and collection of photography. The Addison Gallery of American Art at the Phillips Academy in Andover, Massachusetts, which had been particularly prescient in initiating a photography program as early as 1934, continued to be an active venue. Other institutions also increased their involvement, among them the Museum of Fine Arts, the Institute of Contemporary Art, the Fogg Art Museum and Carpenter Center for the Visual Arts at Harvard, the DeCordova Museum, the Worcester Art Museum, the Boston Athenaeum Gallery, the Hayden Gallery at the Massachusetts Institute of Technology, and the Rose Art Museum at Brandeis. The Creative Photography Gallery at MIT, which had opened in 1965 under the direction of Minor White, continued an active exhibition schedule until it closed in 1983. The Boston Public Library was amassing a collection of nineteenth- and early twentieth-century photographic material and began to add photographs by Boston artists to its collection.

The 1970s also saw a flowering of galleries and community organizations that exposed the public to photography through exhibitions, classes, lectures, and workshops. The Carl Siembab Gallery, the earliest

4. For a discussion of the scene in the 1970s, see James Sheldon's essay in *Aspects of the 70s: Photography, Recent Directions* (Lincoln, MA: DeCordova Museum, 1980), 4–7.

5. Lewis Baltz, "American Photography in the 1970s," in Peter Turner, ed., *American Images: Photography 1945–1980* (New York: Penguin Books, 1985), 157.

photography gallery in Boston and possibly the United States, was very active until it closed in 1983. Other commercial galleries that opened in Boston in the 1970s included Panopticon, opened in 1971 on Bay State Road as a lab and gallery space, the Kiva Gallery and the Vision Gallery, both opened on Newbury Street in 1976, Enjay Gallery (later Boris Memorial Gallery), active by 1977 on Lansdowne Street, and the Atlantic Gallery on Farnsworth Street which showed photography and other media. Rodger Kingston opened The Photographic Eye, Inc., a gallery and bookstore in Harvard Square, in 1975, and the Stephen T. Rose Gallery on Miner Street in Boston opened in 1977, selling mostly nineteenth-century photography. There was also an active cadre of private dealers who sold photographs directly to clients.

Community art centers and alternative spaces run by groups of photographers also flourished in the 1970s. These included the People's Gallery in Cambridge, open from 1970 to 1979 (subsequently called the Prospect Street Photo Co-op and the Cambridge Photo Co-op); Zone V, initially a rental darkroom facility and then run from 1971 to 1973 by Gus Kayafas as a photography gallery; and Voices Gallery, established by Roswell Angier, Jerry Berndt, Donald Dietz, and Eugene Richards in Boston's North End in 1978. The Project Community Arts Center in Cambridge, opened in the early 1960s, soon initiated a photography program with Minor White as director and various students of his, including Peter Laytin and Gus Kayafas, serving as teachers. Project Arts had darkroom rental, classes, small exhibitions, and lectures.[6] It closed in 1986.

One of the more ambitious undertakings of the early 1970s was Imageworks, a school and photography center established in 1971 on Rogers Street in East Cambridge by a group including photographers Carl Chiarenza and Warren Hill and Crimson Camera owner Don Perrin. Imageworks presented lectures, workshops, and exhibitions, involving photographers such as David Akiba, Len Gittleman, Aaron Siskind, Jerry Uelsmann, Minor White, Paul Caponigro, Ralph Gibson, and Bruce Davidson in its exhibition and educational programs. Although it changed hands and focus during the five years it remained open, Imageworks was an extremely active organization in the photographic community.[7]

The organization that most closely resembled Imageworks in its attempt to encourage a community of photographers to gather and share information was the Photographic Resource Center, founded in 1975 by Chris Enos with Jeff Weiss and A. D. Coleman and incorporated in 1976. Enos felt there was a need for a clearinghouse for information about photographic exhibitions, lectures, and workshops in the Boston region. The Photographic Resource Center began to publish a newsletter in September 1977; the first issue described the PRC as a "non-profit, membership organization designed to function as an information resource, a research library, a public lecture sponsor, and a workshop coordinator." In 1979, the newsletter was joined by *Views: A New England Journal of Photography*, which became an important regional vehicle for writing about photography. Also in 1979, through the assistance of Carl Chiarenza, Boston University allocated space in one of its buildings for the PRC.[8] In 1985, the PRC moved to its current space at 602 Commonwealth Avenue, where it remains a vital organization in the photographic life of this region. In addition to the many exhibitions it organizes and hosts, the schedule of lectures and workshops sponsored by the center is impressive. Between 1977 and 1985 the PRC hosted 43 events, involving area photographers such as Bill

6. See Carol Goldfarb, "Idealism vs. Pragmatism: Four Photo Groups of the '70s," *Views: A New England Journal of Photography* 2 (Fall 1980): 21.

7. Ibid., 8, 9.

8. For Enos's recollections on the formation of the Photographic Resource Center, see Chris Enos, "Reflections on the PRC," *Art New England* (February 1985): 5.

Burke, Olivia Parker, Jim Stone, Carl Chiarenza, Aaron Siskind, Harold Edgerton, and Jim Dow, as well as well-known photographers from outside the region.

Another important factor in the development of the photographic community was financial support in the form of grants from government agencies and corporations. The Polaroid Corporation had already initiated its artists' support program in the late 1960s, and many photographers benefited from both free materials and cash grants. The National Endowment for the Arts' formal program of direct grants to photographers began in 1971, and expanded greatly over the following ten years. In those early years, the NEA awarded grants to New Englanders Paul Caponigro, Bill Burke, William Clift (who had by then moved to New Mexico), Jerome Liebling, Aaron Siskind, and Harry Callahan. The NEA also began to award grants to museums to support the purchase of photography (the Fogg Art Museum at Harvard was the first major museum to receive such a grant, in 1972) and to fund photography exhibitions, publications, and surveys.[9] In 1976 the Photography Survey Project was created to encourage state and regional photography surveys, in part aimed at "bolstering the status of photography in the art world."[10] The program ran through 1981, when the funding dried up. The two Boston surveys funded in 1980 were the "Outer Boston Project" under the aegis of the Art Institute of Boston, which focused on the suburban area of Boston between Route 128 and I-495, and "Images of Preservation and Development in the Fort Point Channel and the Leather District" under the auspices of The Artists Foundation. By 1983, however, the NEA had significantly cut back on funding, consolidating its artist fellowship program and discontinuing grants in certain categories, among them grants to organizations for photography exhibitions.[11]

On the state level, The Artists Foundation in Boston, which "was incorporated in 1973 to provide direct and indirect financial and technical assistance to individual creative artists," began to award grants to photographers in 1975,[12] and by 1985 had awarded over 70 fellowships.[13]

The Documentary Tradition *Photographs are better at raising questions than at answering them; they can reveal what you do not understand, and also what you take for granted. It is possible to analyze a photograph as a work of art or for its information on material culture because all the information you need is in the photograph, but to interpret the picture's meaning requires information outside the photograph.*
Barbara Norfleet, *The Champion Pig*[14]

Most of the photographers discussed in Kim Sichel's essay were still actively working in the period from 1970 to 1985, pursuing photography that ranged from formal and metaphorical, to technically experimental, to documentary. The influence of teachers such as White, Callahan, Siskind, and Liebling was profound, yet their students did not necessarily produce work that reflected the look of their teachers. An amazing number of photographers studied at the Rhode Island School of Design with Callahan, Siskind, or both, among them Bill Burke, Jim Dow, Henry Horenstein, Neal Rantoul, Jim Stone, Starr Ockenga, Arno Minkkinen, David Akiba, Jane Tuckerman, and Vaughn Sills. These RISD students branched off in different directions, pursuing photojournalism or self-directed studies, formal studies of the landscape, images of the self and family, and experimental work involving new technologies.

9. For a discussion of the history of photographic grants sponsored by the NEA, see Merry Foresta's introduction in *Exposed and Developed: Photography Sponsored by the National Endowment for the Arts* (Washington, DC: Smithsonian Institution Press, 1984), 6.

10. The NEA Photography Survey Project is described in Mark Rice, "Making History while Making Art: The NEA Photography Survey Projects," National Endowment for the Arts website.

11. See Michael Pretzer, "The Crunch," in *Views: A New England Journal of Photography* 2 (Summer 1981): 3.

12. Susan Channing, ed., *Art of the State: Massachusetts Photographers, 1975–1977* (Boston: Massachusetts Arts and Humanities Foundation, 1978), 9.

13. A list of fellowship recipients for this time period can be obtained from the Massachusetts Cultural Council, the successor to the Massachusetts Arts and Humanities Foundation, which funded The Artists Foundation.

14. Barbara Norfleet, introduction to her *The Champion Pig: Great Moments in Everyday Life* (Boston: David R. Godine, 1979), 5.

Minor White also taught a number of the photographers who began working in the 1970s, among them Eugene Richards, Peter Laytin, Jim Stone, and Wendy Snyder MacNeil. Yet, despite the impact of his presence on the scene, there is less visual evidence of White's direct influence on the work of photographers who came of age at this time. Instead, a pervasive influence was that of Walker Evans, who taught at Yale University from 1965 to 1975. As Andy Grundberg has noted, "What White was for the 1950s and 1960s, we might say, Walker Evans is for the 1970s and 1980s."[15] One of the dominant genres for this younger generation was documentary work, loosely defined to include photojournalism, socially concerned work, photographs of people, and images of the American vernacular environment.

Photographers' growing interest in recording life around them was the result of a number of factors. In response to the political turbulence of the 1960s, many turned their cameras to social and political issues or to studies of subcultures within society. Even though Evans did not like the use of the term documentary to describe his work, his interest in the everyday objects and places that constituted a unique American language struck a chord with many photographers. Many also cite Robert Frank's searing portrait of the American social landscape, *The Americans*, published in 1959, as a powerful influence on their work. Finally, photographers turned to their own communities and families to examine changing neighborhoods and family relationships.

For those who sought out photography shows in the 1970s, there was much documentary and straight photography to be seen at the Addison Gallery of American Art, the museum associated with the Phillips Academy. Beaumont Newhall, one of the most important midcentury curators and historians

of photography, had attended Phillips, as had Walker Evans. Charles Sheeler, an artist who painted and photographed geometric forms in industry and architecture, had been the first artist-in-residence there in 1947. Although the Addison had begun to exhibit photography in the 1930s, it was not until the 1960s that the program blossomed. Don Snyder, a photographer (and brother of Wendy Snyder MacNeil, who was herself teaching photography from 1967 to 1973 at the Abbott Academy, Phillips's sister school), became the first photography curator from 1969 to 1977, succeeded by James Sheldon in 1977.[16] Although the Addison exhibited many types of photography, ranging from straight to experimental, much emphasis was put on documentary work.

Eugene Richards, who exhibited his photographs at the Addison Gallery in 1977, had studied with Minor White at MIT but went on to pursue documentary photography. Richards has emphasized the importance of White's attitude and commitment to photography rather than his teaching a particular style: "Minor taught by experience and ideas rather than by exterior materials and information. He talked about a total creative process. This meant you had to live the life of what you were going to become rather than simply adopt a certain style of photography."[17] Richards indeed has lived a life of social activism. A former VISTA volunteer, he became a committed documentary photographer and filmmaker. He has produced work on drug addiction, poverty, homicide, and aging and has authored nine books, among them *Dorchester Days* (1978), a study of the place where he grew up in Boston, and *Exploding into Life* (1986), a diary of his wife's struggle with cancer. To heighten the emotional charge in his black and white photographs, Richards moves in close to his subject, cropping the image, highlight-

15. Andy Grundberg, "Minor White: The Fall from Grace of a Spiritual Guru," originally published in the *New York Times* in 1984, reprinted in Grundberg, *Crisis of the Real: Writings on Photography, 1974–1989* (New York: Aperture, 1990), 38.

16. For information on the history of the Addison Gallery's photography program, see Kelly Wise, "Photography and the Addison Gallery," *Views: A New England Journal of Photography* 1 (November 1979): 6–8, and James Sheldon, "New England Collections: The Addison Gallery of American Art," *Views* 7 (Fall 1985).

17. Eugene Richards, in *Minor White: A Living Remembrance* (New York: Aperture, 1984), 50–51.

ing the separation between people and visual incongruities. As Max Kozloff has written: "He studies disconnection, makes it happen. The access he gains looks almost like a forced entry into the private horrors of his subjects. For they seem to have no cognizance of an outside, more rational order, or even of the interloper with the camera."[18] In *Grandy, Lima State Hospital for the Criminally Insane* (plate 32), Richards has photographed his subject at very close range, so that we only see part of the patient's face on the left side of the photograph. Grandy's intense, direct stare is magnified by the dark shadows cast by his head and contrasts with the vulnerability of the small bird on his shoulder. Richards's realization that "journalistic photographs seem to become acceptable only after time has passed and they become historical . . . even if they have contemporary ramifications,"[19] led him and Roswell Angier, Jerry Berndt, and Donald Dietz to open Voices Gallery in 1978, as a venue for documentary and socially concerned photography.

Roswell Angier was also committed to humanistic photography. A photojournalist and teacher, educated at Harvard and the University of California, Berkeley, Angier photographed people at patriotic events in Boston and people in Boston's Combat Zone.[20] He also completed a series of photographs of Native Americans and their life in Gallup, New Mexico, intrigued by what "seemed like another world" and with Robert Frank's *The Americans* on his mind.[21] Angier's photographs taken in Gallup are stark, unsettling, and emotionally gripping. The man's face in *Route 66, Gallup, New Mexico* (plate 34) is a few inches from our own, and his relationship to the woman at right, who appears much smaller, is ambiguous. Angier, however, does not see himself as a social crusader: "I'm not out to change the world.

I'm out to see what's there. One of the basic requirements for me is that I feel some kind of connection to the people who are in the pictures I take."[22]

Jerry Berndt, though not formally trained in photography, fell into the medium through his involvement in the civil rights and antiwar movements. He arrived in Cambridge in 1967 and became a staff photographer for Boston's Children's Museum, eventually becoming involved in newspaper photography. He photographed in the Combat Zone in Boston, undertook a project on the homeless at the Long Island Shelter in Boston, and has also photographed in El Salvador, Guatemala, and Haiti. In the series *Missing Persons: The Homeless,* which resulted in a book of that name in 1986, Berndt presented a disturbing and unsentimental look at the plight of Boston's homeless men, women, and children. In a similar compositional style to Richards's and Angier's, Berndt's black and white photographs are close, cropped, and taken from odd angles with a wide-angle lens, so that people in his images are often cut off. In *Long Island Shelter, Boston* (plate 31), an anonymous hand reaches into the photograph from the left to dispense food to a shelter resident. Berndt says, "it's better to use a wide-angle lens because it forces you to get in close to the subject, so close sometimes that your sense of smell kicks in."[23]

Bill Ravanesi's keen interest in social and cultural causes likewise led him to photodocumentary projects on farm labor, inner city life, and environmental and health issues. Ravanesi chose to focus on the city of Holyoke, Massachusetts, as an example of a city plagued by housing shortages, urban renewal, and ethnic tensions, resulting in the 1981 "Holyoke Public History Project." He worked with a community activist and historian to produce the exhibition *The*

18. Max Kozloff, "Photojournalism and Malaise," in *Photojournalism in the 80s* (Greenvale, NY: Hillwood Art Gallery, 1985), n.p.

19. Quoted in Willard Traub, "Voices for the Eyes," *Views: A New England Journal of Photography* 1 (November 1979): 12.

20. These projects resulted in the books *The Patriot Game* (Boston: David R. Godine, 1975) and *A Kind of Life: Conversations in the Combat Zone* (Danbury, NH: Addison House, 1976).

21. Roswell Angier in correspondence with the author, September 2, 1999.

22. Quoted in James Sheldon, "Alternative Space: Roswell Angier," *Art New England* (February 1985): 25.

23. Jerry Berndt in correspondence with the author, September 2, 1999.

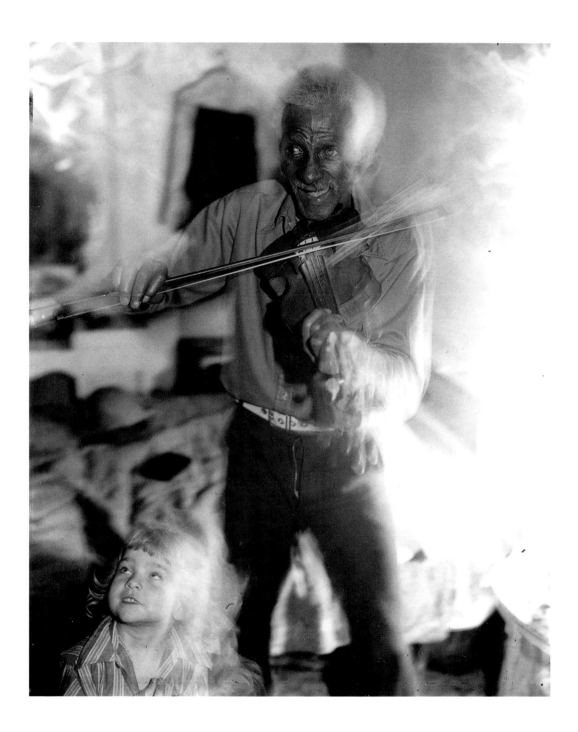

2.1 **Bill Burke** *Fiddlin Bill Livers, Owen County, Kentucky*, 1975

Hidden Holyoke, which included Ravanesi's photographs of the Holyoke Hispanic community, their oral histories, and archival photographs of the city's industrial history and ethnic labor force.[24] Opting to work in color with a large-format view camera rather than in black and white with a hand-held camera, Ravanesi wanted to slow down the documentary process. Thus, his portraits of people in their neighborhood are arranged (but not staged) rather than captured, and they are remarkable for their penetrating color, awareness of formal elements of design, and social content. In *Brothers* (plate 43), we are struck by the identical frowns of the twin toddlers and the tenderness expressed between them and their teenage brothers.

Unlike Richards, Angier, and Berndt, Bill Burke came out of a more traditional art history and photography background. He received a B.A. in art history from Middlebury College and then a B.F.A. and M.F.A. from the Rhode Island School of Design, where he studied with Harry Callahan. Burke became involved in documentary photography when he was invited to work on the Kentucky Bicentennial Documentary Photography Project from 1975 to 1977, a National Endowment for the Arts survey not unlike the Farm Security Administration project of the 1940s. Burke took portraits of the residents of Appalachia using Polaroid materials, which allowed him and his subjects to see their images instantly. *Fiddlin Bill Livers, Owen County, Kentucky* (figure 2.1) captures the energy and joyous fiddle playing of a country musician. The sense of movement and strange light effects were caused by using flash, a long exposure, and allowing the negative to dry overnight. In 1982 Burke took his first trip to Asia, becoming interested in Cambodia and returning several times to spend time on the Thai-Cambodian bor-

der to make portraits of amputees and displaced persons (plate 30).

The American Vernacular Jim Dow, who printed for Walker Evans in 1971 and 1972, followed Evans's tradition of photographing the vernacular American landscape. Dow received his M.F.A. from RISD in 1968, where he studied with Harry Callahan, and began to teach photography and photographic history in 1973 at the School of the Museum of Fine Arts in Boston, where he is a colleague of Bill Burke. Among the many projects he has undertaken are photographs of courthouses in the American South and East, major and minor league baseball parks, soccer stadiums in the United Kingdom and Argentina, and scenery along the old highways of the United States. Referring to his various projects, Dow says: "All of my subjects share a special tension between the totally vernacular and the idiosyncratic. They also represent a metaphor for personal comfort, places where you can be yourself, whoever that self is."[25] Dow acknowledges Callahan as helping him understand his motives: "It wasn't until I met Harry Callahan . . . that I began to understand that the subject comes first. Then you make pictures about it."[26] By 1978 Dow had decided to work only in color, using it as both a descriptive and a unifying element. For example, in *Bar Detail, North Dakota* (plate 21), photographed frontally in the tradition of Walker Evans, the red and blue colors of the bar furnishings are echoed in the colors in the painting of a bar mounted on the wall over the tables.

Another chronicler of the American vernacular landscape is Jim Stone, currently a professor of photography at the University of New Mexico at Albuquerque. Stone studied with White at MIT and

24. For a discussion of *The Hidden Holyoke,* see Sally Eauclaire, *New Color/New Work: Eighteen Photographic Essays* (New York: Abbeville Press, 1984), 197–202.

25. Jim Dow interviewed in "Faculty Spotlight: Jim Dow, Those Are the Good Old Days," *Museum School News* 21 (Winter 1999): 1.

26. Ibid., 3.

with Callahan and Siskind at RISD. He went on to initiate the photography program at Boston College and to write influential books on photographic techniques. Like Dow, Stone has traveled throughout the United States to capture the eccentricities of the cultural landscape. Stone uses Polaroid film, keeping the edge of the black frame visible as a signifier of the process as well as a framing device. Stone seeks out the folk art characteristics of people and places, finding a bar bedecked with 950 hats (plate 23), a man who decorated his house with beer cans, and a woman in Wisconsin who proudly holds a huge squash from her garden.

Rodger Kingston, also a Walker Evans champion, came to photography from a background as a writer, collector, and dealer. He was president and gallery director of The Photographic Eye, Inc., a gallery and bookstore in Cambridge, from 1975 to 1982. In the early 1970s Kingston began to collect what he termed "Forgotten Photographs," mostly anonymous images spanning the history of photography. His interest in vernacular subject matter is continued in his own photographic work, richly saturated color images of storefronts, window displays, signs, billboards, and posters orchestrated into satisfying arrangements of formal elements. What Kingston writes about his work could equally apply to that of Dow and Stone: "These photographs are not about decisive moments or great historical events. For the most part they are quiet images of American artifacts, searching out who we are from our surroundings. I am a connoisseur of the commonplace."[27] Kingston's sense of humor is revealed in *Me and Gene: Cambridge, MA* (plate 22), where his own reflection overlays the poster image of cowboy Gene Autry.

27. Rodger Kingston, "A Connoisseur of the Commonplace," *Dickinson Review* 9 (1994): 3.

The American Social Landscape The interest in vernacular architecture and landscape is paralleled in the work of those photographers who seek out subjects from different social groups. Barbara Norfleet, who has a Ph.D. in social relations from Harvard and was teaching in that field, initially began to use photography for her research projects. She took a course at Harvard's Carpenter Center with Len Gittleman, eventually coteaching a course with him on "Photography as Sociological Description." Although she had no art historical or curatorial background, Norfleet was asked to be the curator of the Carpenter Center photography collection after Davis Pratt moved from that position to become a curator of photography at the Fogg. At the time, the Carpenter Center's collection included a small number of "art" photographs and a much larger selection of photographs from the departments of Geography, Zoology, and Social Ethics. Norfleet's combined interest in social history and photography led her to produce a book and exhibition entitled *The Champion Pig* (1979), a compilation of images of everyday events taken in different American cities and towns by studio photographers. After publishing several thematic photo essays on subjects ranging from weddings to death, Norfleet began to photograph on her own, choosing as her subject what she described as the "hidden upper class," because she felt that they could defend themselves and were not a typical subject for the documentary photographer. Published in the book *All the Right People* (1986), these photographs raise many questions about the power relationships between different people. What is happening, for example, in *Private House: New Providence Island, the Bahamas* (plate 27) between the tanned white man in the bathing suit who leans casually in the door frame and

the embarrassed black woman in a maid's uniform who stands near him? Knowing that the interpretation of photographs depends on who is doing the interpreting, Norfleet wrote,

In spite of the people themselves liking the pictures; other people who aren't in those pictures, who are from a different class, don't like them. Instead of thinking the people in these portraits are filled with pride and assurance they think they look arrogant and entitled. Instead of seeing them as reserved, they see them as lacking spontaneity and emotion.[28]

Like Norfleet, Henry Horenstein has explored different aspects of the American social landscape. He received his B.F.A. and M.F.A. in photography from RISD, where he studied with Siskind and Callahan, and now teaches there. Horenstein was a creative consultant for Polaroid Corporation for several years and has published children's books, monographs, and a number of textbooks on photographic technique. His photographic essays include ones on Route 6 in Massachusetts (the highway went through his hometown of New Bedford), country music, and horse racing. The racetrack photographs were published in the book *Racing Days* (1987); in these images, Horenstein often presents a side of racing that most spectators do not see, as in *Jockey's Excuse, Keeneland* (plate 26), where the jockey explains his loss to the horse's owners. The tension between the disappointed and possibly angry owners and the defensive jockey is palpable.

The documentary tradition also had its western Massachusetts practitioners. Sheron Rupp initially learned photography at the Project Arts Center, then studied with Jerome Liebling and Elaine Mayes in a special hybrid graduate program between the University of Massachusetts, Amherst, and Hampshire College. A long-time interest in photographing people led her to travel to small, rural, nondescript towns, looking for "a heightened sense of suggestion or lyricism in a particular moment in a person's life." She gets "an intuitive, almost visceral reaction when the color and the details of a photograph come together to help describe where someone lives and how they live."[29] Between 1983 and 1985 she photographed in southeastern Ohio. In images such as *New Straitsville, Ohio, 1983* (plate 45), we wonder about the relationship between the man sitting on the stoop, the young woman (or is she a girl?) holding a baby, and a younger girl looking rather wistfully at the woman and baby. Rupp writes, "I have an odd sense of feeling 'at home' with the people I photograph and at the same time challenged to befriend people unlike myself."[30] Rupp's work shares an affinity to Larry Fink's provocative series of photographs of American working-class families.

The role of public funding agencies in supporting photographic projects in the 1970s and early 1980s cannot be underestimated. In 1981–1982, the Artists Foundation, with funding from the National Endowment for the Arts, commissioned six photographers to document the Fort Point Channel and Leather District neighborhoods of Boston.[31] Sage Sohier, a photographer who has always been interested in people in their environments, both indoors and outdoors, was one of the photographers invited by Lee Lockwood to participate. Sohier's photographs are marked by her ability to find the unusual in the everyday, and by the humane approach with which she treats her subjects. In *South Boston* (plate 28), a teenage boy struggles to lift a barbell while a man and other teenagers watch.

28. Barbara Norfleet, quoted in William Johnson, "Interview with Barbara Norfleet," *The Consort* (March 1991): 7.

29. "In Progress," *DoubleTake* 4 (Winter 1998): 23.

30. Sheron Rupp, "The Everydayness of Living," *Helicon Nine* (1986): 133.

31. Susan Channing, ed., *The Leather District and the Fort Point Channel: The Boston Photo-Documentary Project* (Boston: Artists Foundation, 1982). In addition to Sage Sohier, Chris Enos, Eugene Richards, and Jim Stone participated in this project. The photographs were exhibited at the Federal Reserve Bank in Boston and The Museum of Our National Heritage in Lexington.

The scene has a surreal aspect due to its unusual quality of light and its location in an open lot in a warehouse district framed by the buildings of downtown Boston. Describing her method of photography, she has written, "I drive around too much and wait until I see something that strikes me. I don't have to travel far to discover a strange neighborhood, a promising situation, a stunning gesture, a winning dog. I get out of the car and try to catch it, or get people to repeat it, or more likely, do something else interesting."[32] Sohier's photographs are black and white urban equivalents to Sheron Rupp's color photographs of small town scenes.

Nicholas Nixon's primary body of work is photographs of people. Yet when he arrived in Boston in 1974, he began to photograph views of the city taken from high vantage points as a way of coming to terms with the city as a new resident. It was also the first serious project he had done using the 8 x 10 view camera, a format that he was inspired to use after seeing photographs by Walker Evans. Nixon's cityscapes (figure 2.2) belong to a dispassionate and descriptive topographical approach to photography of the man-altered landscape.[33] After the Boston city views, Nixon went on to photograph people in different neighborhoods, stalking the city with his camera, waiting to find the right situation. In *Boston Common* (plate 25), he says that one of the girls in the picture actually approached him, asking if he would photograph her and her friends.[34] The resulting image depicts the girls casually draped on the steps leading up to a monument, informal yet sculptural in the poses that they adopted without the photographer's direction. Nixon prints his photographs as contact prints from 8 x 10 negatives, achieving exquisite details, such as the skin tone of the girls. As Pamela Allara writes, in Nixon's photographs of people "time constantly fluctuates

between the moment and eternity, just as the figures fluctuate between individuals and types."[35]

Many photographers found that the only way to maintain aesthetic independence was to earn their living as commercial photographers while pursuing independent projects on the side. Lou Jones, a self-taught photographer, began to work with color film before it had been readily accepted in the art world. He photographed in Central America for Congressional delegations, took a series of photographs of jazz musicians, and was one of a number of photographers asked by the Massachusetts Bay Transportation Authority (MBTA) to document the dismantling of the Orange Line elevated train. Jones, who believes that "the function of photography is not to make us see accurately but to see better,"[36] has an incredible color sense and keen eye for pattern. His photograph of *Dudley Station* (plate 46) frames a man and woman walking in opposite directions on the street against a huge figurative mural painted on the wall behind them.

Like Jones, Rudolph Robinson worked as a commercial photographer while pursuing his own projects. He studied design at the Philadelphia College of Art and photography in the military, and worked for many years as the photographer for the Museum of the National Center of Afro-American Artists. He was also part of Northeastern University's African-American Master Artist-in-Residence program. Robinson photographed in the neighborhoods of Boston before traveling to Europe in 1985 to work on a series of portraits of black people in Europe. His sensitive portraits are personified in the 1983 image *Ome* (plate 40), where a young boy crouches against the wall of a room, the white light of a lamp just including him in its rays.

A colleague of Robinson's who also worked as a staff archival photographer for the Museum of the

32. Sage Sohier in *PLACE: New England Perambulations* (Andover, MA: Addison Gallery of American Art, 1982), 7.

33. This body of work led to Nixon's inclusion in the 1975 exhibition *New Topographics* at the International Museum of Photography at the George Eastman house. He also had a one-person show of this work at the Museum of Modern Art in 1976.

34. Nicholas Nixon, in conversation with the author, February 9, 1999.

35. Pamela Allara, "Nicholas Nixon's Anonymous Immortals," *Art New England* 1 (January 1980): 3.

36. Artist's statement in Kim Sichel, *Black Boston: Documentary Photography and the African American Experience* (Boston: Boston University Art Gallery, 1994), 41.

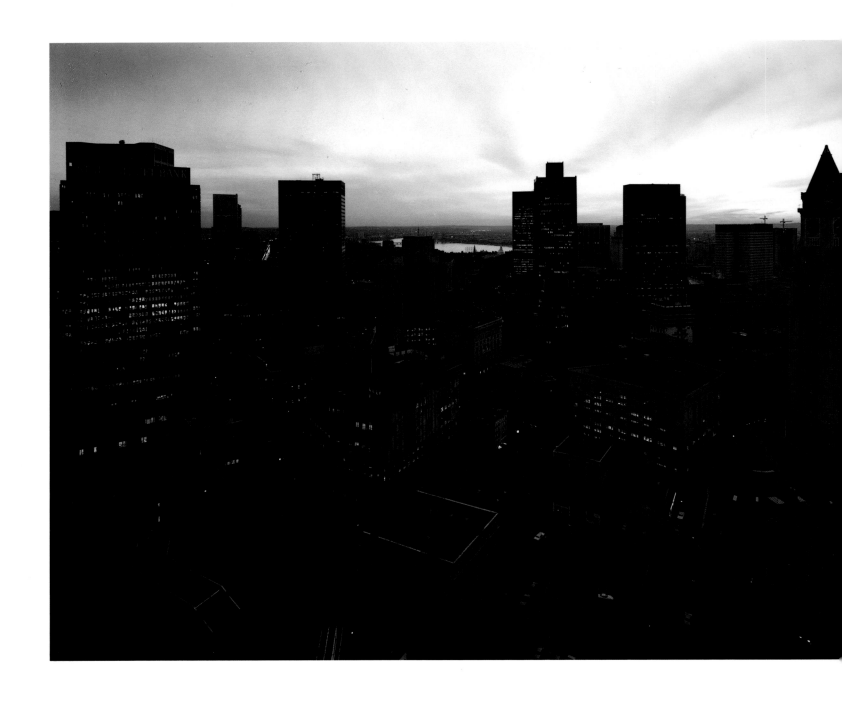

2.2 **Nicholas Nixon** *View of Boston from Commercial Wharf,* 1978

National Center of Afro-American Artists is Hakim Raquib. Born in Panama, Raquib first got involved in photography when he worked as a behavioral researcher in education. He studied at the Massachusetts Institute of Technology and at an MIT-sponsored program called the Roxbury Photographers Training Program from 1969 to 1972, where the goal was for students to use photography as a means of expression. Raquib then took his camera out onto the streets of Boston to capture images such as *Zeigler Street* (plate 24), a street scene of people waiting on a corner, where strong highlights and dark shadows add a sense of mystery to the photograph.

The Expressive Landscape The exploration of the formal and metaphorical properties of landscape, so characteristic of White and Caponigro, of Callahan and Siskind, continued with the next generation of photographers. Peter Laytin, Neal Rantoul, and Jane Tuckerman have photographed landscapes near and far, and from the mid-1970s to the mid-1980s all used infrared film to create images of haunting beauty. Infrared film records light outside of the visible spectrum, resulting in images with high contrast, reversal of dark and light areas, and grainy texture,[37] often giving the photographs an otherworldly dimension suggestive of dreams or visions.

Peter Laytin, who initially came to Boston in 1971 to be Minor White's apprentice, eventually became a codirector of the MIT Creative Photography Lab, leaving in 1977 to teach photography at Fitchburg State College. He was drawn to infrared film in 1974 because of its expressive potential. Its experimental nature—the not knowing what the final image was going to look like in advance—was a release from the practice of previsualization, a nec-

essary step for photographers who used the zone system developed by Ansel Adams. Laytin found the element of accident and chance in infrared film to be refreshing. From his travels to other countries, his photographs of architectural structures such as *Entrance to Bath, Kallithea Spa, Rhodes, Greece* (plate 49) are evocative, mysterious, and theatrical.

Neal Rantoul studied with both Callahan and Siskind at the Rhode Island School of Design and went on to teach at Northeastern University, where he is now head of the photography program. His approach to the landscape has been formal and conceptual; he is interested in capturing a sense of place while also imposing his own sense of order. His square-format infrared photographs were taken from unusual perspectives, emphasizing the emotional tenor of the images. In *Nantucket Sound* (plate 52), the passage of a ferry across the water becomes an eerie voyage as the bright white of the ship's bow seems pulled across dark waters to the distant horizon.

Jane Tuckerman, a graduate of the Art Institute of Boston and the master's program in photography at RISD, went to Benares, India, in 1985 to document Hindu death rituals. The series of photographs she took there with infrared film (plate 51) are filled with a brilliant white light, an apt visual metaphor for the holiness with which Hindus regard the River Ganges, where they bathe, pray, and perform death rituals. Tuckerman's involvement with infrared film led her to cocurate a show with Sharon Fox on the subject in 1981 at the Carpenter Center for the Visual Arts.

Chris Enos, who arrived in Massachusetts from California in 1973, characterized the Boston scene then as conservative, particularly compared with the conceptual work of California photographers such as Robert Heinecken.[38] Enos's own work at the time

37. For a description of the properties of photographs made with infrared film, see Regina Coppola, *Beyond Light: Infrared Photography by Six New England Artists* (Amherst: University Gallery, University of Massachusetts, 1987).

38. Chris Enos, unpublished interview with the author, March 18, 1994.

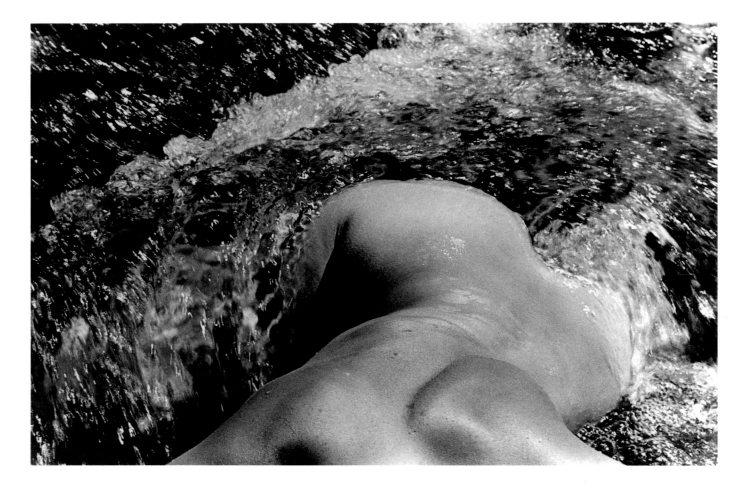

2.3 **Chris Enos** *Untitled*, 1974

consisted of cropped views of nudes in the land-scape—biomorphic and often erotic (figure 2.3). When she spent a year teaching with Jerome Liebling at Hampshire College in 1974, she says that her students "constantly wanted to pit us off against each other because he was a documentary photographer and my work was so far out there. We worked together very well."[39] After she moved to Boston in 1975, Enos quickly became involved in the local photography scene, and her work was included in some

of Minor White's exhibitions at MIT's Creative Photography Gallery. She also became a good friend of Davis Pratt, who by then was associate curator of photography at Harvard University's Fogg Art Museum. Like many photographers working at the time, Enos had the opportunity to experiment with Polaroid materials, working in the SX-70 format and later using the 20 x 24 camera. The SX-70 system, introduced in 1972 by Polaroid, was "the first fully automated, pocket-sized camera, producing prints

39. Ibid.

without a peel-apart sheet. The color balance of SX-70 film is sensitive to temperature and the color of the light source utilized."[40] In 1982 she self-published *Gar·baj́*, a book of her SX-70 images of food debris taken at the Haymarket in Boston. The colors and arrangements of the bruised and decaying fruit create luscious near-abstractions that belie the subject of the photographs. And further investigating the theme of beauty and decay, Enos produced a series of color Polaroid images of flowers (plate 59) shot at close range, the hot lights of the studio causing them to wilt and burn, the burned areas looking red with blood. These sensual photographs are about wilted beauty and aging, and "about enabling sight of and insight into the pathos as well as the loveliness of deteriorating natural forms."[41]

David Akiba, who acknowledges influences as diverse as Walker Evans, Robert Frank, Diane Arbus, Harry Callahan, and Aaron Siskind, studied with the latter two at the Rhode Island School of Design where he received his M.F.A. in photography. Well trained in formalist photography, he liked experimenting with reprographic processes and photographing directly off a television set. In 1978 he began to use copy machines to alter his photographs. Taking 35mm black and white photographs on the street, he then xeroxed and distorted the image, often cropping, burning, and dodging in the darkroom. The altered image, such as *Man Walking* (figure 2.4), represents Akiba's "attempts to get beneath the façade of controlled behavior that is everyday life."[42] Akiba converts the straight photography of the street into hallucinatory images that echo the anxieties of contemporary life. In another provocative series, Akiba photographed runners at a Boston Marathon using a 35mm camera, then rephotographed the image onto a 2 1/4-inch negative,

focusing in on the face. The expressive and sculptural faces of runners at the limit of their endurance become monumental in these square, grainy, black and white images (plate 33).

The Autobiographical Mode At the same time as a large group of Boston area photographers were documenting people and places outside of their daily environment, many others turned their cameras inward, focusing on themselves, their families, and their immediate circles of friends. A. D. Coleman identifies this autobiographical direction and characterizes its three primary forms as the self-portrait, the diary, and the family album.[43] Among those who worked in this mode are Nicholas Nixon, Judith Black, Melissa Shook, Elsa Dorfman, Wendy Snyder MacNeil, Vaughn Sills, Arno Minkkinen, John O'Reilly, Nan Goldin, David Armstrong, and Shellburne Thurber. Not surprisingly, this territory has most often been explored by women, who, for practical reasons—particularly if they had children to raise—found it easier and less expensive to turn the camera on themselves and their surroundings.

Judith Black has commented on her own situation: "I have found photography to be an art form ideally suited to the physical restraints of mothering, and along the way I have often discovered that what I previously perceived as limitations were sources of inspiration. I now use portraits of myself, my children and other family members to express themes of growth and change."[44] Black, who received an M.S. in visual studies from MIT, began to photograph her family when she was in graduate school. Her large black and white images, such as *Erik and Dylan (Mother's Day), May 8, 1983* (plate 29), present an unflinching look at the complexities of family relationships. The

40. *Innovation/Imagination: 50 Years of Polaroid Photography* (New York: Harry N. Abrams, 1999), 115.

41. William Parker, "At the Edge between Beauty and Decay," *Close-Up* 14 (April 1983): 25.

42. David Akiba quoted in Peter Sereny, "Photography Begins Gallery Season," *Artscene* (Fall 1979): 8.

43. A. D. Coleman, "The Autobiographical Mode in Photography," 1975, reprinted in his *Tarnished Silver: After the Photo Boom, Essays and Lectures 1979–1989* (New York: Midmarch Arts Press, 1996), 132.

44. Judith Black, "Mothers/Photographers," *Positive* (1980–1981): 14.

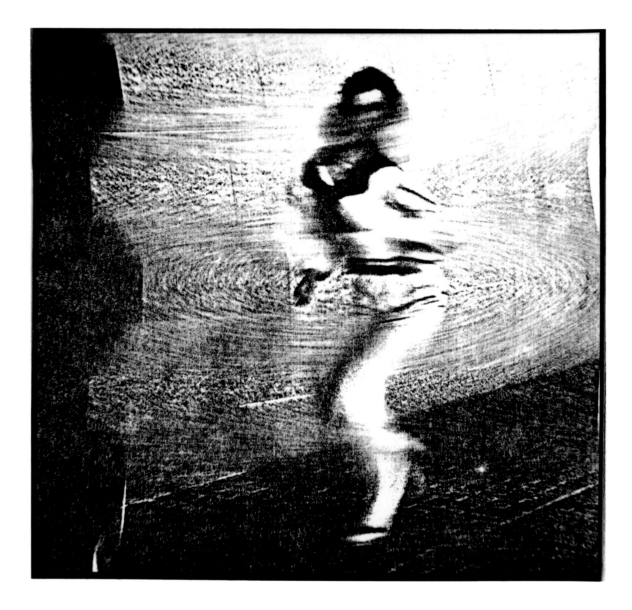

2.4 **David Akiba** *Man Walking*, 1978

subjects look out at us, as if challenging our right to examine this personal moment in their lives.

Melissa Shook began to photograph her daughter Krissy (born 1965) when she was a baby, and with certain gaps continued this process until Krissy graduated from high school in 1984.[45] This ongoing series, a way for a mother to record her child's changing physical and emotional states, provides a portrait of Krissy that is as varied as her personality—alternately pensive, sad, sultry, and playful (plates 35, 36). Somewhere between snapshots and formal portraits, they evidence both the photographer's and subject's awareness of the camera and its role in making personal statements. Writing about her pictures of Krissy, Shook says, "I am bound to human clues, facial gestures, body language, silent signals, demands."[46]

Elsa Dorfman began taking diaristic pictures in the mid-1960s, focusing on herself, her family, and her friends, many of them writers. An aspiring writer who worked for the Grove Press organizing poetry readings, Dorfman learned about photography when at the Educational Development Corporation, where she was helping develop teaching materials for elementary school science teachers.[47] Dorfman turned the camera on the people in her life; her writer friends were supportive and accepting of her self-designation as a photographer. The black and white photographs that she took in those early years culminated in the book *Elsa's Housebook: A Woman's Photojournal*, published by David Godine in 1974. The *Housebook* is both a visual and written diary, combining photographs and text. In *Myself, the Beginning of the Year, March 3, 1973* (figure 2.5), Dorfman perches on her couch, staring straight out at us, holding the shutter release cord that stretches out of the picture, clearly identifying herself as a

photographer. Dorfman also took many photographs of poet Allen Ginsberg, whom she had met through her job at Grove Press. He was one of her first subjects when she first had the opportunity in 1980 to use the Polaroid 20 x 24 camera (plate 41). Hooked on the large camera, the process, the wonderful colors it produces, and its immediacy, she eventually convinced Eelco Wolf of the Polaroid Corporation to rent her one of the 20 x 24 cameras so that she could continue to photograph people in her idiosyncratically engaging and familiar way.

Wendy Snyder MacNeil was educated at Smith College and Harvard University and was a special student of Minor White's at MIT. For many years MacNeil has been interested in relationships between family members and in their physical resemblance. During the mid-1970s she began to experiment with different photographic processes, eventually choosing to use platinum and palladium processes that had been developed in the nineteenth century. According to Kathleen Gauss, who included MacNeil's portraits in an exhibition at the Los Angeles County Museum of Art, the platinum/palladium prints yielded "ethereal nonphotographic qualities" and possessed "an ideal delicacy, strength and sensitivity. Additionally, when the emulsion was combined with translucent vellum tracing paper, the image assumed a remarkable luminosity while projecting a fragile, rare quality."[48] Using this technique, MacNeil began in 1977 a remarkable series of hands silhouetted against an empty background. The hands become the signifier of the person's identity; seen as a set, they serve as a group portrait of family members. Her first photographs in this series were of the siblings Ezra and Adrian Sesto. In the "portrait" of Adrian Sesto (plate 38), as we look at the child's pudgy hand, lined with dirt and appealingly vulnera-

45. For a description of Melissa Shook's photographs of herself and her daughter, see her article "Krissy's Xmas Present," *Camera Arts* (January/February 1998): 23.

46. Ibid., 23.

47. The Educational Development Corporation was where Berenice Abbott had made science photographs for physics textbooks.

48. Kathleen McCarthy Gauss, *New American Photography* (Los Angeles: Los Angeles County Museum of Art, 1985), 58.

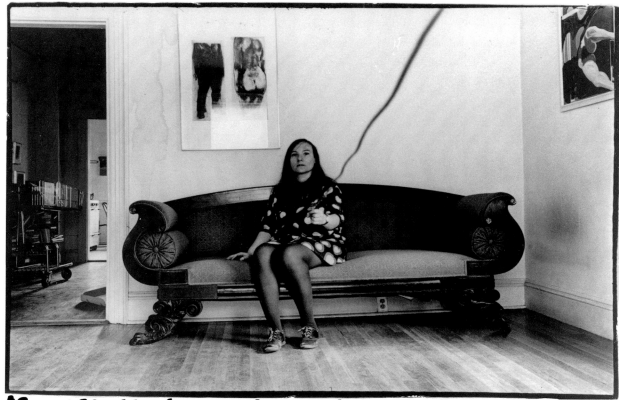

Myself, the beginning of the year. March 3, 1973.

Dorfman

2.5 **Elsa Dorfman** *Myself, the Beginning of the Year, March 3, 1973*

ble, we realize that we do not need to see someone's face to gain knowledge about them.

Vaughn Sills received her M.F.A. in photography from the Rhode Island School of Design, where she studied with Wendy MacNeil. She characterizes her own work as falling somewhere between documentary and portraiture. In the early 1980s she began an autobiographical series, rephotographing images from her childhood and printing them together with contemporary self-portraits, portraits of her mother and grandmother, and, often, diary entries or selected passages from letters. In these images Sills draws from her background in English literature along with photography. Her visual diaries speak to memories, lost childhood, unfulfilled dreams, and feminist musings on a girl's (and later woman's) place in the world. In *I Imagined That I Would Be Beautiful . . .* (plate 47), Sills places a photograph of

herself as a young girl with straight hair, eyeglasses, and gap-toothed grin on an arrangement of feminine lace and satin fabrics. The text underneath the image reads, "I imagined that I would be beautiful. I would wear bright red lipstick and dresses with spaghetti-thin shoulder straps just like my mother." Sills's self-portrait acknowledges that fantasy and reality rarely converge.

A very different approach to autobiography was adopted by Arno Rafael Minkkinen, a Finnish-American photographer who, like many of those included in this exhibition, studied with Callahan and Siskind at the Rhode Island School of Design in the early 1970s. As A. D. Coleman observes, even though Minkkinen studied with two formalists, the photographic education of the time "laid stress on introspection, personal experience and private life as a source of inspiration and a readily available literal subject matter."[49] It was at an Apeiron Workshop in Millerton, New York, in 1970 that Minkkinen decided to photograph himself nude in the landscape, and he has followed that path ever since. Minkkinen adapts his long, lanky body to the contours of the land-scape, creating surreal images that may appear to be manipulated, although they are not. Using his nude body (his face is rarely included in the picture) as an abstract element, he adopts such unusual positions that often one must search to find him in the photo-graph. In *Self-Portrait, Narragansett, Rhode Island* (figure 2.6), for example, Minkkinen's chin, shoul-ders, and accentuated collarbone are visible at the end of a wooden dock overlooking the ocean, the space between the wooden planks leading dramati-cally back to his upside down mouth, open in a pri-mal scream. His photographs have received much more attention—in the form of exhibitions, publica-tions, purchases, and awards—in Europe and Asia

than they have in the United States, attributable, in part, to a European appreciation of fantasy-like pho-tographs, and to Americans' more puritanical aver-sions to the nude male body.

John O'Reilly worked in painting, collage, and sculpture before he became involved in photography in the mid-1970s. That was when he began to place in his collages photographs of himself, pictures from his family albums, and cheap photographs taken at photo booths. As he describes it: "I would take these photographs and try to match them with something that made emotional sense to me. This somewhat chancy way of creating may parallel the working methods of self-exposure and self-investigation that I was using at this time in my work as an art thera-pist."[50] Combining his own image with reproductions of paintings and prints from art history (plate 64), O'Reilly, a former college art history professor, poked fun at icons of art history while investigating issues of identity and raising questions about the veracity of the photograph. In 1984 he purchased a Polaroid camera, initiating a productive relationship with instant photography that allowed him to photograph himself in many and varied poses without assistance and to see the results instantly. He then produced an amusing series of photographs based on art historical sources where he assumes the identity of either the artist, the artist's model, or a mysterious interloper. In *With Olympia* (figure 2.7), for example, O'Reilly, naked with camera in hand, sits on the bed of Manet's odalisque Olympia, staring out at the viewer. What we see of Olympia are her bare legs, and a reproduction of her face that lies curling on the bed. Who is this naked man with the camera, a paparazzo who has invaded Olympia's privacy? By inserting him-self into this intimate scene, O'Reilly raises questions about sexuality, voyeurism, and originality.

49. A. D. Coleman, "Minkkinen's Sauna Sensibility," *New York Observer,* June 26, 1995, p. 19.

50. Quoted in "A Dialogue: John O'Reilly and James Tellin," in *John O'Reilly: Self-Portraits 1977–1995* (Boston: Howard Yezerski Gallery, 1996), n.p.

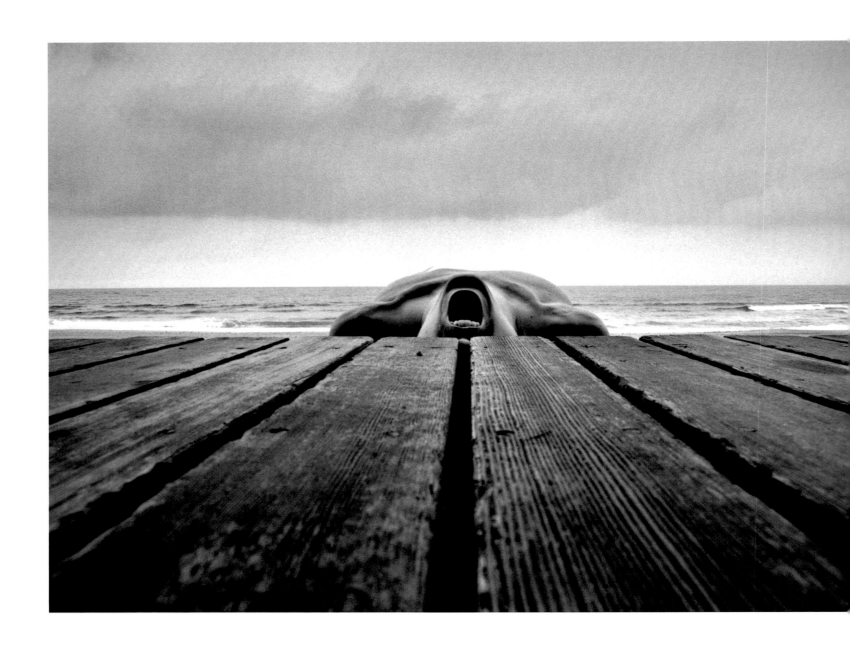

2.6 **Arno Rafael Minkkinen** *Self-Portrait, Narragansett, Rhode Island,* 1973

Among the numerous photographers in the Boston area whose work explores autobiographical issues, one group has been dubbed the "Boston School,"[51] of whom David Armstrong, Nan Goldin, and Shellburne Thurber are included in this exhibition. They were certainly not the first artists to look inward, nor the first to investigate subcultures and marginal groups. The rationale for grouping them seems largely related to their having attended the School of the Museum of Fine Arts at overlapping times, their friendship, and their immersion in the dark underside of life (particularly in the case of Goldin and Armstrong). The photographs of Goldin and Armstrong undoubtedly registered as more sensational because the world they were describing — drag queen club life, heterosexual and homosexual encounters, relationships where physical and substance abuse are in evidence—was more exotic and dangerous than that of Elsa Dorfman's beat poet friends or Judith Black's family.

Nan Goldin began to photograph her friends as a teenager, continuing this focus as she moved through the worlds of art school and the club scene in Boston, and later in her years spent in New York and other cities. Her interest in "capturing life as it's being lived, and the flavor and smell of it,"[52] is present in her photographs from the late 1970s, before she moved to New York City in 1978. The colors in these photographs are exaggerated; at this point in her work she often used artificial light and flash, and her friends are viewed with a loving eye, as they perform personal rituals such taking a bath or bleaching their eyebrows. Goldin also consistently turned the camera on herself, exploring the many different aspects of her persona. In *Nan as a dominatrix, Boston* (plate 42), she stares directly at the camera with eyes made up like a cat, dressed in a black leather dress

bedecked with zippers, buckles, and chains, leather straps around her arms, looking incongruous as she leans against an ordinary kitchen stove.

David Armstrong, Goldin's friend from childhood, has also concentrated on photographing his friends. In contrast to Goldin, Armstrong works in black and white, creating beautiful, romantic portraits that are more formal in their approach, with a conscious awareness of structure and light. Armstrong and Goldin have photographed each other over the years, as well as many of the same people who have been part of their lives. Armstrong's portraits are often less anchored to a particular time period or place than Goldin's, as the sitters are usually framed against a neutral background or centered in the composition, as is the case in *George in the water, Provincetown* from 1977 (plate 39), where the subject stands in the water, his head intersected just above the eyes by the horizon line. There is a sadness and sense of longing in many of Armstrong's portraits, as though he is trying to capture his friends' essential being before it passes. According to Nan Goldin, "David has always used photography as a seductive device, a sublimation of his desire."[53]

Shellburne Thurber, too, was photographing her family, friends, and immediate environment and felt a kinship with Nan Goldin, whom she met at the Museum School, though her photographs are otherwise quite different from Goldin's and Armstrong's. After Thurber's mother's death, she began to photograph her grandmother's house in Indiana as a way of getting to know her mother. Her impetus for doing so was similar to that of Melissa Shook, whose mother's death when she was very young led her to want to capture her daughter's image so that she could fix her memories photographically. Thurber "suddenly realized how photographs can become sur-

51. See Lia Gangitano, ed., *Boston School*, a catalogue published on the occasion of an exhibition at the Institute of Contemporary Art, Boston, October 18–December 31, 1995.

52. Nan Goldin, quoted in "On Acceptance: A Conversation—Nan Goldin Talking with David Armstrong and Walter Keller," in *Nan Goldin: I'll Be Your Mirror* (New York: Whitney Museum of American Art, 1996), 452.

53. Nan Goldin, "Afterword," in David Armstrong, *The Silver Cord* (Zurich and New York: Scalo Publishers, 1997), 120.

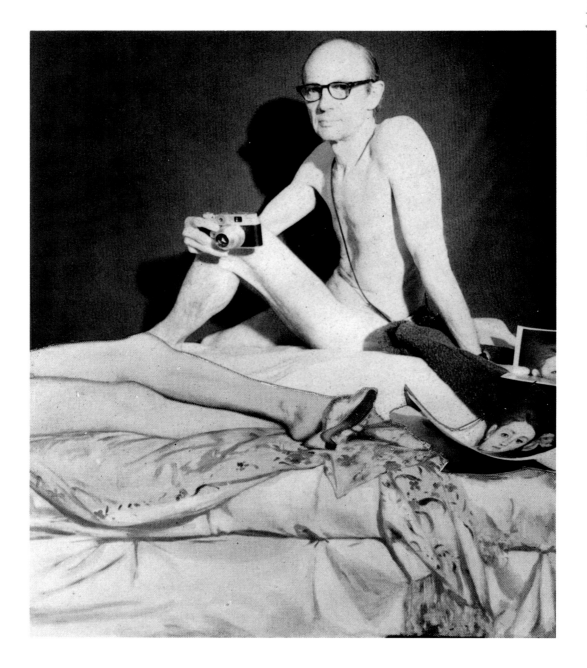

2.7 **John O'Reilly** *With Olympia*, 1984

rogates for actual lived experience."[54] In her 1976 *Grandfather's Bed* (plate 50), the human presence is almost palpable in the slightly rumpled bedclothes and the framed picture of a woman reading in front of a fireplace that hangs over the bed. Yet it is the human absence we take note of, and Thurber's photographs of empty rooms are as much about longing as they are about specific locations.

Experiments with Light Gyorgy Kepes's interest in light as an expressive medium, discussed in Kim Sichel's essay, is carried on in the work of Len Gittleman. Gittleman, like many of the photographers represented in this exhibition, studied with Harry Callahan and Aaron Siskind, but did so at the Institute of Design in Chicago in the 1950s. After beginning a career as a filmmaker and commercial photographer in New York City, Gittleman was invited to Harvard University in 1963 to teach the first photography course at the Carpenter Center for the Visual Arts. Over the next twelve years he taught a number of courses in photography, film, and graphic media, including one on "Photography as Sociological Description," cotaught with Barbara Norfleet, who had been a student in one of his classes. While at the Institute of Design in Chicago he had begun to experiment with color photograms, images made without a camera by placing objects on a sensitized surface and exposing it to light. He arranged pieces of opaque and transparent paper and plastic on light-sensitive paper to create luminous, abstract images of colored light. In the late 1970s, when Gittleman gained access to Polaroid materials, he continued his series of color photograms using Polacolor film. The resulting cameraless images (plate 54), which evolved from a trial

and error process, are rich in color and sensuous in shape; as A. D. Coleman notes, they point out the relationship between photography and sculpture.[55]

Daniel Ranalli, who came to photography from a background in the social sciences, also experimented with the photogram technique between 1975 and 1985. Working in the darkroom, Ranalli used strips of cardboard or paper and tensor and pen lamps to create shape and line. Images such as *Bird Fetish #1* (plate 53) are mysterious, sensual, and emblematic, abstract yet evocative of organic forms. This photogram, with its skeletal birdlike form, presages Ranalli's subsequent work on environmental issues. In 1979 Ranalli's photograms were included in a semihistorical show at the Thomas Segal Gallery in Boston called *Light Drawings, Photogenics and Photograms*, which also included the work of Kepes, Man Ray, and Moholy-Nagy.

Like Ranalli, Sandra Stark was also interested in drawing with light. In works from the early 1980s, she aimed to combine the energy of drawings and the formalism of photographs. To do so, she created constructions like stage sets in her studio, then photographed the darkened room with a 4 x 5 camera using flash and colored filters. The resulting "light events," such as *Night Is the Color of a Woman's Arm* (plate 55), where all the words to the Wallace Stevens poem referred to in the title are superimposed over each other, are lyrical abstractions of color and drawn line, the line achieved by using lasers and flashlights in long exposures, sometimes up to an hour. Stark, who has taught photography at the School of the Museum of Fine Arts, Boston, since 1980, works in a tradition more closely aligned to other media—particularly drawing and sculpture.

54. Shellburne Thurber, interviewed in *Tuftonia: The Magazine of Tufts University* (Fall 1997): 12.

55. A. D. Coleman, "Radiant Light Forms: The Polaroid Photograms of Len Gittleman," *Camera 35* (December 1981): 34.

The Constructed Image Like Stark, Rosamond Purcell and Olivia Parker have chosen to work in the studio. If Stark's photographs relate to the media of drawing and sculpture, Purcell's and Parker's images come out of the tradition of collage. Both artists are fascinated with the history of science and its artifacts, collect natural and man-made objects, and have made these elements an essential part of their creative work.

For Purcell, a graduate of Boston University who is mostly self-taught in photography, it was the opportunity to use Polaroid film that opened the door to photographic experimentation: "I started as a photographer with Polaroid films, and my progress has been defined by the materials. This medium encourages play and active participation, and demands that you figure it out as you go along."[56] Purcell was a pioneer in peeling apart the Polaroid negative and positive and using the negative to make a transfer image. By printing double negatives and photographing objects with light reflecting off them, Purcell created images that suggest alternate versions of reality. Combining photography with her interest in collecting specimens, junk, and books, she began, in the early 1980s, to make sculptural constructions that she then photographed. For example, *Malmaison I* (plate 56), produced on the Polaroid 20 x 24 camera, is a photographic image of four glass windows through which we see a poetic, dreamlike world that includes collaged images from books, excerpts from World War I newspapers, and old prints.

Like Purcell, Olivia Parker is mostly self-taught as a photographer, although she studied art history and painting at Wellesley College. She, too, has a penchant for collecting natural artifacts and books, and is interested in the history of science. When Parker began making photographs in 1970, she com-

bined these interests in the still lifes she made — small, elegant, poetic compositions where objects are carefully selected, arranged, and sometimes altered. Initially working in black and white, using toning as a device to add color and unify the image, Parker created seductive images like *Miss Appleton's Shoes* (plate 48) where the formal qualities of composition—the delicacy of the soft shoes, sheen of the fabric, and sinuous curves of the ribbon laces—are set off by the distinct black edges of the photograph's borders (which Parker leaves in). Parker's black and white photographs became more complex as she layered parts of encyclopedias, maps, flowers, bones, shells, mechanical devices, and shadows. She has also worked with Polaroid color film (plate 60), constructing endlessly inventive combinations of objects that, in her own words, are "rich in human implications." Her "intention is not to document objects but to see them in a new context, where they take on a presence dependent on the world within each photograph."[57]

The 20 x 24 Polaroid camera lent itself to constructed images, because it was exceedingly difficult to take the camera on location. Starr Ockenga used the camera in 1982 and 1983 to photograph babies juxtaposed with embellishments such as fabrics, flowers, bubbles, dolls, and dried fish. Ockenga had received her M.F.A. in photography at the Rhode Island School of Design, studying with Callahan and Siskind. Between 1976 and 1982 she was a professor and eventually director of the Creative Photography Laboratory at MIT, where she worked with Arno Minkkinen. Ockenga had been photographing female nudes; when one of her subjects had a baby, she decided to photograph babies, inspired by art historical images of Madonna and Child ensconced in a decorative environment. Unusual and disarming,

56. Rosamond Purcell, quoted in Jean Caslin, "The Polaroid Collections," *Polaroid Newsletter for Photographic Education* (Fall 1984): 2.

57. Olivia Parker, "Anima Motrix," in her *Weighing the Planets* (Boston: New York Graphic Society, 1987), n.p.

Ockenga's photographs of naked babies (plate 44), as Estelle Jussim writes, "prove quite startling, for her life-size color photographs shatter all the stereotypes of cuddly, bland infants that we have been conditioned to expect."[58]

A Conceptual Sense of Humor Photographers educated outside the region sometimes brought new attitudes to image-making. Karl Baden, for example, moved to Boston in 1979, after obtaining his M.F.A. in photography from the University of Illinois. Influenced by horror films, surrealism, cartoon imagery, and the artists Saul Steinberg, Lucas Samaras, and Charles Adams, Baden brings a sense of irreverence and humor to his photographs. For his series of *Self-Images* begun in 1978, he photographed parts of himself at maximum aperture and very short distances, so that the body part, if recognizable at all, seems to be metamorphosing into something else. Using his knowledge of photographic history to poke fun at acknowledged masters, Baden published an artist's book, *Some Significant Self-Portraits* (1981), in which he inserts his own image into classic photographs of the twentieth century. Baden also produced manipulated photographs using the process of *cliché-verre* (scratching away the coating from 35mm negatives) and then adding his own additions with pen and marker to create ironic images (plate 63) that play visual tricks in the tradition of conceptual artists such as Robert Cumming and William Wegman. Baden also contributed significantly to the Boston photography scene as the director of the Project Arts Center in Cambridge from 1982 to 1985.

Boston has never been a city where conceptual art has flourished. Perhaps the city is too rooted in tradition and concrete evidence to readily accept an art form where ideas take precedence over the actual object. Even artists such as Robert Cumming,[59] long identified with conceptual art, did not practice it until he had left the Boston area. William Wegman, like Cumming, received his B.F.A. from the Massachusetts College of Art, then left to pursue his education and career elsewhere. He returned to Massachusetts in 1979 when he was invited to use the Polaroid 20 x 24 camera, a 235-pound machine on wheels. Initially hesitant to use it because he had not until then worked with color photography, Wegman soon became seduced by the process and the vivid colors of the Polaroid image. Lisa Lyons writes that he "was particularly intrigued by the camera's instant feedback capability that he analogizes to video playback; it allows the artist immediately to see the work he has done."[60] Working with his Weimaraner dogs as models, Wegman used a changing array of props and assistants to create large color photographs that are endlessly inventive, often humorous, and sometimes poignant. Since 1979 Wegman has returned to Boston to work with the Polaroid camera on many occasions. In diptychs such as *Chow* (plates 61, 62), the consequence of a dog's having eaten directly out of a bag of dog food is having his snout covered with red dye, marking him, like a bank robber, guilty for all to see.

Color, Abstraction, and the Built Environment Although color film has been on the commercial market since the 1930s, it took over thirty years for it to be generally accepted for artistic photography. There are several reasons for this. Early color film was expensive and unstable, and color was thought to be too commercial, even vulgar. In documentary photography in the 1940s, 1950s, and 1960s, color seemed inappropriate to the

58. Estelle Jussim, "Starr Ockenga," *Currents*, no. 30 (Boston: Institute of Contemporary Art, 1984).

59. Cumming is not included in this exhibition because he began to work in photography after he left Massachusetts, and did not return to the state until after the period covered by this show.

60. Lisa Lyons and Kim Levin, *Wegman's World* (Minneapolis: Walker Art Center, 1982), 34. This exhibition, organized by the Walker Art Center, traveled to the DeCordova Museum from March 20 to May 1, 1983.

subject matter. Although there were early practitioners of color photography, among them Marie Cosindas, who experimented with Polaroid film in the 1960s, as late as 1969 the influential Walker Evans wrote, "Color tends to corrupt photography and absolute color corrupts it absolutely."[61]

By the early 1970s, more and more artists were turning to color. Many of the technical difficulties of processing color had been overcome. The Polaroid Corporation continued to invent different films and cameras, such as the SX-70 which appeared on the market in 1972. Then in 1976 the Museum of Modern Art in New York presented an exhibition of the color photographs of William Eggleston, shocking many in the photography community, and for others officially validating the use of color for artistic purposes.

Boston photographers, too, have chosen to use color for its descriptive properties, as we have seen in the work of Jim Dow, Rodger Kingston, Lou Jones, and Sheron Rupp. Willard Traub, who came to photography from a background in teaching English and history, liked the challenge of using color. Traub is attracted to architecture and the built environment, and the quality of light and the solitariness of many of his photographs have been inspired by those qualities in the paintings of Edward Hopper. Photographs such as *Quai de Bercy 1* (plate 58) are elegant formal arrangements of line, color, tone, and texture.

Dana Salvo, who had studied photography at the Massachusetts College of Art, was interested in a different aspect of the built environment. Visiting abandoned houses in the Roxbury section of Boston in the early 1980s along with his wife, artist Dawn Southworth, Salvo set up his view camera to photograph "urban ruins" in a state of decay, sometimes altering the scene to make the photograph more interesting (plate 57). Salvo was interested in cap-

turing the beauty of houses before they were torn down, the peeling layers of the walls represented layers of time and history to him.[62] Many of these photographs look like collages, because Salvo has shot them from straight on and framed them so that the abstract quality of color and pattern predominates.

By the mid-1980s, the photo scene in Boston was changing once again. The great boom of the seventies was over, and some galleries and exhibition spaces had closed, like the Creative Photography Gallery at MIT and Project Arts Center in Cambridge. Federal funding for photography and the arts in general had been curtailed, and the photography market had slowed down. Yet museums continued to exhibit, collect, and publish catalogues about photography, and new talent kept emerging on the scene as new faculty arrived to teach at area schools and students graduated from programs. The genres of documentary photography, the vernacular and formal landscape, the social landscape, autobiography, constructed images, and experimentation with alternative processes were all still being practiced in 1985, and continue to this day. The field was wide open for further expansion, particularly with the evolution of digital photography, whose impact has not yet been fully felt.

61. Walker Evans, quoted in Louis Kronenberger, *Quality: Its Image in the Arts* (New York: Atheneum, 1969), 208. Ironically, by 1972 Evans began to use color himself.

62. See Christine Temin, "Couple Hunts for Photo Subjects, Collage Material in Abandoned Urban Buildings," *Boston Globe,* May 24, 1984.

Plates

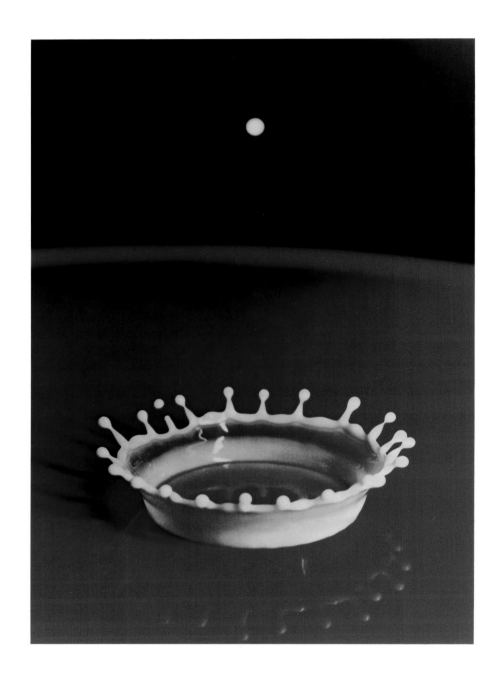

Plate 1 **Harold Edgerton** *Milk Drop Coronet on Red Tin*, 1957

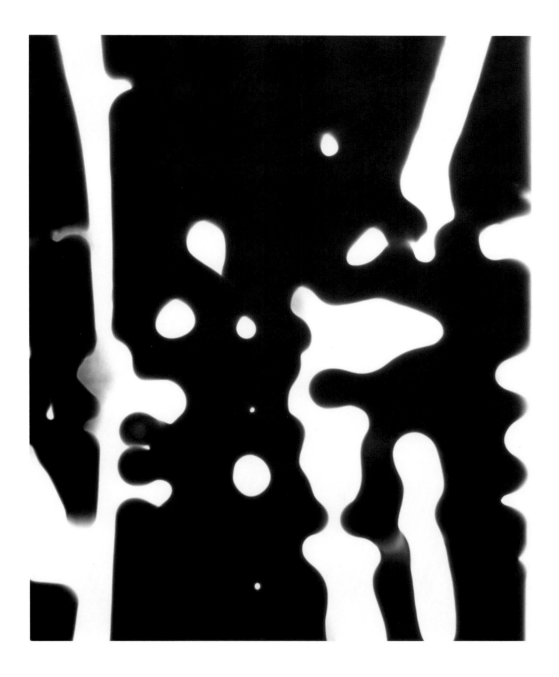

Plate 2 **Gyorgy Kepes** *Free Form*, 1956

Plate 3 **Berenice Abbott** *Magnetic Field*, 1958–1961

Plate 4 **William Clift** *Kings Chapel Burial Ground, Boston*, 1970

Plate 5 **Aaron Siskind** *MV 7*, 1974

Plate 6 **Paul Caponigro** *West Hartford, Connecticut*, 1959

Plate 7 | **Bradford Washburn** | *McKinley's Great Shadow Stretches Eastward for Nearly a Hundred Miles across a Sea of Icy Clouds—Seen from a Flight Altitude of 24,000 ft.—30 Degrees below Zero—Twenty Minutes before Sunset, October 3, 1964*

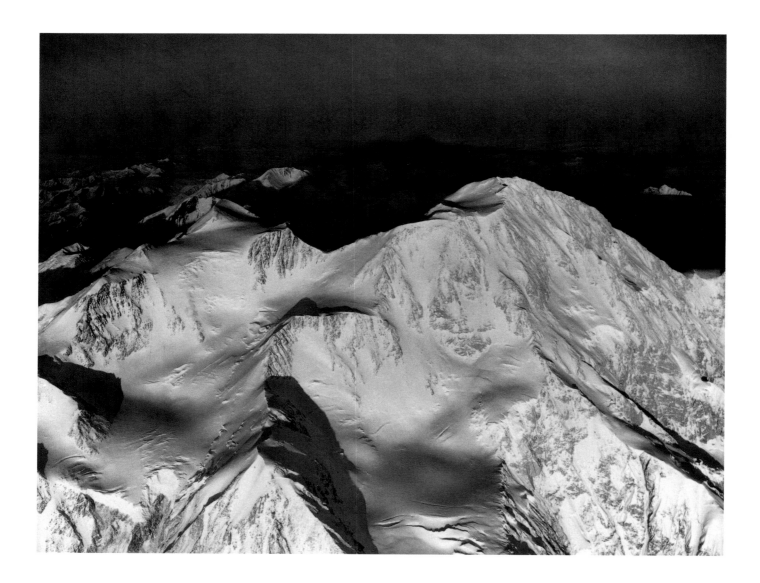

Plate 8 **Paul Petricone** *Untitled*, 1964

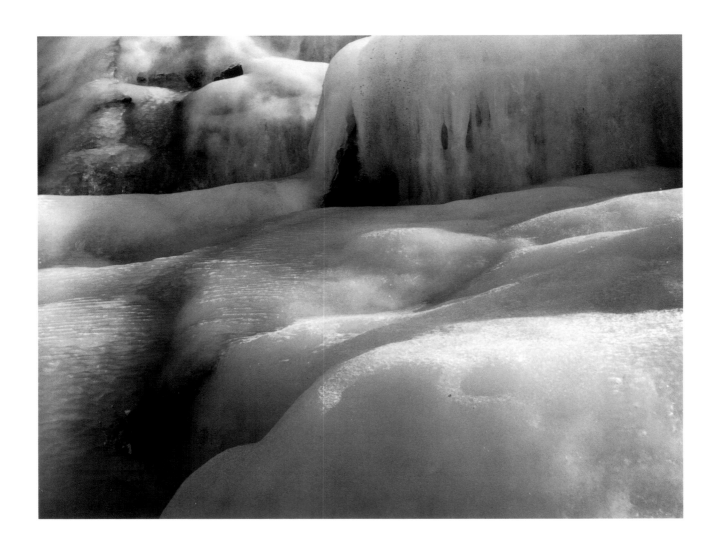

Plate 9 **Nicholas Dean** *Ice, Route 128*, 1963

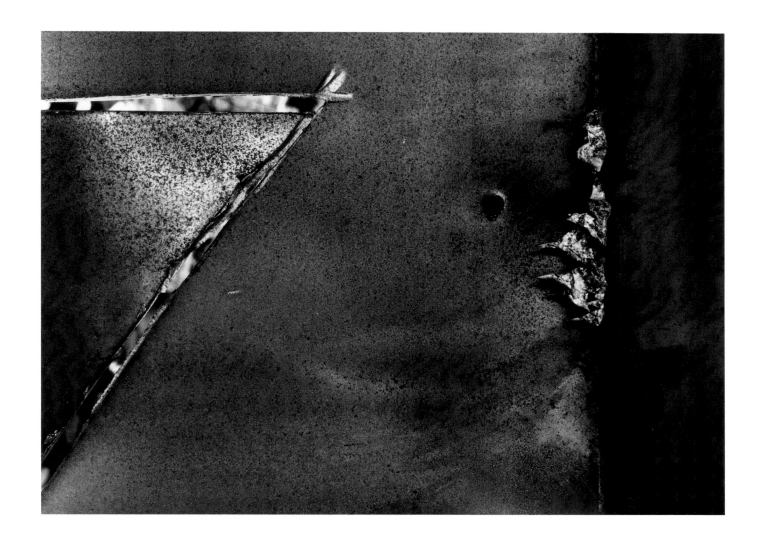

Plate 10 **Carl Chiarenza** *Accabonac (NY) I, 1979*

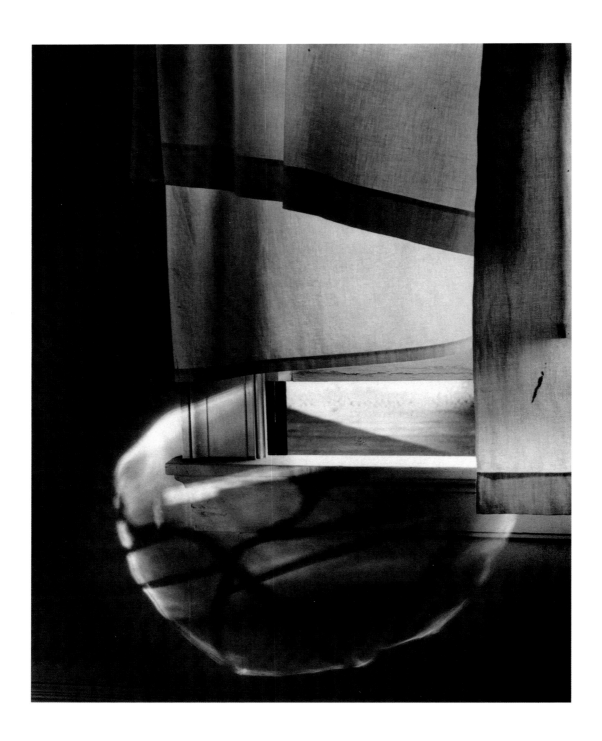

Plate 11 | **Minor White** *Windowsill Daydreaming*, 1958

Plate 12 **Lotte Jacobi** *Minor White, Deering, N.H.,* c. 1962

Plate 13 **John Brook** *Untitled,* early 1960s

Plate 14 **Marie Cosindas** *Ellen,* 1965

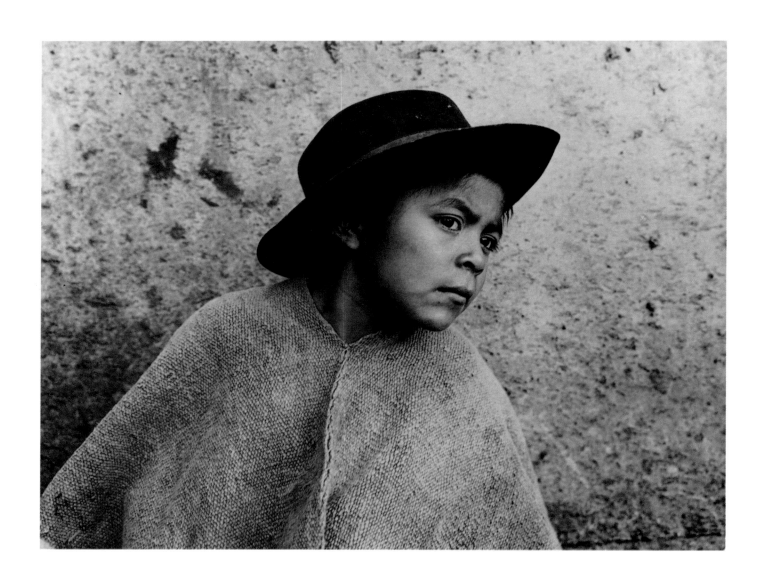

Plate 15 **Jules Aarons** *Indian Boy, Quito, Ecuador,* 1967

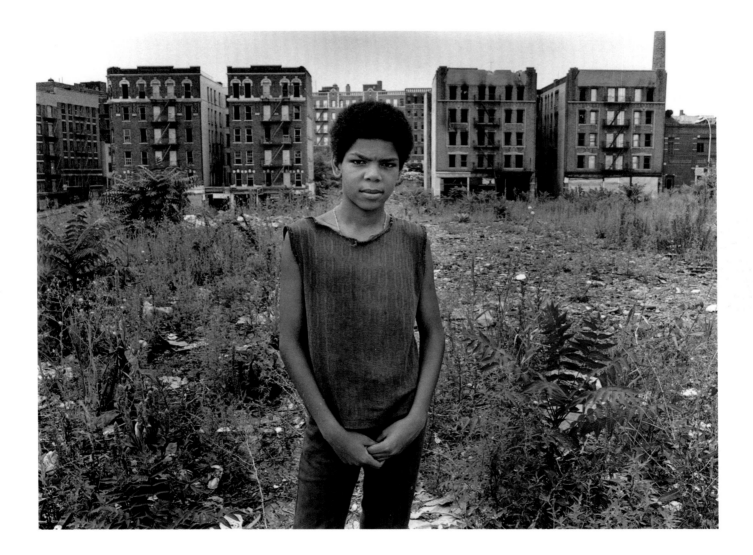

Plate 16 | **Jerome Liebling** *South Bronx, Charlotte Street*, 1977

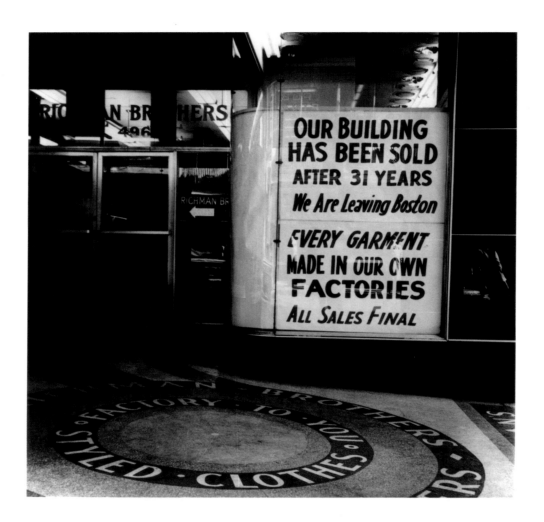

Plate 17 **Irene Shwachman** *Richman Bros., Washington St., November 10, 1961*

Plate 18 | **Steven Trefonides** | *Washington Street*, 1974

Plate 19 **Jules Aarons** *The Boston and Maine Station*, late 1950s

Plate 20 | **Harry Callahan** *Providence*, 1971

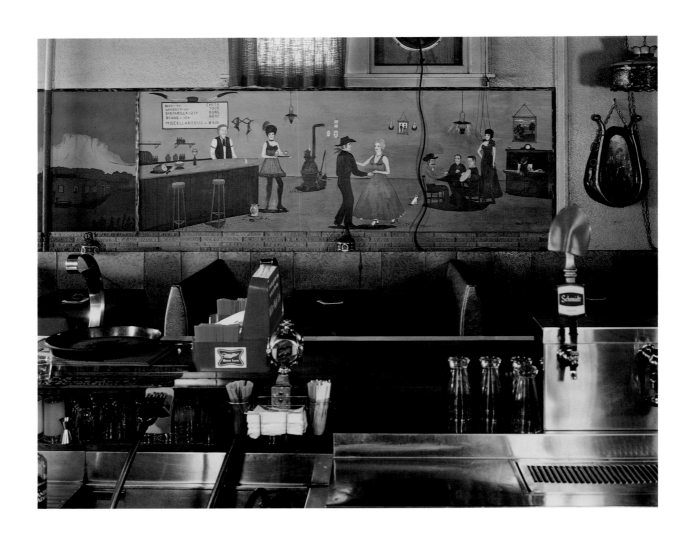

Plate 21 **Jim Dow** *Bar Detail, North Dakota*, 1981

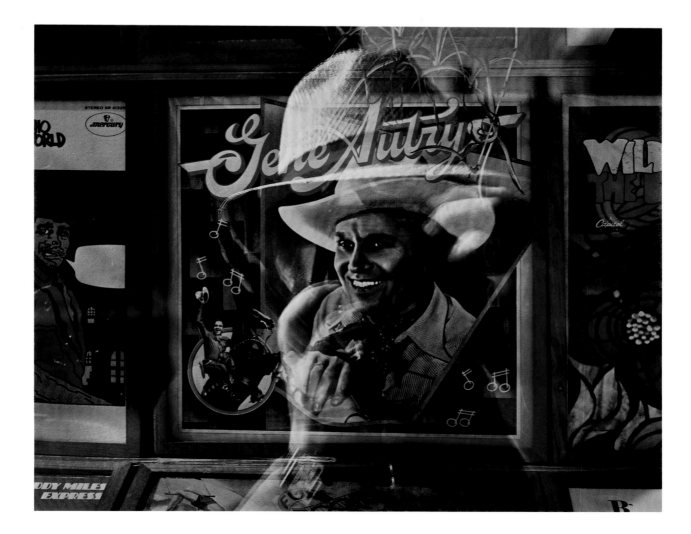

Plate 22 **Rodger Kingston** *Me and Gene, Cambridge, MA, 1983*

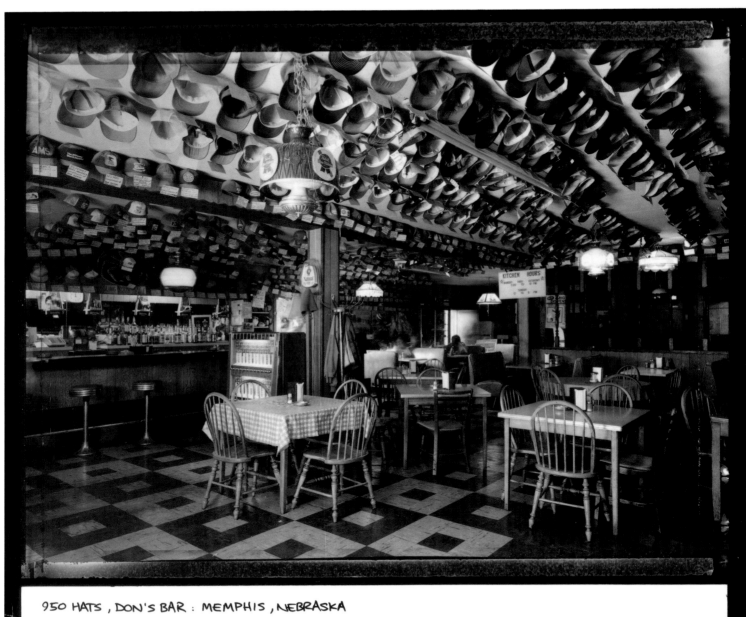

950 HATS, DON'S BAR : MEMPHIS, NEBRASKA

Plate 23 **Jim Stone** *950 Hats, Don's Bar: Memphis, Nebraska,* 1983

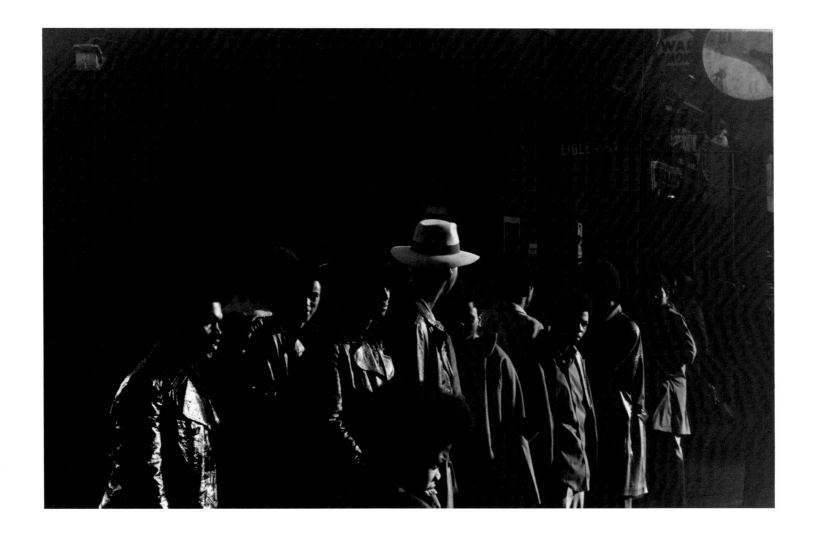

Plate 24 **Hakim Raquib** *Zeigler Street*, 1970

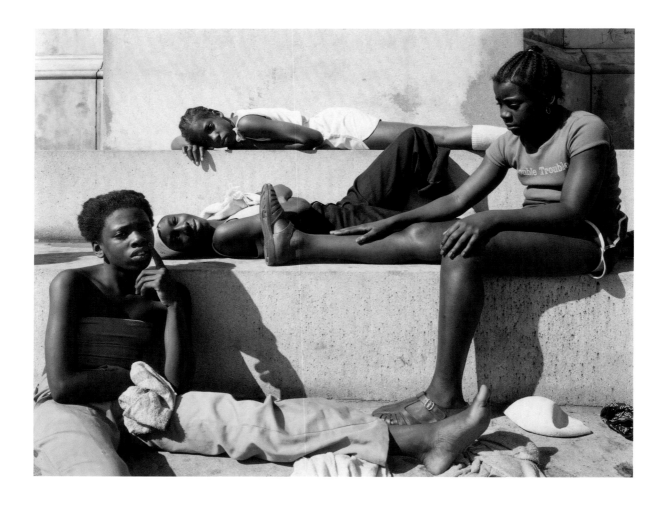

Plate 25 | **Nicholas Nixon** | *Boston Common*, 1978

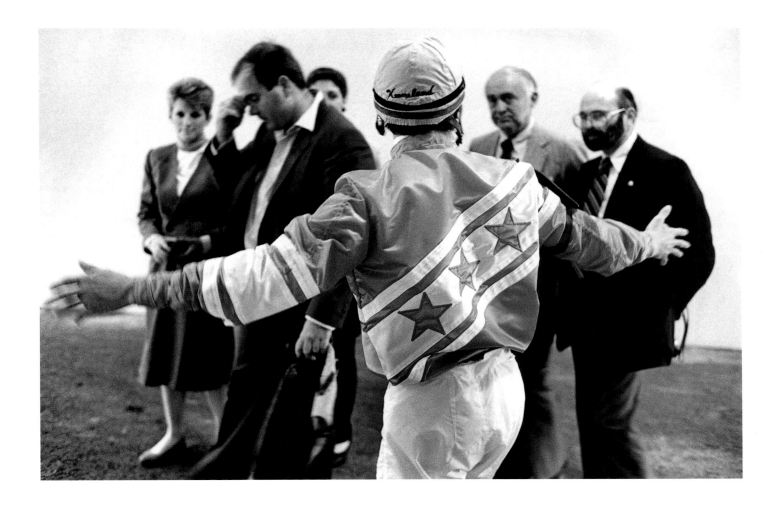

Plate 26 | **Henry Horenstein** | *Jockey's Excuse, Keeneland*, 1985

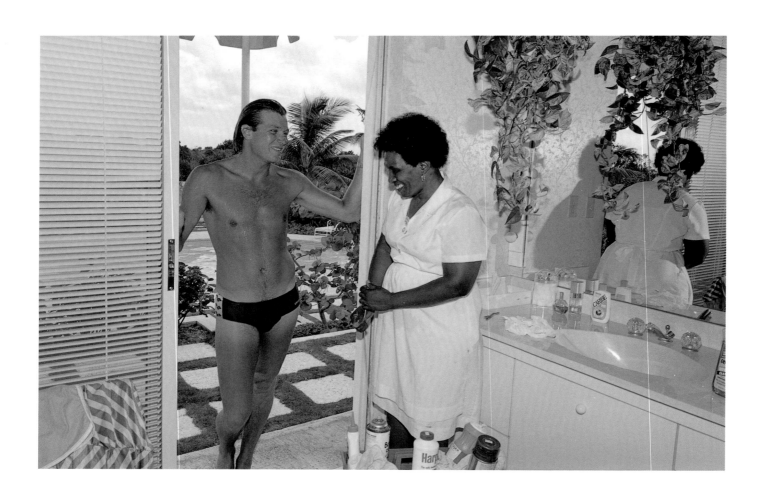

Plate 27 **Barbara Norfleet** *Private House: New Providence Island, the Bahamas, 1982*

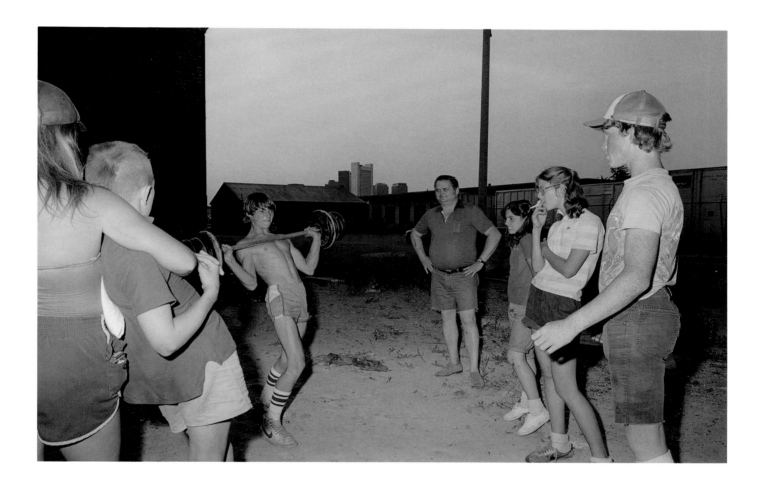

Plate 28 | **Sage Sohier** *South Boston*, 1982

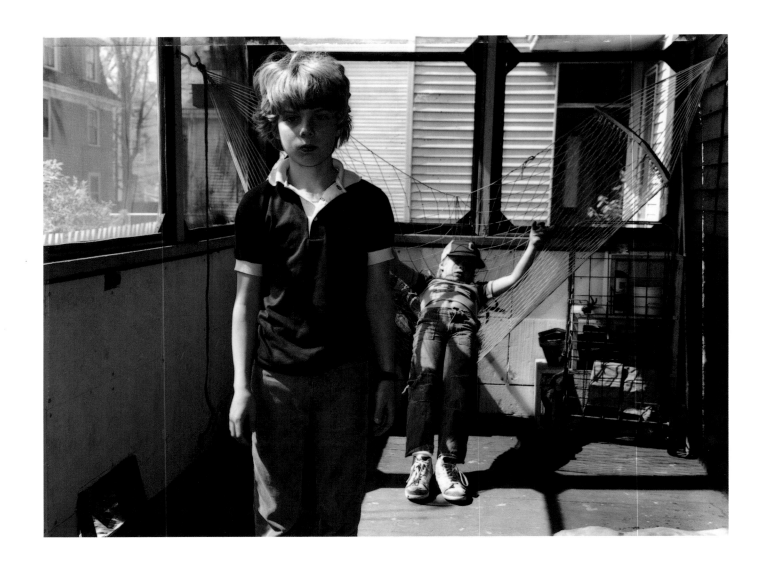

Plate 29 **Judith Black** *Erik and Dylan (Mother's Day), May 8, 1983*

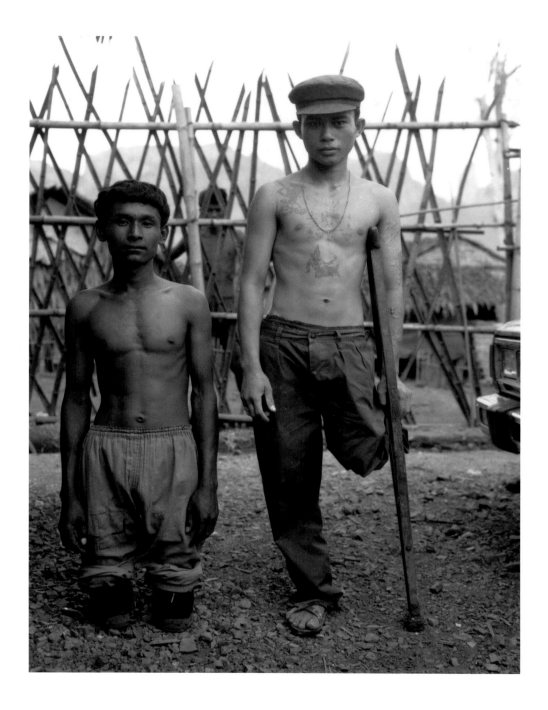

Plate 30 **Bill Burke** *Khmer Rouge Land Mine Victims*, 1984

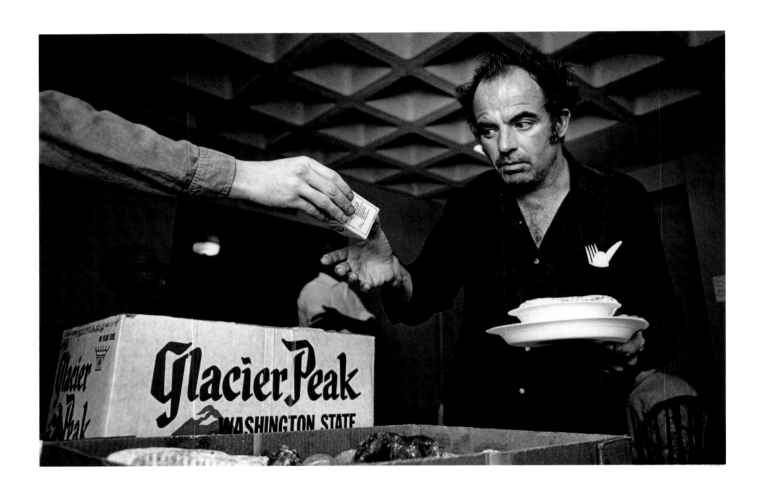

Plate 31 | **Jerry Berndt** | *Long Island Shelter, Boston, 1983–1985*

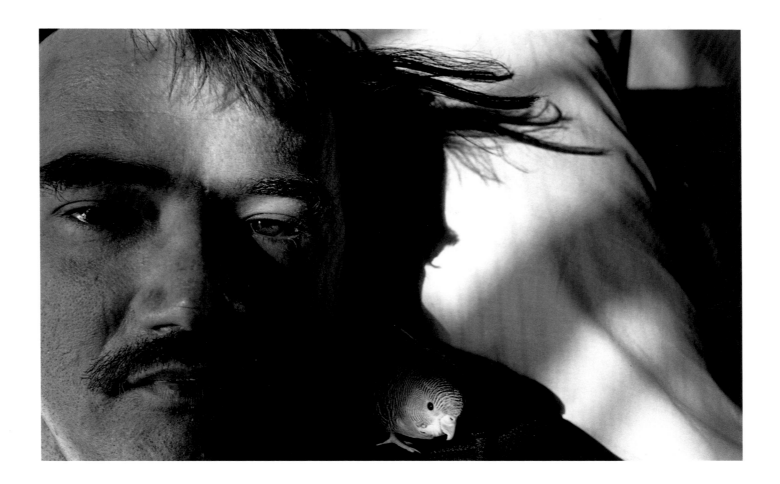

Plate 32 **Eugene Richards** *Grandy, Lima State Hospital for the Criminally Insane,* 1981

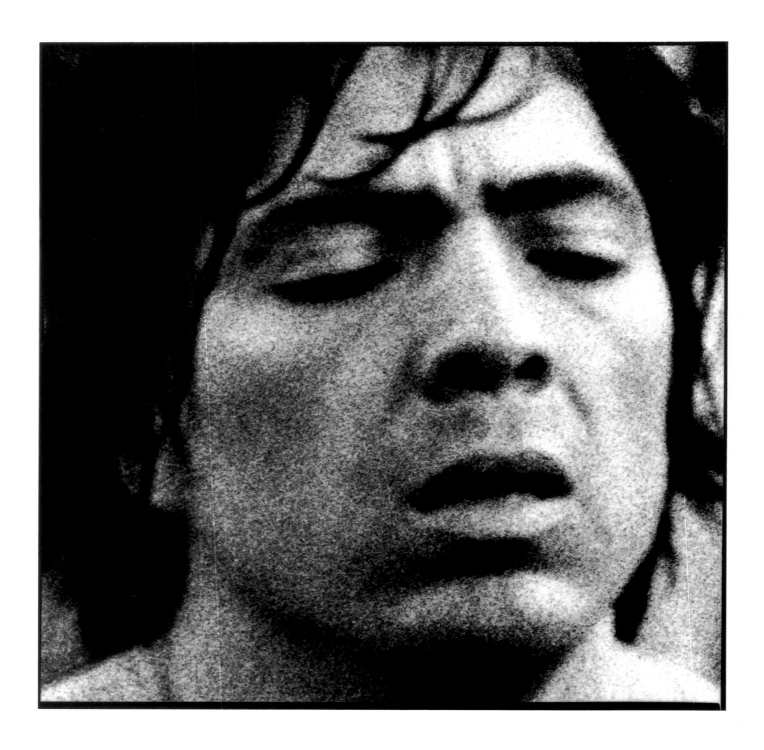

Plate 33 **David Akiba** *Face #5*, 1979

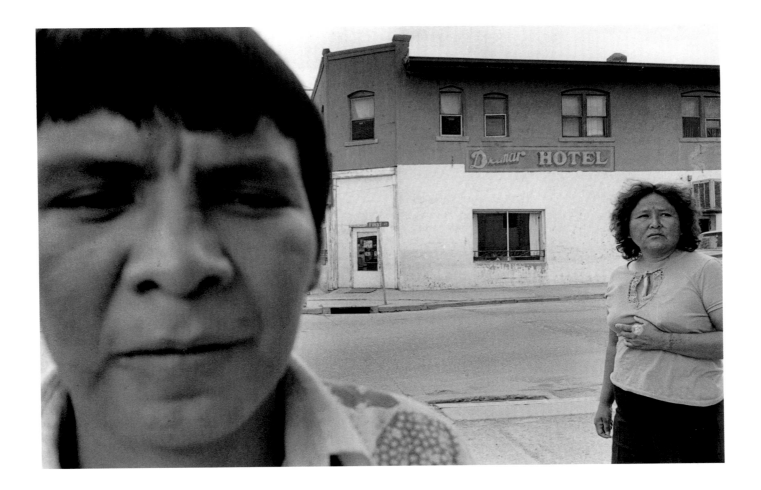

Plate 34 **Roswell Angier** *Route 66, Gallup, New Mexico*, 1979

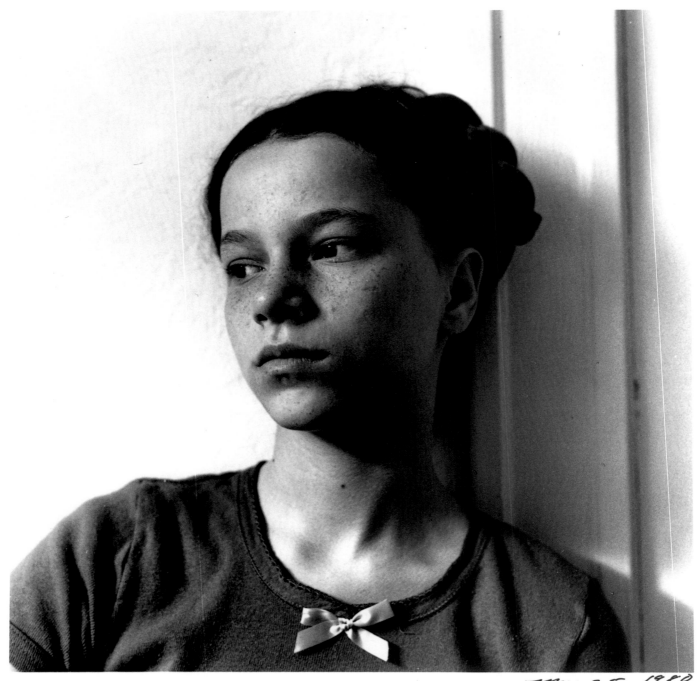

May 25, 1980

Plate 35 **Melissa Shook** *May 25, 1980*

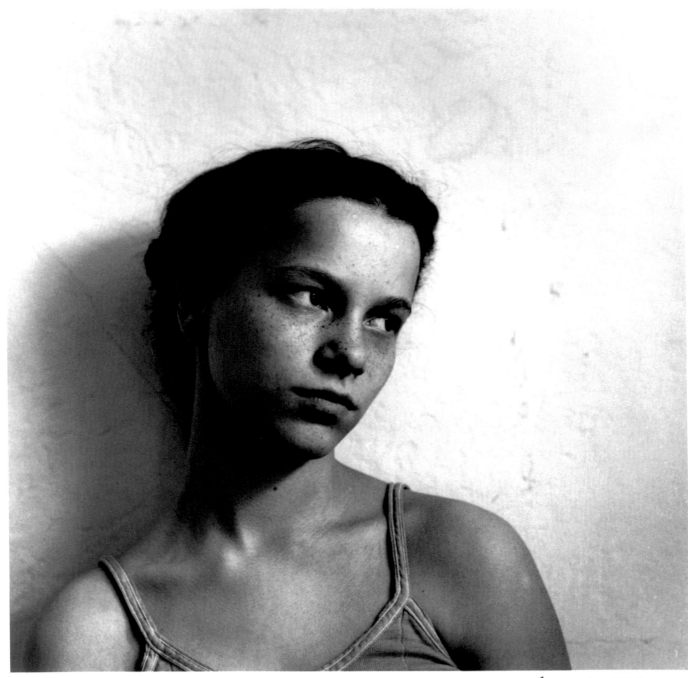

June 16, 1980

Plate 36 **Melissa Shook** *June 16, 1980*

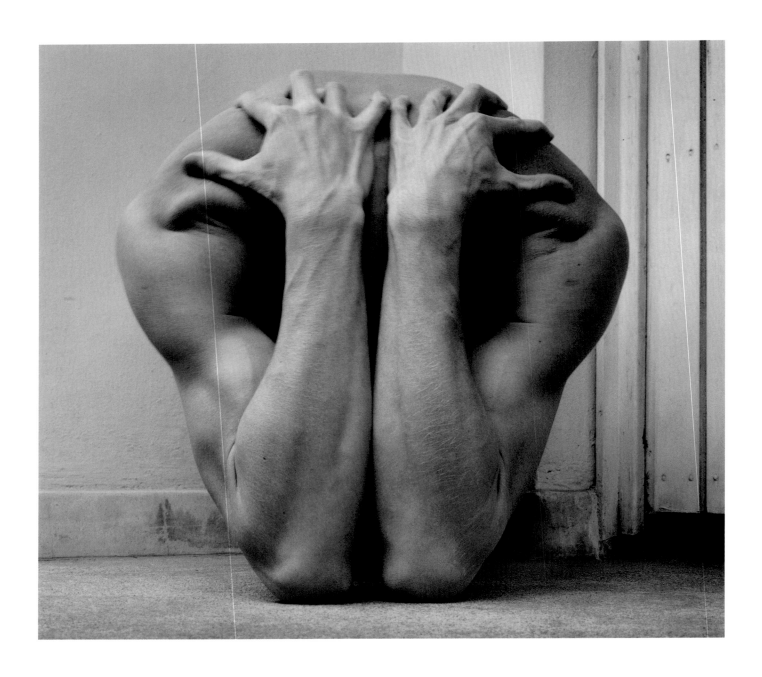

Plate 37 **Arno Rafael Minkkinen** *Self-Portrait, Helsinki, Finland,* 1976

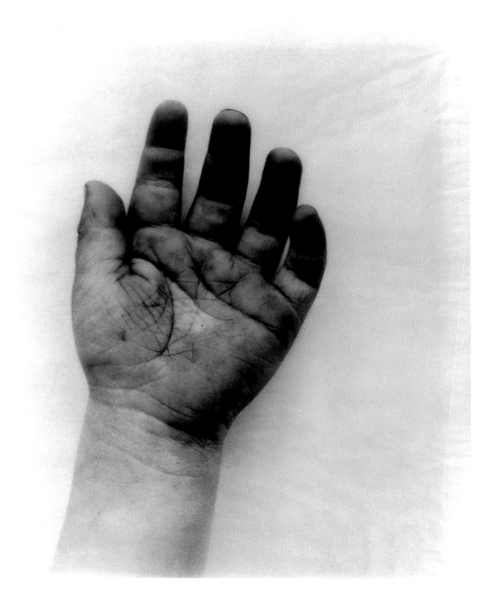

Plate 38 **Wendy Snyder MacNeil** *Adrian Sesto*, 1977–1988

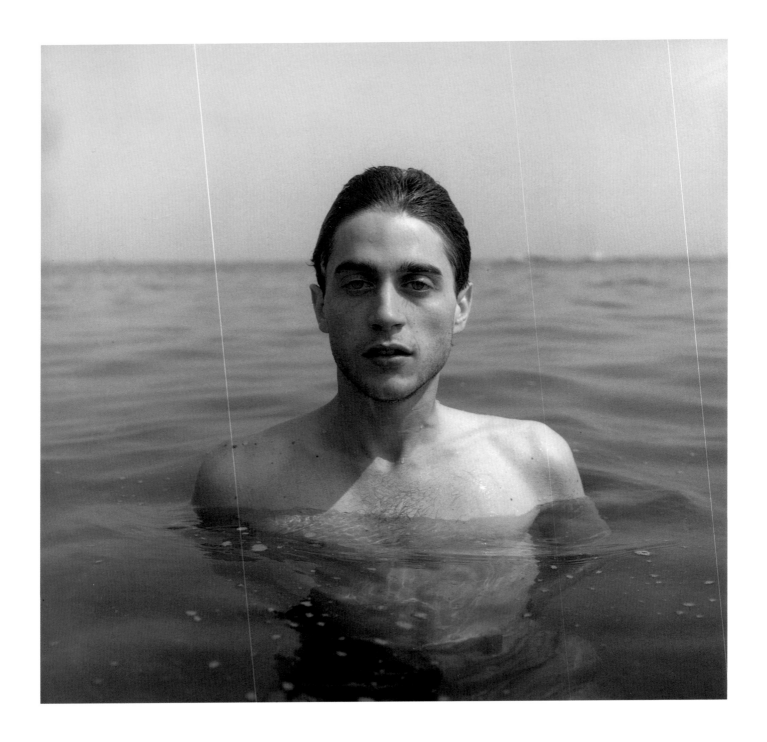

Plate 39 **David Armstrong** *George in the water, Provincetown,* 1977

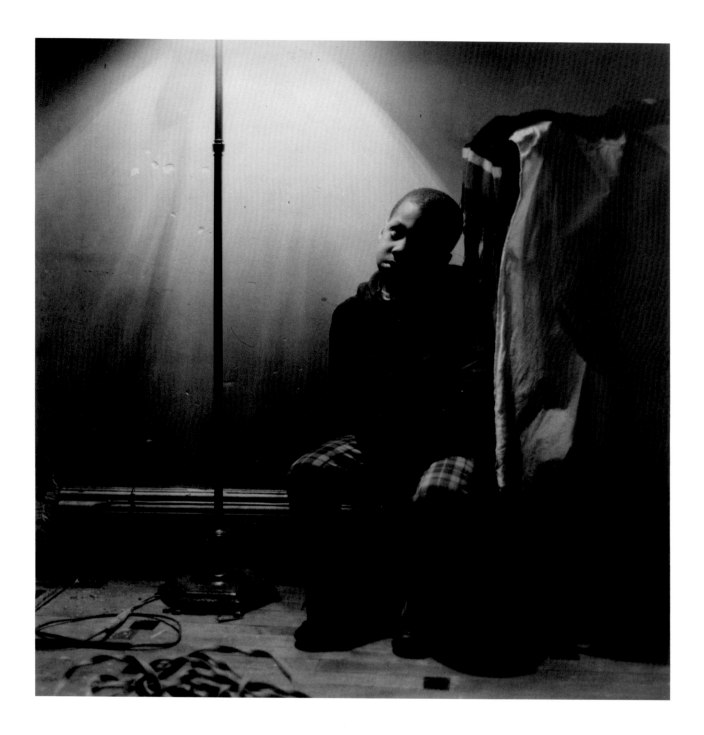

Plate 40 **Rudolph Robinson** *Ome*, 1983

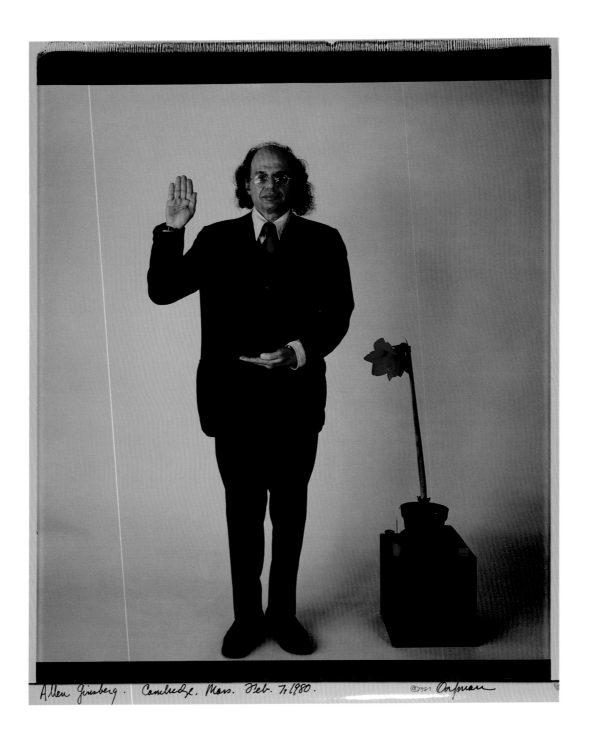

Plate 41 **Elsa Dorfman** *Allen Ginsberg, Cambridge, Mass., February 7, 1980*

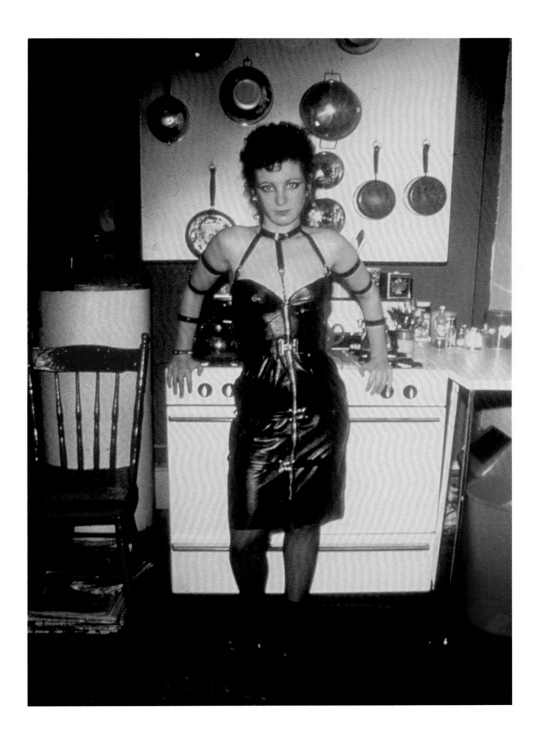

Plate 42 **Nan Goldin** *Nan as a dominatrix, Boston,* 1978

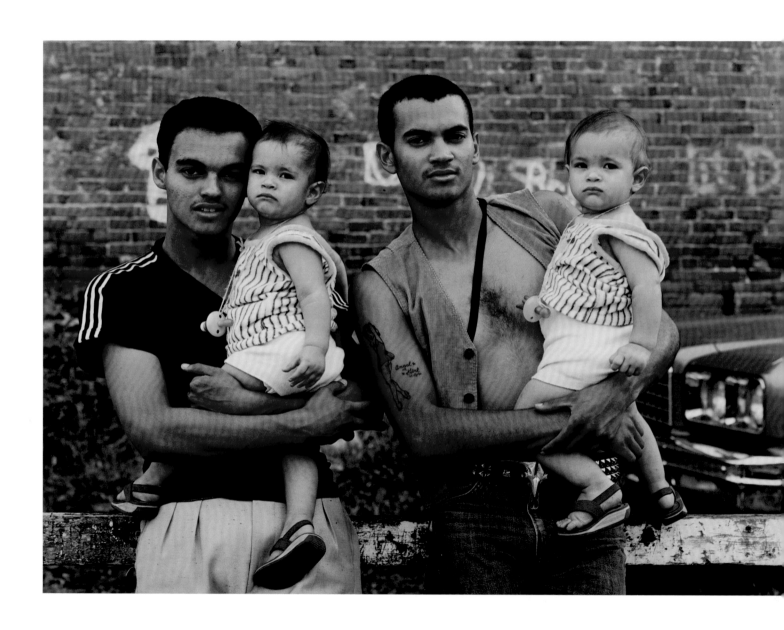

Plate 43 | **Bill Ravanesi** *Brothers*, 1982

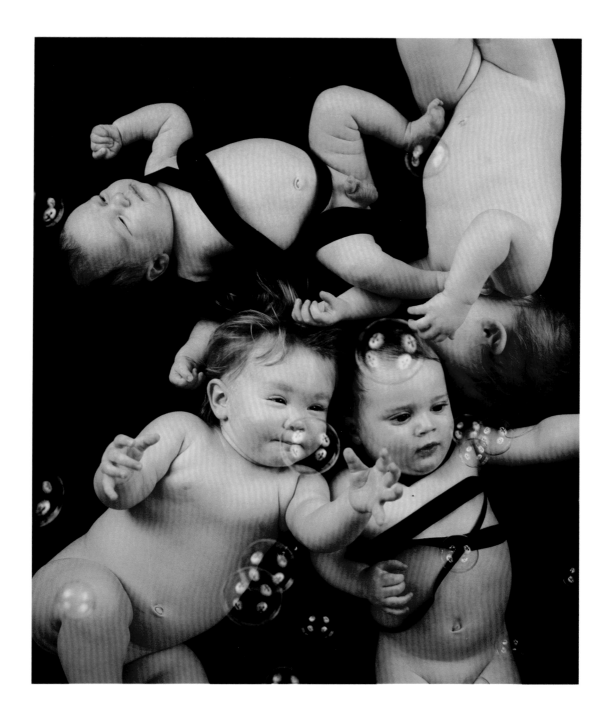

Plate 44 **Starr Ockenga** *Untitled*, 1984

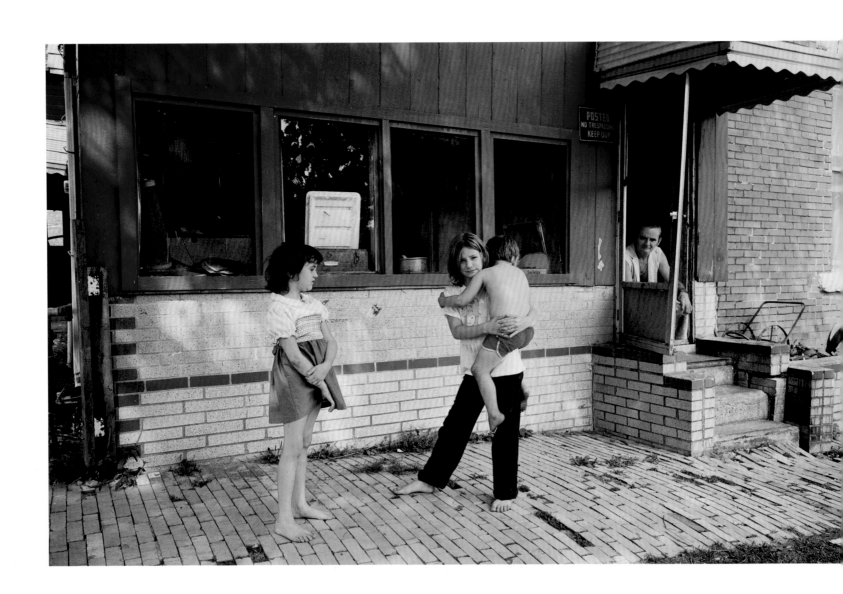

Plate 45 **Sheron Rupp** *New Straitsville, Ohio, 1983*

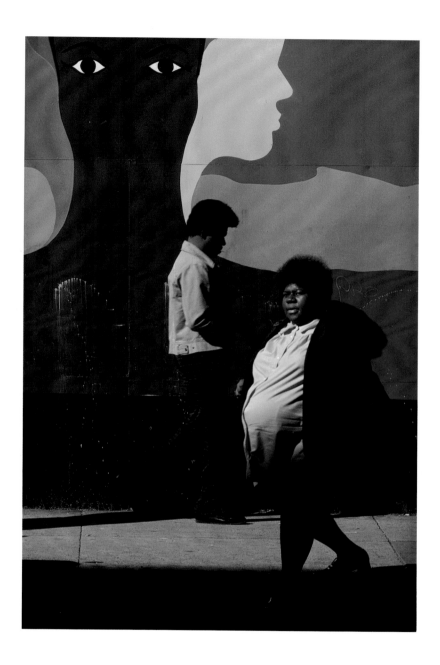

Plate 46 **Lou Jones** *Dudley Station*, 1973–1974

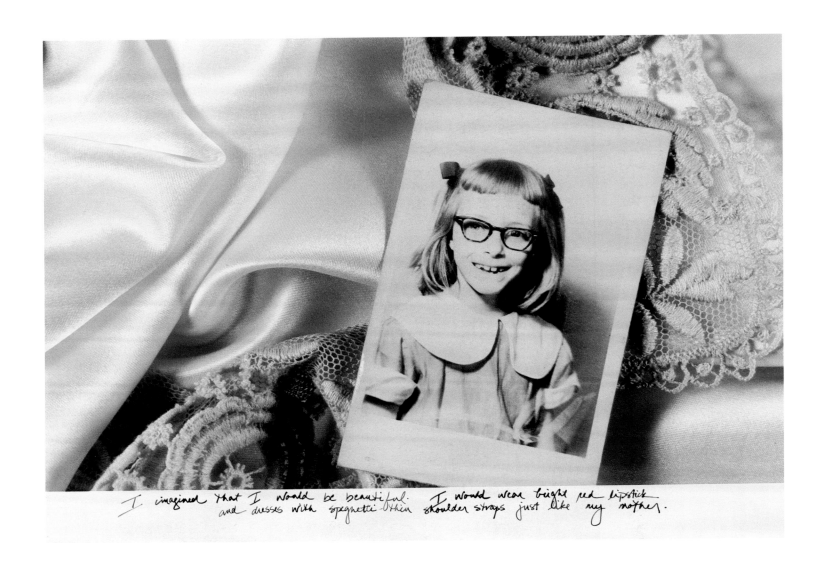

I imagined that I would be beautiful. I would wear bright red lipstick and dresses with spaghetti-thin shoulder straps just like my mother.

Plate 47 **Vaughn Sills** *I Imagined That I Would Be Beautiful . . . ,* 1984

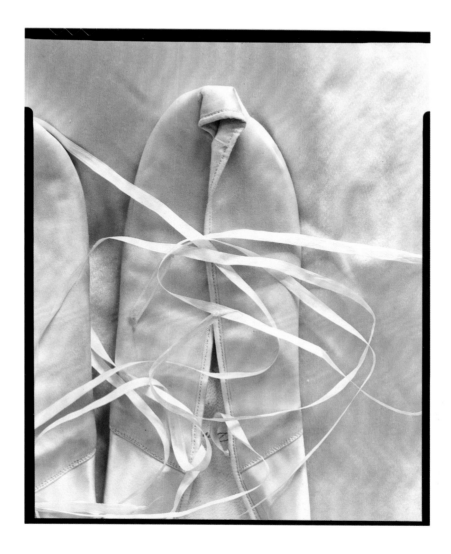

Plate 48 **Olivia Parker** *Miss Appleton's Shoes II*, 1976

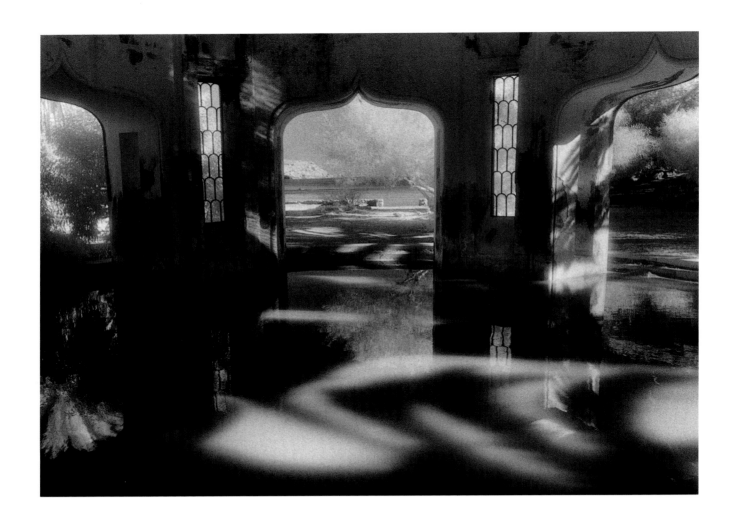

Plate 49 **Peter Laytin** *Entrance to Bath, Kallithea Spa, Rhodes, Greece,* 1985

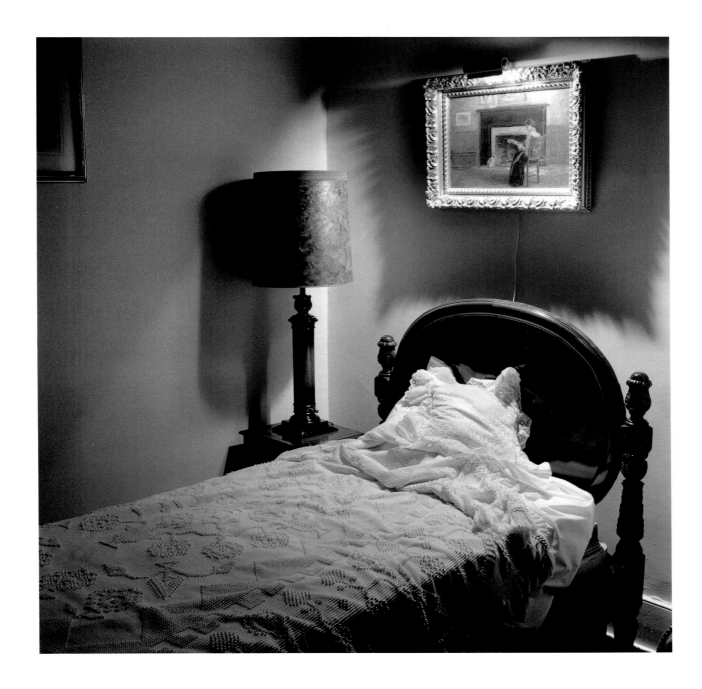

Plate 50 **Shellburne Thurber** *Grandfather's Bed*, 1976

Plate 52 **Neal Rantoul** *Nantucket Sound*, 1979

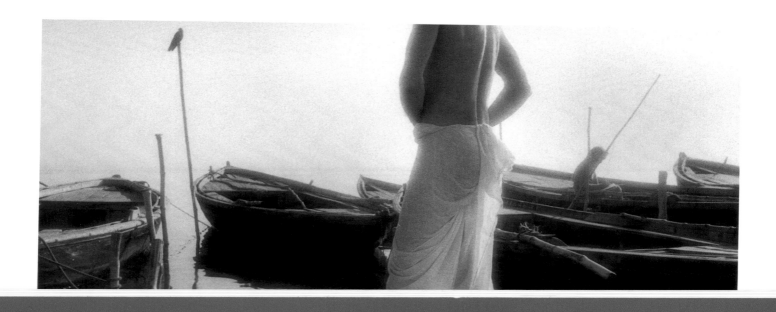

Toward Critical Mass:

A. D. Coleman

Writing and Publishing about Photography in the Boston Area, 1955–1985

This essay began with what seemed a modest ambition: to recount the history of writing about photography in Boston during a three-decade stretch. In the event, I found that its scope inexorably expanded. I've no one to blame for this but myself; I'm an inveterate backtracker, and I tend to write long. So what this essay now sets out to trace is the situation of writing and publishing critical, historical, and theoretical commentary about photography in the Boston area during the period 1955–1985.[1]

In terms of the broader questions involved, that's a relatively arbitrary time frame dictated by the conceptual structure of the larger exhibition in which this investigation has embedded itself, whose delimitations its curator explains in her introduction to this volume. In practice, as it turns out, the narrative version of this analysis begins in a desert and concludes, if not in an orchard, at least at an oasis.

*

By December of 1985, when this project nominally concludes, a comprehensive account of writing about photography and related publication activity in Boston in the preceding three decades would have to include at least the following writers and editors: Clifford S. Ackley, Carl Chiarenza, Susan E. Cohen and William S. Johnson, Thomas Garver, Jonathan Green, Barbara Hitchcock, Estelle Jussim, Rodger Kingston, Lee Lockwood, Anne McCauley, Arno Rafael Minkkinen, Jack Naylor, Barbara Norfleet, Davis Pratt, Mark Roskill, James Sheldon, Maren Stange, Minor White, Kelly Wise. Added to that, necessarily, we'd have comparatively long-lived photo-specific publications like *Aperture, Contemporary Photographer, Polaroid Close-Up,* and *Views: A New England Journal of Photography,* short-lived ones like the *Boston Review of Photography* and *Fox,* and broader-based or general-audience publications like *Art New England* and the *Boston Phoenix.* Finally, it would be necessary to acknowledge the presence of publishing houses including Bulfinch Press/Little, Brown, Houghton Mifflin Co., David R. Godine, and the MIT Press.

Yet, oddly enough, fifteen years ago many of those had already come and gone, either defunct or moved elsewhere; while forty-five years ago, few of them were yet on the scene. Thus what happened in Boston during the period we're examining here could

The notes to this essay begin on page 130.

3.1 Compilation of various Boston-area photography publications

not have been anticipated at midcentury, and apparently depended on a generative force that has provoked—at least so far—only a single blossoming.

*

This is the situation as of January 1955: In terms of thoughtful writing about photography, Boston is a wasteland. In that regard, however, it is no different from anywhere else in the country, or anywhere else in the world, for that matter; the critical tradition in photography—what the literary scholar Hugh Kenner defines as "a continuum of understanding, early commenced"[2]—had not yet even revved up its engines anywhere.

The closest thing to a contribution toward such an eventuality that Boston could claim at that moment would be the art history education that Beaumont Newhall, of Brahmin stock, received under Paul Sachs at Harvard—though his doctoral thesis there concerned paintings about sailing, not photography.[3] (Invited by Sachs to represent the Harvard graduate program at the College Art Association's annual conference in 1934, Newhall produced a controversial paper on "the influence of photography on nineteenth-century Western painting."[4] And, eventually, he'd do some research and writing about the Boston photography scene in its mid-nineteenth-century days.) To which one could add Houghton Mifflin's publication in 1941 of the James Agee–Walker Evans classic, *Let Us Now Praise Famous Men*;[5] the presence at the Massachusetts Institute of Technology of Gyorgy Kepes, whose theoretical/tutorial texts on matters of visual communication exercised wide influence then; and the Polaroid Corporation's decision in the late 1930s to headquarter itself in the Boston area.[6]

To put a finer point on it: In the United States, the field of writing about photography at that point could claim only one periodical that would qualify in any other discipline as a critical journal: the recently founded *Aperture*, birthed in 1952 and at that time published out of San Francisco.[7] (It would later move effectively to Boston; more on that anon.) This quarterly had few counterparts elsewhere in the world.[8] Museum collections of photography as such were few and far between. No commercial gallery in any country specialized in photography, either historic or contemporary,[9] and few art galleries handled the work of any photographer; such few private collectors as the medium could boast typically acquired material directly from the makers, their estates, or—in the case of historical material—from antiques and rare book dealers, secondhand stores, and flea markets.

No working critic anywhere concentrated on the medium; few critics of art or any other medium wrote about photography at all, and even fewer did so with any degree of knowledgeability.[10] The historiography of photography in the English language was, for all intents and purposes, in the hands of two husband-and-wife teams: Beaumont and Nancy Newhall (then based in Rochester, New York) in the United States, and Helmut and Alison Gernsheim in the United Kingdom. These researchers had few equivalents—and none of equal stature—in other cultures and languages; as a result, their work dominated the field internationally.

Scholarship relating to the medium, and people qualified to perform it, were in short supply. The average photography monograph on an individual's work at that juncture contained little or no critical, biographical, or bibliographical apparatus.[11] The same held true for museum shows; typically, when the very institution sponsoring this long-overdue

survey, the DeCordova Museum, held the second of two ambitious and diverse invitational survey exhibitions of photography in 1968—"the largest photography exhibition ever shown in the Boston metropolitan area," comprising 450 images by 93 photographers[12]—the only trace thereof that it would generate would be a catalogue whose illustrations came accompanied by no information save the photographers' names and the images' titles and sizes, and whose texts consisted of one-paragraph biographies of the photographers and a 700-word introductory essay that spoke mainly of the selection process and exhibition design.[13]

At midcentury, then, Boston exemplifies the national (and, indeed, the global) condition of the discourse on photography: occasional, fragmentary, haphazard, and pursued by only a few far-flung individuals, most of them with no formal training in media studies, art history or theory, material culture research methods, historianship, or critical writing. In retrospect, and especially in light of the current widespread, polyvocal dialogue about the medium, this state of affairs astonishes. Nonetheless, it stands as a fact of life, the rock bottom from which we can measure all development since.

*

What Boston did have circa 1955 we can see, in hindsight, as useful, integral components of an eventual facilitating infrastructure. The city and its outlying territories contained an unusually high concentration of colleges, universities, and other institutions of higher learning with respected programs in art history, history, sociology, anthropology, English literature, communications theory, cultural studies, and many of the other disciplines from

which, we know now, those inclined to write about photography are often drawn. It had (for a North American metropolis) a long and rich tradition of cultural and intellectual life, second only to that of New York City; this meant museums, libraries, galleries, newspapers and magazines, and a social context in which informed attention to the visual arts generally had established itself as an accepted aspect of the life of the mind and the enjoyment of the cultural milieu.

As a result of the presence of those schools, museums, libraries, historical societies, and other traditional repositories, photographs and photo-related materials of many kinds and in large quantities (prints, books, periodicals, and more) had already entered various thematically based collections, even if they hadn't been gathered with purposeful attention to their significance in the medium's history. All of this meant that the city, and certainly the broader New England region, was one in which one could live *la vie bohème* on a bohemian income, and that various interests in photography could be pursued there fruitfully as well. This, in combination with employment possibilities in the educational system and the distinctive light and topography of the region, drew photographers to settle there and provided photographers born there with reasons to stay.

Finally, the presence of that network of colleges, universities, and art schools generated a steady flow of open-minded young thinkers from all over who, as they grounded themselves in research and writing in liberal arts programs or the making of pictures in fine arts programs, would reasonably begin to seek out and, when they couldn't find it, to generate a discourse about the various media in which they developed a serious interest.

These elements, taken ensemble, would provide fertile ground for the emergence of critical discussion of photography, in a way quite comparable to the parallel and approximately simultaneous upsurge of a Boston-based critical discourse about rock and roll.[14] The analogy is not meant frivolously. In 1955 photography and rock and roll had much in common. For intellectuals—those who constitute what the historian Lynn White, Jr., describes as "the small and specialized segments of our race which have had the habit of scribbling"[15]—both these creative forms were, in effect, guilty pleasures. The average cultured person who enjoyed music and treated rock (or rhythm and blues, or even electrified urban blues) as part of his or her listening diet simply did not discuss it with anyone as serious music; there were no "Chuck Berry studies" to parallel the "Madonna studies" of recent years. Similarly, the typical sophisticated looker at the visual arts might enjoy spending time with photographs, might even own some notable photography books, but would not likely venture to opine that photography was an art form, or seek out any critical commentary on it.

Not that there was any to be found. Even Hollywood movies, television, and jazz enjoyed a higher status and more written consideration as criticizable media than photography and rock, but most educated people would have agreed that critical attention to any of these subjects was not fit work for a grown man. They were all perceived as masscult, middle-brow (even, in the cases of TV and rock, low-brow) forms of entertainment, with some generic cultural significance as barometers of the zeitgeist but no credibility as serious media within which the concerns of the poet or the impulse for potent, personalized social commentary and analysis could be explored.

Who's likely to contradict such biases and assumptions about any despised, ghettoized, and widely ignored young medium? Its practitioners (particularly the teaching artists among them, for whom the need for a critical, historical, and theoretical literature becomes urgent as the pedagogy evolves)[16] and its devotees, especially the youthful sector of its educated audience (whose members are prone to apply the methodologies they've acquired in the study of more traditional, established forms to the new, not yet legitimated ones they've grown up with and come to love).[17]

That, at least, describes the seeding and the initial trajectory of writing about photography in the Boston area during the period under consideration here. Yet, with the exceptions of Houghton Mifflin's republication, in 1960, of Agee and Evans's *Let Us Now Praise Famous Men*,[18] the formation of the Association of Heliographers in 1963,[19] and a related

3.2 *Aperture*, volume 19, number 1, 1974

34. Kao, "Photography at the Crossroads," 289, n. 21.

35. The quarterly's last issue was vol. 6, no. 2, datelined 1968, though Chiarenza indicates that, as they were chronically behind their nominal publication schedule, it may not have appeared till 1969. Chiarenza recalls "passing the torch" of editor-publisher to yet another writer-photographer, the Washington-based Mark Power, but nothing tangible ensued from that. Lockwood transmitted his archives on the magazine to Chiarenza, who in turn eventually placed them at the Center for Creative Photography in Tucson. (Chiarenza in conversation with the author, August 5, 1999.) Further research on the history and influence of this important periodical—including its interconnection with the equally short-lived, equally influential collective, the Association of Heliographers—remains to be done; and a much-needed anthology of the best writing to appear in its pages has not yet appeared.

36. On assignment from *Fox*'s publisher, I interviewed Edward Steichen, but the magazine folded before the interview could be published there. Subsequently it appeared elsewhere.

37. See, published by the Friends of Photography in San Francisco in the 1990s, and *DoubleTake*, which was published by the Center for Documentary Studies at Duke University until summer 1999 before moving to a new location in Somerville, Massachusetts, represent two recent instances of the risks of following that model.

38. Details of this episode, including both sections of my half of that critique, can be found in my book *Light Readings: A Photography Critic's Writings, 1968–1978* (London: Oxford University Press, 1979; 2d ed., Albuquerque: University of New Mexico Press, 1998). Both my text and White's response appeared in a special issue of *Camera 35* (see note 40 below).

39. My critique of White's *Octave of Prayer* closely paralleled White's *Aperture* critique of the Steichen project, a coincidence I didn't note till some years later.

40. See "'Before Man Existed, Natural Symbolism Was.' Minor White vs. 'Before Man Existed, Natural Symbolism Was Not.' A. D. Coleman," *Camera 35* (November 1973): 32–40.

41. *Camera 35* and *Camera Arts* among them; both would go under in the early to mid-eighties, regrettably.

42. Robert Muffoletto's *Camera Lucida* and Don Owen's *Picture* and *Photoshow,* for example.

43. *The Photo Review*, published in the Philadelphia area, and the *Center Quarterly*, from the Center for Photography in Woodstock, New York, are two of these; this author has served on the boards of both organizations.

44. According to Polaroid's Barbara Hitchcock (letter to the author, February 11, 1999).

45. Distributed by mail only, its commissioned contributors included Owen Edwards, Peter Galassi, Brendan Gill, Andy Grundberg, Marvin Heiferman, Estelle Jussim, Max Kozloff, Jane Livingston, Beaumont Newhall, and Carol Squiers, with pertinent selections from the writings of Daniel Halpern, Isaac Asimov, Italo Calvino, Donald Barthelme, Robert Coover, Mark Strand, and Roger Tory Peterson. As one who contributed to it during Samuelson's tenure, I want to note that though it was entirely funded by Polaroid, the editorial staff didn't censor or even question my critique therein of the book *One of a Kind*, the catalogue of a Polaroid-sponsored survey of fine art photography done on Polaroid materials. See "One-of-a-Kind (Recent Polaroid Color Photography)," *Polaroid Close-Up* 11 (Spring 1980); reprinted in my book *Tarnished Silver: After the Photo Boom, Essays and Lectures 1979–1989* (New York: Midmarch Arts Press, 1996), 62–68. So the magazine was far more than a promotional house organ.

46. Coles, who has done some thoughtful writing on various bodies of photographic work and on issues of documentary, and is based at Harvard, would end up deeply involved with another "little" photography magazine in the 1990s—the lavish journal *DoubleTake*— rescuing it from dire financial peril in North Carolina in 1999 and finding a new home for it in the Boston area.

47. Eugenia Parry Janis and Wendy MacNeil, eds., *Photography within the Humanities* (Danbury, NH: Addison House Publishers, 1977).

48. *Criticism of Photography: Eleven Contemporary Photographers* (Amherst: University Gallery, University of Massachusetts, 1978), 1–12, 25–27.

49. My account of this event opened my 1996 "Founder's Lecture" at the PRC: "Do It Yourself: Toward a Responsible Audience," the text of which remains unpublished. It can be found online in my newsletter at The Nearby Café, "C: The Speed of Light," at www.nearbycafe.com/adc/adc.html.

50. The PRC also published the first edition of a modest model of critical inquiry—*Lee/Model/Parks/Samaras/Turner: Five Interviews before the Fact* (Boston: Photographic Resource Center, 1979)—that I created as the opening lecture in a series sponsored by the PRC that year.

51. *The Center Quarterly* (Woodstock, New York), *The Photo Review* (Philadelphia), *Frame/Work* (Los Angeles), and *San Francisco Camerawork Quarterly* are a few of the other publications that wove themselves into that mesh.

52. My expertise and credibility in the field aside, Enos, Weiss, and I decided it would be advantageous for the first editor to be a carpetbagging outsider to the New England scene, whose internal politics could easily have paralyzed any local figure and polarized the readership early on. In retrospect, I'd say the strategy succeeded.

53. Briefly at the helm in 1981, though no issue appeared under his editorship, was Jon Holmes. As I'm implicated in

the ensuing *contretemps*, I'll direct the reader to Holmes's one-sided account of that upheaval, *The Narrowing of* Views: *PEN American Center and the Censor on the "Freedom to Write Committee"* (Boston: Jon Holmes, 1985), and recuse myself from further commentary. With a definite sense of ironic closure, I should also add that years later the journal shut down while under the editorship of Robert Seydel, a former student of mine at New York University.

54. Along with historian Naomi Rosenblum, I served as juror for this award in 1985.

55. I'm excluding here various awards for photography books, such as those given yearly by the International Center of Photography, the Maine Photographic Workshops, the Rencontres Internationales de la Photographie in France, and the Kraszna-Krausz Photography Book Awards in the United Kingdom, some of which go to historians, critics, and theorists for published books. The Logan Grants subsidized and rewarded the creation of specific essays, which initially were judged blind. For a selection of the results, see Daniel P. Younger, ed., *Multiple Views: Logan Grant Essays on Photography, 1983–89* (Albuquerque: University of New Mexico Press, 1991).

56. Milanowski's article, "Notes on the Stability of Color Materials in Photography," appeared in issue 2 (1981).

57. In 1990, Benedict-Jones served briefly as curator of the Polaroid Collection, working with Barbara Hitchcock.

58. I served for a time on this publication's advisory board and published in it an essay on the late Todd Walker. The *Newsletter*'s last issue appeared in the winter of 1991, according to Hitchcock (letter to the author, February 11, 1999).

59. Naylor, one of the founders of the PHSNE, was a collector of photographica and the creator of the Naylor Collection of Cameras and Images, Boston, whose 31,000 pieces he eventually sold to a museum in Yokohama. He's now building a new collection.

60. Contributors from the region included Chiarenza, Jussim, and Stange; a hardbound version of the issue was eventually made available.

61. See her essay "Taking a Risk: The Blueprint for a Museum of Modern Art," in *Dissent: The Issue of Modern Art in Boston* (Boston: Institute of Contemporary Art, 1985), 12, which addresses, among other things, the seeding of photography as a museum-worthy medium and that idea's Harvard connection.

62. Chiarenza's brilliant 1982 study, *Aaron Siskind: Pleasures and Terrors* (Boston: New York Graphic Society)— one of the few true critical biographies ever produced on a photographer and his work—remains a model for the field. So, in a very different mode, does his speculative provocation, "Notes Toward an Integrated History of

Picturemaking," *Afterimage* 7, nos. 1–2 (Summer 1979): 35–41. And Estelle Jussim's previously mentioned *Visual Communication and the Graphic Arts*, on the evolution of the photomechanical processes, is the logical extension of the innovative ideas of William M. Ivins. These three examples indicate the bounty this cohort produced during their heyday in the areas of scholarship and theory. But I'd also argue that the more topical, ostensibly more perishable running account of activity in the region provided cumulatively by the younger writers of that period is no less valuable to the medium's critical tradition.

63. Many of these writers also contributed to publications from outside the region, and had books issued by publishing houses located elsewhere. Notably, in fact, there's seemingly little connection between this cohort of writers and the several local book publishers; few of the photo-specific titles issued by New England publishing houses represent works by area writers.

64. The appellation "Boston School" isn't one conferred upon them by critics and historians, but rather one they themselves have adopted—as if the School of Paris had decided to dub itself that, rather than wait for the future's scrutiny of connective threads. See Milena Kalinovska, preface to Lia Gangitano, ed., *Boston School* (Boston: Institute of Contemporary Art, 1995), 6: "Boston School, as labeled by Nan Goldin in a formative discussion a year or so ago . . .".

65. Gangitano, introduction to *Boston School*, 12.

66. This is a historical fact that goes entirely unmentioned by all of the two dozen contributors to the Boston School exhibition catalogue. Cf. Elisabeth Sussman's discussion of the educational and intellectual milieu of Boston circa 1974, "Wish You Were: Armstrong, Goldin, Boston," in *Boston School*, 128–130.

67. Gerald Peary, "Boston Photography: Is Its Renaissance Over?" *Boston Magazine* (December 1983): 152–157, 188–194.

68. And it's worth pointing out that this harbinger of its demise did precious little to encourage and sustain that "rebirth."

69. The last issue in its standard format, vol. 14, no. 2, appeared in Spring/Summer 1993, under the editorship of Daniel P. Younger. In a more magazine-like format, it was revived a year later for a single issue—vol. 14, no. 3— under the coeditorship of M. Darsie Alexander, John P. Jacob, and Robert E. Seydel. No subsequent issues have been produced.

70. For my comments on this, see "Do It Yourself" (note 49 above).

71. According to Wise, in conversation with the author, August 11, 1999. Wise's last *Globe* column appeared in 1992.

Treasures of the Moment:

Arno Rafael Minkkinen

Thirty Years of Polaroid Photography in Boston

Nearly every New Year's Day for the past twenty-five years I have attempted to make a new photograph, an image that must be conceived *and* completed on the very first day of the year. It was André Kertész's New Year's Day image from 1972—of a man in Martinique, the transfigured apparition behind a frosted glass balcony divider—that inspired this first day obsession to get an image on the scoreboard as quickly as possible.[1] From concept to completion before day's end? What better way to make the attempt than popping in a Polaroid?

Dr. Edwin H. Land's invention of Polaroid instant film in 1947—tucked between the years that Tupperware, ballpoint pens, and disposable diapers all made their marks as postwar household jealousy items—was as brilliant in concept as it was in realization. In many ways, it was a reinvention of the invention itself, what photography, the "light drawing" medium, should have been about in the first place. The image held by the piece of tissue paper placed at the back of the camera obscura was supposed to stick to the paper and stay there, not vanish as soon as the tissue was lifted away nor, as the eventual procedure required, go back inside a holder or roll back inside a cassette, spool onto a reel and after processing blow up with an enlarger only to slosh back into more slippery liquids under red light. The dream concept should have had the picture in hand immediately after the eye saw it, the treasure of the moment done within an instant. At least that's what Tiphaigne de La Roche prophesied in his anagrammatic novel *Giphantie* written in 1760, some eighty years before photography was launched into the world.[2] The sci-fi novel describes the wonders of life on an imaginary island called Giphantie. There the author encounters a miraculous mirror that projects images onto a canvas; "the canvas, by means of viscous matter, retains the image." The prediction is an extraordinary one. "The mirrour shows the objects exactly; but keeps none; our canvases show them with the same exactness, and retains them all."[3] Tiphaigne comes within striking distance of predicting Polaroid itself: "This impression of the images is made the first instant they are received on the canvas, which is immediately carried away into some dark place; an hour after, the subtile matter dries, and you have a picture so much the more valuable, as it cannot be imitated by art nor damaged by time."[4]

1. See Nicholas Ducrot, ed., *André Kertész: Sixty Years of Photography, 1912–1972* (New York: Grossman Publishers, 1972), plate 224.

2. Beaumont Newhall, ed., *Photography: Essays & Images, Illustrated Readings in the History of Photography* (New York: Museum of Modern Art, 1980), 13. Reprinted from Charles François Tiphaigne de La Roche, *Giphantia: or, A View of What Has Passed, What Is Now Passing, and During the Present Century, What Will Pass, in the World* (London: printed for Robert Horsfield, 1761), 93–100.

3. Newhall, *Photography: Essays & Images*, 13.

4. Ibid., 13.

Dr. Land's miracle, of course, was to accomplish the task in a matter of a minute.

Sixty-Second Excitement Standing before a roomful of journalists at the Hotel Pennsylvania in New York in 1947, Edwin Land peeled apart positive from negative to reveal an image taken of himself sixty seconds earlier.[5] The first instant photograph made without the benefit of any darkroom gadgetry or chemistry was born. In his recent biography of the great inventor, Victor K. McElheny describes the day Land first demonstrated his invention. It was a Friday, February 21, with more than 24 hours of snow on the ground, "such a snowy day that many events from Maine to North Carolina were canceled." Even President Truman "skipped his usual morning walk in Washington."[6] Shortly before his address to the Optical Society of America, Land had gathered members of the press in a small room to demonstrate his one-step process; hardly the regal event we get in history book illustrations showing Daguerre before the joint assembly of the Académie des Sciences and the Académie des Beaux-Arts at the Palais de l'Institut along the banks of the Seine on August 19, 1839.[7] Francis Arago, the celebrated orator, spoke for the diffident inventor, who had cloaked a sudden gun-shyness with complaints of a sore throat.[8] At the Hotel Pennsylvania no one stood in for Land. The new camera, its proud inventor proclaimed, "will make it possible for anyone to take pictures anywhere, without special equipment for developing and printing and without waiting for his films to be processed."[9] In short, what could be easier? Land even snapped pictures of the reporters. "Develop it in full daylight on the scene by simply pulling it out of the camera" is how the *New York Herald Tribune* described what Land had demonstrated.[10] A week

later, at the Parker House rooftop ballroom in Boston, New England journalists got a chance to see the process in action too. "I don't know much about photography," Land told the crowd. "But as an amateur hobbyist I have read most of the histories on it, particularly those dealing with the Fox Talbot experiments." The clincher in a nutshell: "What I've been able to develop here has been inherent in the photographic process for a hundred years."[11] Sometimes the genius of genius is knowing that the answer is staring you in the face.

According to McElheny, one of Land's favorite words was "atavistic," meaning "a tendency to hark back to ancient ideas and experiences."[12] William Henry Fox Talbot, the British scientist, botanist, and Lacock Abbey lord who invented photography as we know it today, may well have been Land's ancient Kokopelli. There is something of Talbot's brilliant double thinking—of repeating the exposure through the paper negative to create the paper positive—in the Land equation. It was a stroke of genius considering how simple it was: the silver *not used* in making the negative could be used to make the positive! The Polaroid "Land" Camera, as the apparatus was to be called, had arrived. (Daguerre himself, violating his contract with his deceased partner Nicéphore Niepce that the process be termed heliography, had used his own name when coining the word Daguerreotype, just as Talbot's calotypes ran with the name Talbotype while the patent remained in his steadfast and bullheaded grip.)[13]

In her review of the McElheny biography for the *New York Times Book Review*, Dr. Nancy Maull of Harvard University pivots her essay on this delightful Land quote from the book: "Any problem can be solved using the materials in the room."[14] Technically speaking, this meant that in highlight-dominated pictures where more silver was needed to

5. Victor K. McElheny, *Insisting on the Impossible: The Life of Edwin Land* (Reading, MA: Perseus Books, 1998), 185.

6. Ibid.

7. See illustration in M. Susan Barger and William B. White, *The Daguerreotype, Nineteenth-Century Technology and Modern Science* (Washington and London: Smithsonian Institution Press, 1991), fig. 1.1.

8. See Arago's apology in Beaumont Newhall, *Latent Image: The Discovery of Photography* (Garden City, NY: Doubleday, 1967), 90.

9. McElheny, *Insisting on the Impossible,* 185–186.

10. Ibid., 185.

11. Ibid., 187.

12. Ibid., 161. By taking up ancient problems, Land found not only solutions but convincing rationales for selling his ideas to colleagues.

13. See Newhall, *Latent Image,* 48–49. At the bottom of a letter Daguerre wrote to Niepce on April 23, 1838, he drops this bombshell: "I have baptized my process thus: DAGUERREOTIPE [sic]."

14. See "The Problem Solver," Nancy Maull's review of McElheny's *Insisting on the Impossible,* in the *New York Times Book Review,* March 21, 1999, p. 28. Maull compares Land's problem-solving philosophy to the dilemma faced by the doomed astronauts in the movie *Apollo 13:* only the resources they have on board can be used to construct the implements to bring them back to Earth alive.

Bill Burke Speaking

Two young boys—or are they men?—face the camera, shirtless, footless. The shock of the image comes in the first glimpse, the way the boy on the left drops into the ground as if he still had his legs and was only buried in sand, but the boy on the right with his crutch and stump swiftly denies that, leaving the more unfortunate of the two pinned down for good. The bitter irony and unbearable sadness of *Khmer Rouge Land Mine Victims* (plate 30) comes from the car peeking in on the right edge of the frame. These boys won't be doing much traveling. They are physically anchored to the land that nearly killed them, fenced off by circumstances we will never know. Already behind the barricade peer the curious, witnessing the making of the photograph as much as wondering for what purpose it is being made, what insanity caused these lives to be cut down at such an early age.

I met Bill Burke some twelve years ago at a Photographic Resource Center fundraiser auction on Beacon Street. It might have been the only time we ever saw one another face to face. Still, speaking with Bill on the phone was easy, as if we were simply carrying on the earlier conversation, having wandered off into separate rooms for the last twelve years.

"So what was your working method like?" I asked.

"Put the camera on the tripod and everyone knows you're there."

Cigarettes, too, played an important role in the ritual of asking someone to have their picture taken. "The act of taking out the cigarette, reaching it across to a perfect stranger, cupping hands to light it, looking into each other's eyes, that was the unspoken handshake of approval. After that, the picture was easy."

A lot of the times Bill doubted the people really knew what was happening; they got the positive and that was that. "Hard to know what people understood. I couldn't speak a word with anybody, hardly anything, it was as if I was the amusement park that just rolled into town.

"After the Polaroid neg cleared," he went on, "I'd show it to them and try to tell them I can make a big print. Anyway, I had no plans to keep the positive, that was part of the deal. I gave 95 percent of them away."

He was concerned about getting "sidetracked" when there were a lot of people hanging around. "A family member or passerby will suddenly tell them what to do, try getting them to smile or otherwise distracting them. If you don't pay strict attention yourself, the whole thing can turn tables on you. It's better to look for situations in which you can be alone with someone."

Bill Burke conversation took place on February 19, 1999.

generate the negative, less silver would be required to complete the positive. Conversely, in photographs of darker subjects requiring thinner negatives, a plentitude of silver remained ready to generate a rich, black positive. The mathematical balance between negative use of silver and positive use was always fixed. It simply depended on where the equal sign was placed. Numerically, a 6 + 4 = 10 image would be a light one, whereas a 4 + 6 = 10 image would be a dark version. Other combinations include 1 + 9, 2 + 8, or 3 + 7. Even a gray card, 5 + 5, depicting a sad gray sky over a sad gray ocean was possible. Where the madness lay was in the mechanics. But that's a story for the production team to tell, for the marketing boys, as they would, to tout.

For most photographers, of course, it is the results that count and the process of getting there, which hasn't changed all that much to this day. Take the gleaming Polaroid package, for example. Inside the sturdy box—the bright blue Type 55 Positive/Negative container, for example—are lodged the fragile contents of twenty unexposed and potentially extraordinary transformations, if the gods and clouds cooperate. Then there is the touch of the Polaroid material itself, the workings of the film holder, the way it loads and drops into the camera back, a commanding *plunk* that always seems to impress students; and after exposure, the delightful *pring* of the processing rollers as the film packet is ejected, setting in motion the immediate conversion. Even the 20-second wait is part of the gratification. Peeling away positive from negative is yet one more adrenaline rush. Students can't fail to notice how smoothly the two leaves separate, and then they're even more shocked to see the positive rejected in favor of the negative which gets lovingly dunked, dunked, and dunked again into the sodium sulfite bath. It's all part of the ritual and craft of making an instant pho-

tograph. In black and white or color, every Polaroid photographer knows and feels a unique ceremony. What we see in the dimly lit upside-down slab of ground glass in the camera reappears in the palm of our hand, sturdy and upright, smooth-toned and grainless; often a brilliant interpretation of the facts before the lens. In the finest of results, I daresay a heart-stopping joy arrives as my hunches come to life. It is hard to imagine such immediate turn-arounds with any other creative medium.

To look and see, then take and make before one minute can move to the next was the substance of Land's concept. Few poems arrive so swiftly, hardly a tune comes off the piano so confidently, certainly no canvas is ready to hang with the speed of creation Polaroid offers.

Learning from the Masters On the heels of the Land announcement in 1947, assembly lines began rolling out Polaroid Model 95 cameras and Type 40 instant film, soon to be selling like hotcakes off store shelves across America. At the same time, discussions at the corporate level were already centering on how to position the new snapshot phenomenon; just how far could the benefits of the concept be taken? The philosophical mission of the company had never been forged according to Fortune 500 scriptures; instead, with Land's leadership each new invention introduced, ipso facto, brand-new artistic frontiers to explore.

To discover what a product as inherently spontaneous and uncomplicated as Polaroid could do, the company turned to the expert advice of America's finest artistic photographers. Already well recognized for his accomplishments with the American landscape, it was natural that Ansel Adams should be tapped first, hired by Land to work closely with company technicians as an ongoing consultant. His role

Olivia Parker: A New World Order

Under the Lilacs (The Leopard's Garden) (plate 60) depicts a house of cards that a silver leopard appears charged to topple. A tenpin stands precariously at the lip of an old box ready to tip over, a wooden top resembling a silhouette of a Monet haystack or the prow of a Viking ship is likely off balance too. The world order of objects and their images is about to cave in. A funereal bouquet is already in place. But it is not a sad farewell; a glowing yellow background and bright pink cards portend the much-anticipated pleasures of a new curiosity shop, Photoshop.

"Tell me about the *Under the Lilacs (The Leopard's Garden)*, the 20 x 24 color Polaroid photograph you made in 1980. What are those pink pieces of cardboard in the image?"

"They're from an Italian game, I don't know the name of it, some kind of bingo or lotto. We see the reverse side of the cards. I got them from a friend of mine, including the round wooden pieces."

"So everything is on the natural scale?" I asked

"That's right. It was a chance to make big pictures. We had to build things straight up. Later, John Reuter, who operated the camera, solved the problem by using a mirror so that things could be laid flat down on the floor. This really opened up the stage for exploration."

At the time, Parker had just turned to color, moving away from her classic split-toned still lifes. "I hadn't used color before so it was really important to see the results right away. It became a learning experience to see what I was doing as a beginner in color. The split-toned work was getting too known, too easy to keep doing that. I was more interested in moving on and growing."

There's an image of a pear hanging off a piece of red thread looped around it that has always struck

me as a powerful way to put color into black and white photography. "Polacolor was a particular kind of color. At first I thought this is what color should be.

"I also learned to use artificial light. The light sensitivity of Polacolor was so low you couldn't photograph in ordinary daylight, so we added tungsten illumination which mixed with the daylight particularly well. Marie Cosindas also used this technique with movie lights, which gave off that greenish color."

We spoke about Joseph Cornell's boxes, of being compartmentalized. "We're placed in the position of God looking down at a truth we, as human beings, could never see," I said.

"Any photograph becomes a box, an intimate box," she replied. "An intimate edge of the photograph. When I was painting in the mid-seventies and drawing grids with organic forms in them, junk shop muffin tins did pretty much the same thing."

"Do you have favorites?"

"What I edit out leaves favorites; beyond that it is hard to say. Maybe favorites are the ones I'm working on, while others have left me, if you will? Then there are the funny ones. They are gifts, you can't premeditate them."

Olivia Parker conversation took place on January 25, 1999.

4.1 **John Benson** *Family Portrait,* 1972 (silver gelatin print; The Polaroid Collections)

process itself.[17] This compendium of everything you wanted to know about instant photography also contained a lavish portfolio of instant photographs by Adams and Minor White, but also showcased emerging talents such as Paul Caponigro and Nicholas Dean. Caponigro, Dean, and John Benson were later hired by Polaroid as consultants to continue the investigation of the medium's artistic potentials.

These consultants each utilized the Polaroid product in their own work and in many cases advanced their creative output manyfold through the association. Certainly Caponigro achieved some of his finest masterpieces on Polaroid film. Looking at Benson's images—like the one used as frontispiece in Minor White's *Be-ing without Clothes* (figure 4.1), the Aperture publication based on the MIT exhibition of 1970—one gets the impression that he was drawn to Polaroid instant photography for its ability to keep a secret.[18] The exquisite series of nudes he produced are among the first to investigate nudity among family and friends, male and female, young and old alike.

Polaroid is renowned, of course, not only for encouraging its products to be used in nontraditional ways but for standing behind the pioneering exploits of its practitioners. Through its exhibitions, publications, and collection purchase policies, the company has demonstrated an astonishing aesthetic flexibility. During the stormy polyester suit controversies of the early 1980s, when Senator Jesse Helms waved photographs of body parts on the Senate floor, Polaroid established a tolerance for subject matter that one could say was politically correct in all directions, especially with regard to male and female nudity. In a time of tightening censorship in America, Boston photographers found aesthetic shelter with the Polaroid Corporation. The guiding spirit behind that sentiment was undoubtedly Dr. Land

was to test the new films and products and make suggestions. Barbara Hitchcock, director of corporate cultural affairs at the Polaroid Corporation, recounts the strategy behind enlisting artists on the aesthetic payroll of the company. "Dr. Land felt that artists such as Ansel Adams could tell us things about our products from a point of view quite different from the technical staff. He [Land] sensed that artists would push our film to the limits and report back even the most minute problems."[15] Other photographers recruited to assist Polaroid in the development of its products were Philippe Halsman, Bert Stern, Marie Cosindas, William Clift, Nicholas Dean, Paul Caponigro, Carl Chiarenza, and Brett Weston.

According to McElheny's biography, at every turn, both professional and personal, Ansel Adams was there for Land. "Ansel criticizes with love and a very heavy hand" is how Land described Adams's role in suggesting improvements for the company products.[16] When the SX-70 was launched in the early 1970s, it was Adams who accompanied Mrs. Land to the occasion. In 1963, Morgan & Morgan of Dobbs Ferry, New York, which published Adams's famous craft series, *The Camera, The Negative,* and *The Print,* published a definitive how-to book on the Polaroid

15. Quoted in Richard W. Cooke, "Polaroid Corporation: Helping Artists Explore New Photographic Frontiers," *ArtToday* 6, no. 1 (1991): 26.

16. In McElheny, *Insisting on the Impossible,* 386.

17. Ansel Adams, *Polaroid Land Photography Manual: A Technical Handbook* (New York: Morgan and Morgan, Inc., 1963).

18. Linda Connor related to me that the man in the center of the image is the painter George Morrison, surrounded by his family.

Rosamond Purcell: Seeing Double

I reached Rosamond Purcell, many area codes away from her Medford home, in San Francisco, where she was a guest at the hands-on science museum called the Exploratorium.

I asked her what was it like using Polaroid materials.

"With Polaroid film, I could go on and on from print to print, not just as a test print, but as a final print. And I could change my ideas as I went along. I would never have been able to do that with such agility using conventional processes.

"It was a total creative process for me. When I first began photography I didn't learn how to really print for almost two years. With Polaroid providing all the film, I had a free ride without having to have a darkroom."

She described how she had to come to understand the discrepancy between what was there and the material "turning what I saw into something else." There was a vast difference, she explained, between "what you feel and the appearance of what you receive.

"Type 58 4 x 5 color film gave me a whole rift of appearances. I could use it normally or peel it apart before it cooked so that the dense gummy opaque sheet still held chemicals that had not been transferred. This I would solarize in the light and spray with water before transferring it onto rice paper. When I photographed it, some parts looked real, other parts unreal."

Duality always interested Purcell. From one of her very first images, of a mermaid and bird in a window (figure 4.2), she has always been seeking the double. "I was never interested in a straight image as such . . . mine was a backyard art of seeing doubles."

When she moved to color, it was natural for her to use sandwich negatives. "A myriad of dimensions in a flat surface," that is what fascinated her.

For Purcell, as for many other Polaroid photographers, the expendability of the materials allowed a spontaneous freedom to create. She speaks with admiration of her good fortune in having started with Polaroid materials. "I don't mind sounding like an advertisement," she says. "I am so grateful I began this way. I could never have survived in the typical grad school critique."

4.2 **Rosamond Purcell** *Mermaid #1*, 1970

Rosamond Purcell conversation took place on February 5, 1999.

himself, but the front-line decision-maker from the early 1980s on was Barbara Hitchcock. "The photos are my choice—I use my own sense of aesthetic taste and judgment and try not to let issues of censorship intervene in my decisions."[19] It was part of the corporate philosophy that art and photography become one. "We believe it is important," she notes, "to underscore the creative side of life, to try to further enhance the quality of life of the community in which we are a guest. And our commitment to the artists who use our products and materials is a further reflection of that philosophy."[20] Still, without Dr. Land's blessings, surely the content of the creative output would have been altered considerably.

Technical guidelines might have imposed a different set of creative limitations on artists using Polaroid materials. But Ansel Adams clarified that issue, separating artistic freedom from technical constraints. "I give full credit to the excellent scientists and technicians involved in the photographic industry," he wrote in his book *Examples: The Making of 40 Photographs* in 1983. "The research, development, and design aspects, as well as production, are extraordinary. However, very few photographic manufacturing technicians comprehend photography as an art form, or understand the kinds of equipment the creative person requires."[21] True enough. Still, not all segments of the technical staff endorsed the idea that some photographers could thwart hard-won technical achievements through such pyrotechnics as scratching, rubbing, and heating of the emulsion, as initiated, for example, by Lucas Samaras in his *Autopolaroids*. Writing in *View Camera* magazine, Dennis Purcell, a Polaroid consultant, analyzed the situation quite accurately. "To engineers and scientists struggling to make a product foolproof enough for amateurs, and consistent enough for professionals, some of the artistic license

took the film far beyond the scope of normal quality control."[22] Eventually, however, as the renegade imagemakers found public acceptance for their unorthodox machinations, so too did the technically faithful come to accept such courses of action, yet another example of the company's continuing advocacy of unfettered product use. The Polaroid transfer imaging process—whereby the negative emulsion itself becomes the work of art—is a perfect example of an unauthorized practice evolving into a highly influential artistic trend.

A Collection Takes Shape Among the far-reaching contributions made by Adams was the recommendation to establish a yardstick by which to judge the new medium. In 1949, he suggested to Land that it might be wise to have a collection of traditional photographs at Polaroid against which the results of the new invention could be measured and compared. "The Library Collection," as this grouping of approximately 200 photographs compiled by Adams and purchased by Polaroid came to be known, included important works from 1924 to 1955 by such photographers as Imogen Cunningham, Dorothea Lange, Eliot Porter, Aaron Siskind, and Edward Weston.

The founding of the Library Collection set the stage in the late 1960s for the development of a program that would eventually become one of the stellar examples in American business lore of corporate collaboration between a manufacturer and the consumers of its products. The Polaroid Collection, as it was called, contains today well over 23,000 photographs made by over 1,000 photographers worldwide. Intended to be more than a repository of the crème de la crème, the collection was based as much upon the need to accumulate quality examples of instant Polaroid photographs as upon the opportu-

19. Quoted in Cooke, "Polaroid Corporation," 30.

20. Ibid., 31.

21. Ansel Adams, *Examples: The Making of 40 Photographs* (Boston: Little, Brown, 1983), 59. In his discussion of his image *Sand Dunes, Sunrise, Death Valley National Monument, California, 1948*, Adams begins by scolding the photo industry for making "dark cases and bags, and focusing cloths with both sides dark. Obviously," he goes on, "their designers never worked in the desert." While his lament begins with the technical aspects, his commentary soon shifts to the creative.

22. Dennis W. Purcell, "The Polaroid Collection, Twenty Thousand Experiments," *View Camera* (January/February 1993): 12.

Judith Black: Making Photography Housework

Since the arrival of photography, men—most of them husbands—have turned their cameras on their wives or their lovers, their loved ones, and their immediate families. We can think of Jacques-Henri Lartigue from the turn of the century and his hilarious documents of château shenanigans, as well as the later family albums of his wife Bibi before a slinky fashion model named Renée turned that fabled romance inside out.[1] There is, of course, Stieglitz and the series of portraits he made of Georgia O'Keeffe—before and after they were married—over more than 18 years; from the 1950s, we have Harry Callahan's exquisitely rendered private world, seen as if in a vitrine without glass. In our time, Emmet Gowin inherits the mantle of homegrown affection with his now classic series of photographs of his wife Edith and their offspring. But how many women in the history of photography have devoted their energies toward a loved one or the family for any length of time? Julia Margaret Cameron certainly enlisted a seraphic clan of kids and parlor maids in her allegorical narratives, but these wistful pines or pouts of petulance before the lens were often to play characters from dramas other than their own lives.

It's only when we get to contemporary times that we see the emergence of the feminine eye and voice taking on the intimacy of home life, in spite of the fact that no woman appears to have produced a lasting body of work about an individual man. Edith and Eleanor, but no Albert or Edward, at least in the common lore as yet. Still, among contemporary women, Sally Mann stands out for the brave new territory she explored, the unflinching faith she and her children placed on the idea that the life of a child could be more gracefully and honestly expressed when the kid's two cents counted.

Concurrent with Mann's work, and commencing some years earlier, Judith Black began a series of self-portraits, often visceral and deeply personal. Unlike Francesca Woodman and Cindy Sherman who sought other identities to embody, Black remained herself, white terrycloth bathrobe and all, fresh out of the shower. It was when she began to include her children in the self-portraits that she turned to Polaroid materials. The give-and-take of raising four children—Laura, Johanna, Erik, and Dylan—not only became a way of working daily with the camera, but it enabled her to explore the relationship she had with her children and they had with each other. With Polaroid film always on hand, taking portraits in and around the house soon became as natural "as catching up spills with paper towels."

In *Erik and Dylan (Mother's Day), May 8, 1983* (plate 29), the brothers are out on the front porch. Erik, the older one in the foreground, stands beyond the frame edge as Dylan, the younger, leans back on the hammock like a tautly pulled arrow, ready to cast off and knock big brother out of the picture. The formal elements of the image cooperate with the unfolding drama. Dylan's outstretched arms mimic the hammock as does the white collar of Erik's rugby shirt. A neatly folded shopping cart in the corner sums up the tensions of home life at the moment.

"When you're working with a subject that doesn't want to be captive for so long, the Polaroid process is the perfect tool. If the image wasn't right, you could do another."

"How did the children react to the camera?"

"Actually, the kids are more interested to see the results now than when they were little. It didn't matter so much when they were younger. Now, what they come out looking like is a big issue around here."

"What were some of the drawbacks of using Polaroid film?"

1. Arno Rafael Minkkinen, *Elegant Intimacy* (Punkaharju, Finland: Retretti Art Center, 1993), 17. Exhibition catalogue centering on the family album images of Jacques-Henri Lartigue and Sally Mann, with additional works by Claude Batho, Harry Callahan, Emmet Gowin, Yves Trémorin, as well as Alfred Stieglitz and Roman Vishniac.

Judith Black conversation took place on February 11, 1999.

nity to have a center established for their study, exhibition, and preservation. The selection committee—comprised of a group of corporate volunteers who initially supplied film and materials to more than several dozen photographers—reviewed portfolios regularly and made periodic purchase decisions. Through these efforts, a rich and diverse assemblage of Polaroid images began to form, with substantial bodies of work from such photographers as Roswell Angier, Karl Baden, Christopher James, Elsa Dorfman, Peter Laytin, Starr Ockenga, Melissa Shook, and Jane Tuckerman entering the collection.

The Polaroid Collection originally began as a domestic enterprise based in Cambridge and devoted almost exclusively to the work of young American photographers. Soon after it was officially formed, however, it became clear that if the collection were to grow, Polaroid would need to extend the base of the collection internationally as well. It was Allan Porter, editor of *Camera* magazine, the prestigious Swiss photography journal, who set the process in motion with the suggestion of producing a special issue on the history of instant photography.[23] The problem was that most of the photographers using Polaroid products were non-European. "When the effort to collect and edit images for the magazine began, it didn't take long to realize how little high-quality, creative Polaroid photography existed by photographers outside the U.S.," recalls Eelco Wolf, then director of worldwide marketing and publicity at Polaroid headquarters in Amsterdam. To remedy the situation, he suggested inviting a number of international photographers—such as Helmut Newton, Kishin Shinoyama, David Bailey, Josef Sudek, Jeanloup Sieff, and Sarah Moon—to give Polaroid a shot.[24] Their cooperation was essential in forming the bedrock of the International Collection. Instead of building with younger visions from the

ground up, as the domestic collection had been assembled, the International Collection emerged straight off the top of the pyramid. A number of collaborative efforts and exhibition concepts ensued soon after, among them the well-known *Selections* series of exhibitions and publications devoted to both national and international trends and attitudes in contemporary instant photography.

The first exhibition, *Selections 1*, was curated by Professor L. Fritz Gruber of Germany in 1979; two years later, *Selections 2* was assembled by Alain Sayag of the Centre Nationale de la Photographie in Paris. In his introductory remarks Sayag noted the special relationship Polaroid as a company had with its many artists. "The diversity and scope of the assembled images attest to the vitality of exemplary acquisition. Few global enterprises accord as many technical and human resources to the systematic collection of art."[25] In subsequent *Selections* efforts, curators such as Mark Haworth Booth of the Victoria and Albert Museum in London or Jean-Claude Lemagny of the Bibliothèque Nationale in Paris were enlisted to make their choices for the *Selections* exhibitions, which regularly debuted at Photokina and from there went on to impressive and extensive world tours to countries such as Switzerland, Israel, and Venezuela.

While the domestic collection was housed permanently in Cambridge, the International Collection was quite the European traveler during the first two decades of its existence.[26] Initially housed at the Polaroid headquarters in Amsterdam in the early 1970s, it was transferred to the Polaroid Gallery in Offenbach, Germany, in 1983. Five years later, as the collections grew, select holdings were packed off again, this time for the Musée de l'Élysée in Lausanne, Switzerland, where Charles-Henri Favrod was director at the time. A long-term home for 2,000

23. Jean Caslin, "The Polaroid Collections," *Polaroid Newsletter for Photographic Education* (Fall 1984). See also Cooke, "Polaroid Corporation," 28. Allan Porter is not mentioned by name in either article but simply referred to as the editor of the magazine.

24. Caslin, "The Polaroid Collections," 3.

25. *Selections 2* (Schaffhausen, Switzerland: Verlag Photographi, 1984), introduction, n.p.

26. The domestic collection and the International Collection were merged into the Polaroid Collections in 1990.

"Every medium has its drawbacks. The film is expensive, so you take your time and work more carefully. Because you don't want to waste film, you grow to like some things you never thought you'd like."

"Any favorites for you?"

"Favorites are hard to find. It's a family album . . . strawberry, chocolate, or vanilla? I'll have them all."

"And now?"

"Laura is 30 and I'm a grandmother."

1. Barbara London and John Upton, *Photography* (New York: HarperCollins, 5th ed. 1994), 155.

Jim Stone conversations took place twice. The first time I lost my notes, the second time Mr. Stone didn't lose his patience. The second conversation took place on April 25, 1999.

Two Beers with Jim Stone

950 Hats, Don's Bar: Memphis, Nebraska (plate 23) by Jim Stone is an image familiar to thousands of would-be photographers learning to judge the difference between exposure and contrast in a print. The photograph has been repeatedly published in one of the best-selling college photography texts in America.[1] The image was likely chosen for the mind-boggling detail within the frame—not to mention 950 hats to count—and the clarity of extremes the image illustrates when density and contrast go haywire. And for the humor of Memphis, not in Tennessee.

I called directory assistance to get Jim Stone's new number in Albuquerque. Not easy spelling it in my phone book, more u's than q's. Scratch out Dorchester, scribble in University of New Mexico.

"So, what gets you to stop someplace," I ask, "a flip of the coin?"

"There's no real plan. *Don's Bar* is a perfect example of my peripatetic style of picture-making."

Jim had been in Colorado that summer doing a workshop and met a friend who invited him to Nebraska. "It was the only state in the Union I had yet to visit. He showed me what a wonderful place Nebraska was, including Memphis where Don's Bar was."

The next friend that came along steered him in the direction of Sioux City, Iowa. "So I headed east and did a bunch of pictures there. Partially directed wandering, I guess you'd call it."

"Why Polaroid film, in a picture like *Don's Bar*?"

"The big advantage with Polaroid materials is the portrait; it's important to find out if your subject is comfortable with the image or not. In this photograph, nobody was there except for the bartender. But the Polaroid positive print did confirm my guess about the exposure."

collection photographs was finally established in 1997 at the Maison Européenne de la Photographie in Paris. There is a special facility called L'Espace Polaroid that serves as a permanent gallery for Polaroid works and theme shows, as well as a storage center for the International Collection.

The Visions of Tomorrow Sometime in the mid-1960s, Meroë Marston Morse, research manager of black and white photography and Dr. Land's ace technician, inventor, and guiding light in many matters of corporate policy, advocated the establishment of the Artist Support Program at Polaroid.[27] Lending assistance to emerging artists with film and equipment grants in exchange for imagery created with Polaroid materials became the channel through which both the domestic and international collections prospered and grew. Portfolios by lesser-known, often younger photographers were thereafter solicited on a regular basis for the collection. In Europe, in places like the Hôtel D'Arlatan courtyard during the famed Rencontres d'Arles International Photography Festivals, the scene was quite the contrary. Young photographers, portfolio in one arm, Evian water in the other, were lining up to have their work viewed by museum curators, magazine editors, and, at one particularly busy table, by Barbara Hitchcock for the chance to enter the Polaroid International Collection.

The Artist Support Program options varied over the years, from outright purchases of works when times were good to one print exchanged for every one hundred 4 x 5 Type 55 film exposed. When the material in question was Polaroid 20 x 24 film, the most expensive in the world, the photographer usually donated one print to the collection for every ten shot. "Many young artists have benefited from this program," Hitchcock points out. "The program pro-

vided photographers with the incentive to experiment—to try out new approaches they might not have been able to afford on their own."[28]

The 1970s were a particularly dynamic period of growth for the Artist Support Program. In America, and particularly in Boston, many younger artists, such as Chris Enos, Rosamond Purcell, and Eugene Richards, were given material support over an extended period of time. The photographers also benefited from the wide exposure they received through the many Polaroid exhibitions that were touring the country as well as through their accompanying catalogue publications.

A Permanent Showcase In the summer of 1969, Edwin Land lost his dear friend Meroë Morse to cancer. Still working at Polaroid up to her final weeks, Morse had been engrossed with her colleagues in setting strategies for the continuation of the collection and the inauguration of a permanent Polaroid gallery.[29] Three summers later, with Dr. Land's blessing, suitable quarters for such a gallery were found at 770 Main Street in Cambridge. Named in honor of his close associate and longtime friend Clarence Kennedy, the Clarence Kennedy Gallery became the showcase of Polaroid photography in America. (Kennedy had been there with Land in 1934 when his newly launched polarizing material was in dire need of a name. "How about Polaroid?" is what Kennedy is reported to have uttered to the 25-year-old Land in the same breath as he coined the word.)[30]

The Clarence Kennedy Gallery opened its doors in April 1973 with a show of SX-70 photographs made by Polaroid staff members. From the outside, the place hardly looked like a gallery; it was easy to miss the building altogether and find yourself in Central Square heading either to Harvard or to MIT. The

27. Notes from an unpublished conversation between Rachel Rosenfield Lafo and Barbara Hitchcock on September 20, 1994, in which Hitchcock credits Morse with the decision to "give materials to young, up-and-coming artists and in that way help support the creative process."

28. Quoted in Cooke, "Polaroid Corporation," 27.

29. For a moving account of Morse's last days at Polaroid and on earth, read the last section of the Morse chapter in McElheny, *Insisting on the Impossible,* 218–219. Also note Caslin, "The Polaroid Collections," 2.

30. McElheny, *Insisting on the Impossible,* 66.

"Must have been pretty dark in there . . . what was the shutter speed?"

"Two beers."

"When you make a portrait, do you give away the positive?"

"On the spot; but sometimes in situations where I have to process afterwards, I send the print later."

"How else has the Polaroid process helped?"

"Knowing when you have it."

"You mean knowing when to stop, not having to waste more film?"

"That's right. You know the picture with a Stealth bomber in the background . . ."

"The one in Yuma?"

"Yes, that one. I stood in front of these people engrossed in the air show waiting to disappear until I got the one where no one was noticing me except this guy with the Coke. Once I had it, I knew I was done."

"There's a looming quality in the image."

"I prefer people to see that side of the work."

"As well as the humor?"

"I don't want them to be about humor alone. The tragic side should be just as visible. Since the pictures don't always achieve the same balance between comedy and tragedy, sequencing the pictures becomes very important."

"It's easy to spot a Jim Stone, just from the caption in fact."

"I wanted to include a punch line, to create satire. It was a form of haiku or something to defuse the first thoughts, to get the viewer thinking on the big questions, like why."

"What was it like to be in the Polaroid Collection?"

"Being part of the collection was important, having your work be paid attention to, but even more important was the product itself. With the 20 x 24 studio camera you can make changes and see what happens. You shoot and process, check and reshoot. It's an accelerating process. For my kind of work, it's different. The portraits wouldn't have happened without the Polaroid camera. Nobody is going to wait around a whole day to see what you got. Getting it there on the spot, there's the real magic."

entrance itself was on a side street, but once you got inside the place took over. A welcoming presence greeted you. It was free and you could spend all the time you wished viewing the current monthly exhibition or make an appointment to view the collections.

From 1972 to 1985, approximately sixty exhibitions were mounted at the gallery featuring the work of some of the photography world's best-known imagemakers, photographers such as Henri Cartier-Bresson, W. Eugene Smith, and Roy DeCarava. A number of the shows were also non-Polaroid exhibitions. In May 1984, for example, the albumen prints of Julia Margaret Cameron from the Royal Photographic Society in Bath, England, were on display. Curated by Gail Buckland, the show allowed viewers to encounter vintage photographs and find themselves face to face with Thomas Carlyle or Alfred Lord Tennyson.

Mark Klett, perhaps the quintessential Polaroid photographer of his generation, exhibited *Traces of Eden: Travels in the Desert Southwest* at the gallery in 1984. It introduced not only his vision of the western landscape to an east coast audience, but a unique method of captioning his work directly on the Polaroid frame edge. Other gallery highlights from the mid-eighties included Lucas Samaras, John Coplans, Joyce Niemanas, the collaborative pair Patrick Nagatani and Andree Tracey, Michael Spano, Wendy Ewald, Sandi Fellman, Neal Slavin, and Jim Goldberg. Among Bostonians/New Englanders showing during this period were Paul Caponigro, Jim Stone, Laura Blacklow, John Craig, Donald Dietz, and Elaine O'Neil.

Expanding the Vision When it first came out, the 20 x 24-inch Polaroid print was, for many conventional photographers, enor-

mous in size. For photographers used to thinking 16 x 20 was big, the 20 x 24 Polaroid print, with its extra top and bottom white-edged sidewalks included, now took three hands to hold! The scale of the 20 x 24 format may have contributed in part to contemporary photography's current fascination with making the image a wall-sized experience. From Samaras's palm-sized SX-70 transformations of the early seventies it's a giant step (backward!) to view Chuck Close's room-sized self-portraits of the eighties. Other photographers, such as Olivia Parker and Rosamond Purcell, created tableaus large enough to mimic one-on-one, object for object, the life-size scale of their hoary bestiaries and attic kingdoms.

It was not the first time that the Polaroid Corporation influenced the direction creative photography was to take. The SX-70 Polaroid camera, introduced in the early seventies, the instant art machine that even Walker Evans got a chance to test against his fading eyesight, encouraged photographers to consider sequence and collage. Each image was alluring in its own right; even the duds had ineffable appeal as they transformed the reality captured not a minute earlier into glossy-surfaced image jewels. Display them all, arrange each roll out, as William Larson first demonstrated, into narrative panoramas, or, as David Hockney later prescribed, into expressive collages of tea time and Scrabble.

The first Polaroid 20 x 24 studio was officially opened on April 11, 1979, at Boston's School of the Museum of Fine Arts. Resembling a miniature organ on a shopping cart, the unwieldy camera has produced some of the finest examples of photographic art ever seen. Any photographer worth his or her creative salt wanted to have a share in this, the grandest of Polaroid experiences. The five-foot-high, 235-pound view camera required stand-on-your-head

Paul Caponigro: The Voice of Nature

Ansel Adams's majestic half dome, Harry Callahan's austere weeds in the snow, Minor White's littoral epiphanies, Imogen Cunningham's triumphant lilies; I am able to give shape to each of these images directly in my mind. With the work of Paul Caponigro, I must have the work in front of me to verify the astounding richness of its humble grandeur; the image needs to be in front of my eyes every time, not in my brain. Caponigro is, after all, the voice of nature, and I need to be near it to hear it: a road coming and going, the forces of creation in a babbling brook, the twinkling galaxies in a well-polished apple; or as a student recently wrote, "a cloud tugging at a treetop like a magnet."[1] From the powerful themes of Adams and White that informed his initial enthusiasm for photography with their "Zone and Zen" systems, Caponigro moved toward a personal world of his own, using the clarity of vision carved out by his viewfinder and taking the craft of his profession as far as it would go to create some of the most pristine and touching photographs of nature ever made. As David Stroud writes in his essay for Caponigro's *Masterworks from Forty Years*, "The great images of West Coast photography went far beyond a preoccupation with design and craft. But Caponigro was seeking something more intimate, more introverted than the physically expressive work of older California artists."[2]

I met Paul Caponigro for a very brief moment in Rockport, Maine. The encounter between the hello handshake and the goodbye handshake was a warm and memorable one.[3]

We met again a year later at his new home deep in the seacoast forests Maine is famous for. A group of workshop students had come with me but we arrived very late. Paul was playing at the piano as the cars pulled up. The coffee needed major reheating. Still the visit went well. We got a chance to see his new facilities and incredible darkroom. He had a deep, soothing voice, and answered every question with a welcoming embrace.

About a half year later we spoke again on the telephone about his use of Polaroid materials.

"How did the Polaroid Corporation help shape your vision?"

"No one shaped my vision but my life. Polaroid was a job, three hundred dollars a month and all the film I could eat."

It was on Ansel Adams's recommendation that Caponigro had been hired by Polaroid as a consultant to help test the film. For Caponigro, it was a turning point away from commercialism to pure practice and experimentation.

4.3 **Lotte Jacobi** *Paul Caponigro, Deering, N.H.*, c. 1965

1. John Cadgwaan, "Paul Caponigro," a final project presentation paper for the "Documentary Image" course at the University of Massachusetts, Lowell.

2. David Stroud, in Paul Caponigro, *Paul Caponigro: Masterworks from Forty Years* (Carmel, CA: Photography West Graphics, 1993), n.p.

3. It was Timothy Whelan who arranged the meeting in Paul's studio in the schoolhouse atop Lookout Hill where Mr. Whelan operated a photo bookshop. The store has relocated downhill since then, where Maine Photography Workshop students can easily drop by en route to the dining hall.

Paul Caponigro conversation took place on January 25, 1999.

acrobatics and next-to-impossible focusing through the dimly lit, full-view Fresnel-type ground glass. The thing blared like a basketball game buzzer when development time was up and it was safe to pull apart the print. Seventy seconds after an exposure, a full-color or black and white contact image appeared with breathtaking, astounding flourish. A full-time technical assistant was needed to operate the camera and adjust the studio lights. One of the first of these was Bob Roden, who likened his role to that of a teacher. "They [the assistants] have to be sensitive enough to back off when the time comes, and let the individual create."[31] John Reuter, who first worked in Boston and later in the New York Polaroid studio, as well as Jan Hnizdo in Prague, have served as the camera's most steadfast and longest-running "operators." Without their expert guidance and understanding of what each photographer was seeking, many an attempt to make a successful 20 x 24 Polaroid photograph would undoubtedly have missed its mark.

Across the Millennium The Polaroid Collection, the Artist Support Program, the worldwide traveling exhibitions, the loan programs, publications, the 20 x 24 studios, the 23,000-print collection itself—it is mind-boggling to think of the corporate structure that would be needed to operate such a range of activities. Stepping inside the old Land homestead on 2 Osborn Street in Cambridge, one would never know it; the entryway looks more like a back alley stage door than an entrance into one of the most important photographic collections of our time.

There is a curious railing just outside the Osborn Street doorway that, as staffers explain, was erected to prevent Dr. Land from running off with his next brainstorm straight into a delivery truck rounding the corner. So what is around the corner now as the Polaroid Corporation finds itself at the millennium gate? A fork in the road. Since its founding, the company has wrestled with the exigencies of sound business practice, a.k.a. the bottom line, and the lure of altruism, lopsided as it sometimes has been, as the basis for innovative market development. At the moment of this exhibition, little doubt remains about which way the corporate lens is focused; the art dictates of 57th Street are no match for the market forces on Wall Street. Still, in the eyes of many, going after the fickle youth market with eye-catching gadgetry makes sense. Every artist was once a teenager. And whatever the future holds, it will be in their hands. Adams knew that: "I am sure the next step will be the electronic image, and I hope I shall live to see it. I trust that the creative eye will continue to function, whatever the technological innovations may develop."[32]

Working with Polaroid materials has always been a collaboration. Much more hinges on the process than aperture and shutter speed, focus and focal length. There's a whole darkroom process riding on the rollers. While the brochures and advertising campaigns, as much as the photographers themselves, speak of instant gratification, the outcome, as any photographer knows, is never the exact replication of the scene before the lens. And when the black and white print peels away from the negative or the color image with all its wondrous hues floats up to the surface, we're done with the anticipation, done with the collaboration, the image is there; and if it worked, the dream has come true.

New Year's Day 2001 is not far off.

31. Marita Sturken, "Polaroid to Open Studio for 20 x 24 Camera," *Afterimage* (April 1979): 3. Roden describes how Chuck Close, invited to work with the 20 x 24 camera at MIT, used an enlarging lens to photograph "small sections of his face to build a 9 x 10-foot panel." I recall, as a professor there at the time, that students were also invited to participate in experimenting with the new camera. Imaginative risk-taking, as I recall, was highly encouraged by the technical staff.

32. Adams, *Examples,* 59.

"What was it like using Polaroid film?" I asked from a more practical standpoint.

"You could easily become a litterbug. There was a lot of stuff to carry around. I kept everything in the back seat of the car. Still, trying to coat the prints in the wind was tough."

"How about the film, what was it like?"

"Type 33 was exquisite, but that was modified to increase the speed. It only lasted three or four years and took a whole minute then to develop. With the ten-second chemistry you didn't get the same quality."

"Could you tell me something about the Polaroid Collection and how that started?"

"Adams had recommended the purchase of prints to the collection. Many of them were conventional prints, mine too. Still, among the ones on Type 55 Positive/Negative there were a lot of blockbusters."

"I noticed in the collection that there were a number of images made in the city or in the townships outside Boston."

"I had deadlines on getting work to them," he said. "Sometimes I made images in the suburbs because I didn't have time to go out in nature."

"What about instant feedback . . . how did the process help you in this regard?"

"Polaroid was very good at telling us how full of shit the Zone System was, how impossible it was to previsualize the image. I could only get what was there in nature, what nature cooperated with. Compose, expose, presuppose." He repeated the rhyme making sure the order was right. "Not that previsualization doesn't make you pay attention."

"Minor believed in that. What was he like?"

"He was gentle, kind, curious . . . adamant when it came to Zen and spirit, the symbolism of 'me'."

"So maybe the image got sidetracked."

"Spirit isn't the result of photography, it's the result of talking too much. Spirit is someone plumb-ing his own depths. He was taking the meaning out of the meaning, creating meaning for its own sake. The image itself didn't have a chance. But the vodka tonics were good."

"If not f/64 and not Minor White, where is the ground you stand on?"

"I could have developed my own systems but it would just have added to the chatter about the matter. The ground to stand on is freedom. To get away from all of it you have to break with the formulas. To become free of yourself you cannot lie to yourself."

"And the treasures come?"

"You think I made my photographs? Freedom from myself made those photographs."

Chronology

Compiled by Mary Louise Hoss and Gillian Nagler. The entries through 1981 are largely based on those compiled by David Herwaldt in *A Photographic Patron: The Carl Siembab Gallery* (Boston: Institute of Contemporary Art, 1981).

1924

Through the initiative of Ananda K. Coomaraswamy, keeper of Indian and Muhammedan art, Alfred Stieglitz gives 27 prints to the Museum of Fine Arts, Boston, "the first group of photographs by one artist to enter an American museum." It is intended that this gift be supplemented by work by other photographers. Although a small number of photographs are acquired, the intention is only realized later.

1930

The Harvard Society of Contemporary Art presents a large group exhibition, *International Photography*. The show includes works by Berenice Abbott and Walker Evans.

1931

Harold Edgerton first publishes research on electrical stroboscopy, developed while a student at the Massachusetts Institute of Technology (MIT).

1933

Harold Edgerton applies for a U.S. patent on the stroboscope. Seeking to interest a wider public in his invention, he begins making high-speed photographs of such subjects as hummingbirds in flight, athletes in action, and speeding bullets.

1934

The Addison Gallery of American Art, Phillips Academy, Andover, Massachusetts, begins a photography acquisition and exhibition program.

1937

Beaumont Newhall organizes a comprehensive exhibition on the history of photography for the Museum of Modern Art. The exhibition travels to the Addison Gallery of American Art.

Gyorgy Kepes emigrates to the United States from Hungary. He heads the Light and Color Workshop at the New Bauhaus in Chicago (later the Institute of Design), directed by László Moholy-Nagy, remaining there until 1943.

1939

Harold Edgerton works with the Army Air Corps, producing stroboscopes to make nighttime aerial reconnaissance photographs. His first book, *Flash! Seeing the Unseen by Ultra High-Speed Photography*, is published.

1946

John Brook establishes a portrait studio on Newbury Street.

Gyorgy Kepes introduces courses in visual design at the School of Architecture and Planning at MIT.

Harry Callahan begins teaching at the Institute of Design, Chicago.

1947

Dr. Edwin H. Land, president of the Polaroid Corporation, announces his invention of the instant-picture process.

Charles Sheeler is appointed artist-in-residence at the Phillips Academy, Andover.

1948

Polaroid sells the first Land Camera. Edwin Land hires Ansel Adams as a consultant to test new films and analyze results.

Early 1950s

Polaroid invites Paul Caponigro, William Clift, and Nicholas Dean to join Ansel Adams in testing its film. Meroë Marston Morse, research manager, becomes the liaison between scientists and artists.

Ansel Adams and Edwin Land initiate a collection of non-Polaroid photographs dating from 1924 to 1955 for reference purposes in studying the results of the new Polaroid photography. The collection includes work by Edward Weston, Aaron Siskind, Minor White, and Eliot Porter.

1951

The Institute of Contemporary Art exhibits Jules Aarons's photographs in the show *Life in Boston*. The DeCordova Museum, which opened in 1950, exhibits *The Photographs of Jules Aarons*.

Irene Shwachman begins a career as a free-lance photographer and consultant in photography for a variety of organizations and publications. She is also included in the exhibition *Abstraction in Photography* at the Museum of Modern Art, New York.

1952

The DeCordova Museum exhibits *New England: A Photographic Interpretation*.

Aperture magazine is founded; Minor White is appointed editor.

1953

Massachusetts College of Art begins offering courses in photography, with an emphasis on technical and aesthetic aspects of camera operation.

1954

Paul Caponigro, while living in San Francisco, meets Minor White.

1955

Phillips Academy institutes a photography requirement in the art curriculum.

Lotte Jacobi moves from New York City to New Hampshire.

Steven Trefonides begins commercial portraiture. His pictures from Europe are exhibited at the Institute of Contemporary Art.

Carl Siembab opens a frame shop and gallery at 161 Newbury Street.

John Brook exhibits photographs at Sidney Kanegis Gallery. Trefonides, learning of Brook's show at Kanegis, persuades Siembab to exhibit Trefonides's pictures of the Hebrew Home for the Aged. This is Siembab's first photography show.

1957

Carl Chiarenza leaves Rochester Institute of Technology with a bachelor's degree to come to Boston University as a graduate student in journalism.

1958

Acting on a longstanding interest in science photography, Berenice Abbott begins making images illustrating the laws of physics. Commuting from New York City over the next three years, she works for the Physical Science Study Committee in a laboratory in Watertown.

Carl Chiarenza, while a graduate student in journalism, organizes the Image Study Gallery at Boston University.

Nicholas Dean, advised by Ansel Adams, organizes the exhibition *West Coast Photography*, the first presentation of photography at the Boston Arts Festival. Dean studies with Adams at his Yosemite Workshop.

1959

Carl Siembab, assisted by Irene Shwachman, begins exhibiting photography regularly, using a room previously rented to Marie Cosindas. Aaron Siskind's photographs are the first shown.

Irene Shwachman meets Carl Chiarenza and Paul Caponigro through the gallery at Boston University; she, in turn, introduces them to Siembab.

Steven Trefonides begins a series of meetings for photographers. The meetings are held in his studio until he goes to India on a Fulbright fellowship, at which time they shift to the Siembab Gallery. They continue for approximately one year.

Paul Caponigro and Minor White travel across the United States together. Caponigro assists White with workshops in Oregon and California.

Paul Caponigro opens an architectural photography business on Newbury Street, across from the Carl Siembab Gallery. Through Carl Chiarenza, he obtains a teaching position at Boston University. He also teaches photography at the Spiral Gallery, a loft space rented out by several

artists from a gift shop. His first two students there are William Clift and Marie Cosindas.

Carl Siembab, on a visit to Rochester with Carl Chiarenza and Paul Caponigro, meets Minor White. Over the years, a strong friendship develops and the Siembab Gallery presents a number of successful Minor White exhibitions.

1960
The first issue of *Contemporary Photographer* is published.

1961
The Rhode Island School of Design (RISD) hires Harry Callahan from the Institute of Design, Chicago, to develop an undergraduate major and master's program in photography. He remains there until his retirement in 1977.

Marie Cosindas studies with Ansel Adams at Yosemite Workshop. She soon begins working with Polaroid material.

1962
The DeCordova Museum presents *Photography, U.S.A.*, a national invitational photography exhibition.

The Worcester Art Museum begins its "sustained exhibition and acquisition program" in photography. Peter Pollack organizes the first show, *Ideas in Images*.

Carl Chiarenza begins to experiment with Polaroid materials, and is asked to serve as a consultant to the company.

1963
Polaroid Polacolor Land Film is first sold.

Six Boston photographers (Paul Caponigro, Carl Chiarenza, William Clift, Marie Cosindas, Nicholas Dean, and Paul Petricone) join with Walter Chappell to form the Association of Heliographers. An exhibition of their work is presented by Lever House, New York. Soon after, they open a cooperative gallery, the Heliographers Gallery Archive, also in New York. The show and the gallery are extremely successful and soon other photographers join the group. Within months, the Boston photographers withdraw because of policy conflicts.

Len Gittleman begins the photography program at Harvard University in the newly opened Carpenter Center.

Lotte Jacobi Place, in Deering, New Hampshire, initiates its exhibition program.

The Carl Siembab Gallery closes.

Project Community Arts Center, an arts and crafts center providing alternatives in children's education, opens in Cambridge. Several years later, Anne Kureen and Steven Gersh, students of Minor White, establish a photography division with White as its director. Early faculty members include Peter Laytin, Lee Parks, and Gus Kayafas. The Center flourishes through the seventies; it closes in 1986.

Marie Cosindas coordinates Minor White's first workshop in Boston.

1964
The Rose Art Museum, Brandeis University, presents the exhibition *The Painter and the Photograph*, organized by Van Deren Coke and staff of the Art Gallery at University of New Mexico.

The Society for Photographic Education is founded.

A group exhibition in honor of Carl and Marie Siembab is installed at the Grover Cronin Store, Waltham.

Carl Siembab serves as curator of the Fine Arts Exhibition and Boston Arts Festival. He installs two photography shows: *An Invitational Exhibition of Photography* (including Ansel Adams, Minor White, Edward Weston, and Dorothea Lange, among others) and *A New England Invitational Exhibition*.

Carl Chiarenza is appointed professor of Art History at Boston University and offers a course on the history of photography. He continues to teach there until 1986.

Marie Cosindas opens a gallery on Martha's Vineyard; it operates during the summers of 1964 and 1965. Through it she meets Harry Callahan and Aaron Siskind.

Harry Callahan becomes a full professor at RISD.

1965

The Museum of Fine Arts exhibits its collection of Stieglitz photographs and publishes *Alfred Stieglitz: Photographer*.

Carl Chiarenza becomes associate editor of *Contemporary Photographer*. He serves as editor from 1966 to 1969.

Walker Evans begins teaching photography at the Yale School of Art and Architecture.

Minor White accepts appointment as visiting professor in the Department of Architecture at MIT. By 1968, the Creative Photography Laboratory program consists of five courses. The Creative Photography Gallery, a permanent exhibition space, is set aside as part of the teaching facilities. It opens with a group show of twenty-two New England photographers entitled *Exhibition One*. White also purchases a home at 203 Park Avenue, Arlington, Massachusetts, and holds his first spring resident workshop.

1966

Berenice Abbott moves from New York City to the coast of Maine.

Clifford Ackley is appointed curatorial assistant in the Department of Prints and Drawings at the Museum of Fine Arts.

Davis Pratt is appointed curator of still photography at the Carpenter Center, Harvard University.

Irene Shwachman takes a position as an instructor of photography at the School of the Worcester Art Museum. She continues to teach there until 1979.

Marie Cosindas has her first exhibition at the Museum of Modern Art, New York.

Carl Siembab Gallery reopens at 133 Newbury Street with a group show of Jules Aarons, John Brook, Harry Callahan, Paul Caponigro, Carl Chiarenza, Warren Hill, Chester Michalik, Paul Petricone, and Minor White.

1967

Clifford Ackley begins an active photography acquisitions program for the Museum of Fine Arts, acquiring a small group of Edward Weston photographs from the Carl Siembab Gallery.

The Museum of Fine Arts exhibits *Marie Cosindas: Polaroid Color Photography*.

The Center for Advanced Visual Studies at MIT is inaugurated with Gyorgy Kepes as its director. It emphasizes collaboration between artists, scientists, and engineers.

Carl Chiarenza becomes the director of the New England region of the Society for Photographic Education, a position he holds until 1973.

Stephen G. Perrin begins publication of the *Boston Review of Photography*; five issues are published.

Davis Pratt and Carl Chiarenza mount the exhibition *The Portrait in Photography, 1848–1966* at the Fogg Art Museum, Harvard University.

The Art Institute of Boston creates a photography department.

1968

The DeCordova Museum presents the second *Photography, U.S.A.* exhibition.

The Andover Gallery opens in Andover, Massachusetts. By the mid-1970s, owner Howard Yezerski is showing photography.

Nicholas Dean starts a photography program at the Portland School of Art, Portland, Maine.

Jonathan Green comes to MIT as professor of photography, staying until 1976.

Minor White organizes *Light*, the first of four biennial exhibitions at MIT. The other shows included *Be-ing without Clothes* (1970), *Octave of Prayer* (1972), and *Celebrations* (1974). White begins to acquire permanent collection for MIT, drawing from *Light*.

1969

Carroll Hartwell of the Minneapolis Institute of Arts organizes an exhibition entitled *Fourteen Photographers from*

the Carl Siembab Gallery. The exhibition travels to the Museum of Fine Arts, Boston.

The School of the Museum of Fine Arts introduces its photography program.

Bernarda B. Shahn, Ben Shahn's widow, donates 4,000 photographs from his estate to the Fogg Art Museum, Harvard University. Davis Pratt and William S. Johnson organize the exhibition *Ben Shahn as Photographer*, displaying seventy-five pictures taken between 1931 and 1968.

Davis Pratt reports that an ad hoc committee at Harvard University, chaired by Alfred H. Barr, Jr., recommends that courses should be "offered in the history of photography within the Department of Fine Arts, that a teaching collection of photographs should be established, and that photographs should be exhibited for both teaching purposes and to serve the community as a whole."

Late 1960s
Polaroid officially begins the Artist Support Program to encourage and assist photographers in the use of Polaroid instant photography and to acquire a collection of original instant images. Polaroid gives photographers film and equipment grants and asks for one image per grant for its collection in return. Additional works are also purchased.

1970
Carl Siembab Gallery moves to 162 Newbury Street.

Minor White begins teaching "Creative Audience" course at MIT.

Berenice Abbott is the subject of a retrospective exhibition at the Museum of Modern Art, New York.

Jerome Liebling joins the faculty of Hampshire College, Amherst, as professor of film and photography.

William S. Johnson begins offering courses in the history of photography at Harvard University.

The People's Gallery in Cambridge opens and offers course in basic photography. In 1972 it changes its name to the Prospect Street Photo Co-op. It provides a darkroom, classes, critiques, film series, and formal gallery space. It eventually changes its name again to the Cambridge Photo Co-op before closing in December 1979.

1971
Aaron Siskind begins teaching photography at RISD, remaining there until 1976.

Bill Burke begins teaching at the Museum School.

Polaroid begins publication of *Close-Up* as a "means of communication between Polaroid Corporation and the owners and users of Polaroid Land industrial equipment."

Eugenia Parry Janis teaches a history of photography course at Wellesley College.

Davis Pratt is appointed associate curator of photographs at the Fogg and begins a series of contemporary photography exhibitions.

Imageworks, a school and center of photography, is organized by a committee including Carl Siembab (in charge of the gallery), Carl Chiarenza, and Warren Hill; it opens in October. Don Perrin provides financial backing. Its workshops and lecture series set a precedent for later lecture series sponsored by the University of Massachusetts, Wellesley College, MIT, and the Photographic Resource Center (PRC).

Joe Wielette and Mimi Zinkler open Zone V, a for-profit rental darkroom. Gus Kayafas, Wielette's photography teacher, is given the upstairs space and a small budget to produce monthly photography exhibitions.

Peter Laytin comes east to work as an apprentice to Minor White.

Tony Decaneas opens Panopticon, a photography lab and gallery space.

1972

The DeCordova Museum exhibits *The New England Experience*, two competitive photography exhibitions juried by Paul Petricone, Carl Siembab, John Brook, and Marie Cosindas.

Polaroid's SX-70 camera and film system are first sold.

The Polaroid Foundation gives the first of four grants to the Museum of Fine Arts, Boston, to fund the acquisition of contemporary photography.

Wellesley College begins instruction in photography.

Harry Otagura edits and publishes *Fox*, a magazine of photography portfolios; three issues are published.

Peter Laytin becomes the Photography Lab manager at MIT; he eventually works his way up to associate professor.

Steven Trefonides organizes *Photovision 72*, an exhibition of work by New England photographers, for the Boston Center for the Arts.

Harvard receives a $10,000 National Endowment for the Arts Grant to acquire 200 photographs by fifty American photographers.

The Project Community Arts Center opens a photography gallery in its building on Huron Avenue, Cambridge. Conceived as a showcase for talented local photographers, it expands its commitment to photographers working in the greater New England area.

The New England School of Photography moves to its current home in Kenmore Square, Boston.

Estelle Jussim teaches a history of photography course at Simmons College.

Barbara Norfleet is appointed curator of photography at the Carpenter Center for the Visual Arts, Harvard University.

1973

The Institute of Contemporary Art presents the exhibition *Points of View: Recent Work by Twenty-five Area Photographers*.

The Worcester Art Museum presents an exhibition of the work of Diane Arbus, organized by the Museum of Modern Art.

In April the Polaroid Corporation's Clarence Kennedy Gallery opens on Main Street in Cambridge with the exhibition *SX-70 Photographs by Polaroid Employees*. The gallery provides a space for the display of continuing exhibitions of work from the two Polaroid collections, as well as invitational exhibitions and historical shows.

Jim Dow begins teaching at the Museum School.

Jim Stone begins the photography program at Boston College.

Boston University's School of Fine Arts begins offering photography courses.

Carl Chiarenza finishes his dissertation on Aaron Siskind at Harvard. He is appointed associate professor of art history at Boston University.

Nan Goldin attends classes at Imageworks, Cambridge, and has her first solo exhibition at Project Community Arts Center, Cambridge.

1974

Clifford Ackley curates *Private Realities*, an exhibition at the Museum of Fine Arts that focuses on photographers whose work is "primarily concerned with the recording of subjective states of feelings."

The University of Massachusetts, Boston, offers courses in photography.

Nicholas Nixon moves to Boston and begins a series on topographical landscapes of Boston.

Minor White retires from the MIT faculty but continues to teach the "Creative Audience" course.

1975

The Massachusetts Arts and Humanities Foundation awards the first Artists Fellowships in photography.

Chris Enos, Jeff Weiss, and A. D. Coleman found the Photographic Resource Center. Enos's apartment serves as

The Institute of Contemporary Art presents the exhibition *New Contacts: Photographs by Nicholas Nixon*, along with a series of talks connected to the exhibition.

The Museum of Fine Arts presents the exhibition *Henri Cartier-Bresson: Photographer*.

Sponsored by the PRC, the Boston University Art Gallery presents *New Works by Ten Massachusetts Photographers,* with work by Roswell Angier, Karl Baden, William M. Burke, Steven Halpern, Christopher James, Olivia Parker, Daniel Ranalli, Eugene Richards, Sage Sohier, and Jane Tuckerman.

The PRC publishes an expanded version of *The Photography Guide: Schools & Galleries in Massachusetts,* containing "comprehensive listings of schools and galleries involved with photography in the state."

The Polaroid Collection begins circulating exhibitions from its collections to international museums and galleries.

Lee Gallery opens in Boston.

Sage Sohier is appointed instructor at the Massachusetts College of Art.

Eugene Richards moves to New York.

Karl Baden becomes the director of Project Community Arts Center, serving until 1985.

The Boston Photo-Documentary Project, through the Artists Foundation and funding from the National Endowment for the Arts, documents the Leather District and the Fort Point Channel neighborhoods. A book and exhibition result.

1983
MIT's Creative Photography Laboratory closes.

Carl Siembab Gallery closes.

The Art Institute of Boston and the PRC present *A New England Symposium on Photography*, including speakers Judith Black, Fred Bodin, Ken Brown, Roger Bruce, Sharon Fox, Jonathan Goell, Steve Grohe, Bill Ravanesi, James Sheldon, Brent Sikkema, Sage Sohier, Craig Stevens, Jim Stone, and Jane Tuckerman.

The ICA's annual exhibit *Boston Now* showcases four photographers: Chris Enos, Barbara Norfleet, Elsa Dorfman, and Betsy Connors.

Judith Black takes a position at Brandeis University as a scientific photographer; she stays through 1991.

Chris Enos leaves Boston to take a position as visiting lecturer in photography at UCLA.

The Polaroid Corporation begins publishing the *Polaroid Newsletter for Photographic Education*, which features technical and new product information, book reviews, and exhibition schedules and offers suggestions on the use of Polaroid materials in the classroom.

Between 1983 and 1987, Polaroid circulates *Encounters*, an exhibition of 40 photographs by Bill Burke.

1984
The Rose Art Museum, Brandeis University, exhibits its collection of twentieth-century photography for the first time. New England photographers in the collection include Roswell Angier, Judith Black, Karl Baden, Olivia Parker, and Daniel Ranalli.

Robert Klein opens a gallery on Boylston Street, exhibiting both American and European historical and contemporary work. The gallery moves to South Street in 1987, then back to Newbury Street in 1993.

Gyorgy Kepes photographs with the Polaroid 20 x 24 camera for the first time.

The Cambridge Arts Council sponsors the exhibition *Massachusetts Photographers 1984*, curated by Roswell Angier, at the Federal Reserve Bank, Boston.

1985
The Institute of Contemporary Art presents the exhibition *Boston Now: Photography*.

Under director Stan Trecker, the PRC moves to renovated facilities on the Boston University campus and initiates continuing exhibitions program.

Nan Goldin has a solo exhibition at the Institute of Contemporary Art.

Exhibition Checklist

All dimensions are in inches; height precedes width. All works are lent by the artist, unless otherwise noted. Works marked with an asterisk are reproduced in the catalogue.

Jules Aarons, born 1921

The Boston and Maine Station, late 1950s
silver gelatin print
13 $^1/_4$ x 16 $^3/_4$

Indian Boy, Quito, Ecuador, 1967
silver gelatin print
10 $^1/_2$ x 13 $^1/_2$

St. Spiritos Procession, Corfu, Greece, 1971
silver gelatin print
10 $^1/_2$ x 13

Two Portuguese Men at a Wedding, 1964
silver gelatin print
10 x 13

Berenice Abbott, born 1898, died 1991

Beams of Light through Glass, 1958–1961
silver gelatin print (printed 1982)
15 $^3/_8$ x 19 $^3/_8$
Courtesy Mt. Holyoke College Art Museum, Gift of Joseph R. Lasser and Ruth Lasser (Ruth H. Pollak, Class of 1947)

Collision of Two Balls, 1958–1961
silver gelatin print (printed 1982)
18 $^5/_8$ x 15 $^7/_{16}$
Courtesy Mt. Holyoke College Art Museum, Gift of Joseph R. Lasser and Ruth Lasser (Ruth H. Pollak, Class of 1947)

Interference of Waves, 1958–1961
silver gelatin print
7 x 8 $^1/_4$
Courtesy List Visual Arts Center, Massachusetts Institute of Technology

Magnetic Field, 1958–1961
silver gelatin print (printed 1982)
19 $^1/_2$ x 15 $^1/_8$
Courtesy Mt. Holyoke College Art Museum, Gift of Joseph R. Lasser and Ruth Lasser (Ruth H. Pollak, Class of 1947)

David Akiba, born 1940

Face #5, 1979
from the *Faces* series
silver gelatin print
15 $^1/_2$ x 15 $^1/_2$

Face #8, 1979
from the *Faces* series
silver gelatin print
15 $^1/_2$ x 15 $^1/_2$

Man Walking, 1978
silver gelatin print
15 $^1/_2$ x 15 $^1/_2$

Woman by the River, 1979
silver gelatin print
15 $^1/_2$ x 15 $^1/_2$

Roswell Angier, born 1940

Downtown Gallup, 1979
silver gelatin print
11 x 14

Inter-Tribal Ceremonial, Gallup, New Mexico, 1980
silver gelatin print
11 x 14

Route 66, Gallup, New Mexico, 1979
silver gelatin print
11 x 14

David Armstrong, born 1953

George in the water, Provincetown, 1977
silver gelatin print
24 x 20
Lent by the Artist; Courtesy Matthew Marks Gallery, New York

Mark at Otis St., Cambridge, 1977
silver gelatin print
20 x 24
Lent by the Artist; Courtesy Matthew Marks Gallery, New York

Suzanne at Elizabeth St., NYC, 1978
silver gelatin print
24 x 20
Lent by the Artist; Courtesy Matthew Marks Gallery,
New York

Karl Baden, born 1952
Self-Image, 1979
silver gelatin print
16 x 20

Self-Image, 1979
silver gelatin print
16 x 20

Some Significant Self-Portraits
artist's book
Cambridge: Badger Press, 1981

**Untitled*, 1984
silver gelatin print
16 x 20

Untitled, 1983
silver gelatin print with select selenium toning
16 x 20

Jerry Berndt, born 1943
Homeless Woman, Hartford, Connecticut, 1983–1985
from the *Missing Persons: The Homeless* series
silver gelatin print
11 $^1/_2$ x 14 $^1/_2$

**Long Island Shelter, Boston*, 1983–1985
from the *Missing Persons: The Homeless* series
silver gelatin print
11 $^1/_2$ x 14 $^1/_2$

Long Island Shelter, Boston, 1983–1985
from the *Missing Persons: The Homeless* series
silver gelatin print
11 $^1/_2$ x 14 $^1/_2$

Long Island Shelter, Boston, 1983–1985
from the *Missing Persons: The Homeless* series
silver gelatin print
11 $^1/_2$ x 14 $^1/_2$

Judith Black, born 1945
*Dylan, Erik, Laura, Johanna (Before Vacation with Their
Father), July 21, 1985*
silver gelatin print from Polaroid negative
20 x 16

**Erik and Dylan (Mother's Day), May 8, 1983*
silver gelatin print from Polaroid negative
16 x 20

Laura and Self (First Day of School), September 8, 1980
silver gelatin print from Polaroid negative
20 x 16

John Brook, born 1924
A Long the Riverrun
artist's book
San Francisco: Scrimshaw Press, 1970
Courtesy Boston Public Library, Print Department

Untitled, 1972
silver gelatin print
9 $^3/_4$ diameter
Courtesy Boston Public Library, Print Department

Untitled, 1962
silver gelatin print
14 x 11
Courtesy Boston Public Library, Print Department

**Untitled*, early 1960s
silver gelatin print
11 x 14
Courtesy Boston Public Library, Print Department

Untitled, n.d.
silver gelatin print
13 $^1/_4$ x 5 $^3/_4$
Courtesy Boston Public Library, Print Department

Bill Burke, born 1943
Coalmining Brothers, Hopkins County, Kentucky, 1977
silver gelatin print from Polaroid negative
16 x 20

Fiddlin Bill Livers, Owen County, Kentucky, 1975
silver gelatin print from Polaroid negative
16 x 20

Khmer Rouge Land Mine Victims, 1984
silver gelatin print from Polaroid negative
16 x 20

O Sralao, Thai-Cambodia Border, 1984
silver gelatin print from Polaroid negative
16 x 20

Harry Callahan, born 1912, died 1999
Cape Cod, 1972
silver gelatin print
9 $^{15}/_{16}$ x 9 $^{1}/_{2}$
Courtesy Worcester Art Museum, Worcester, Massachusetts,
Austin S. Garver Fund

Cape Cod, 1972
silver gelatin print
9 $^{7}/_{16}$ x 9 $^{11}/_{16}$
Courtesy Worcester Art Museum, Worcester, Massachusetts,
Austin S. Garver Fund

Horseneck Beach, c. 1965
silver gelatin print
35 $^{1}/_{2}$ x 45 $^{3}/_{4}$
Collection of DeCordova Museum and Sculpture Park,
Gift of Arlette and Gus Kayafas 1994.27

Providence, 1977
dye transfer print
9 x 13 $^{1}/_{2}$
Courtesy LIGHT Gallery, New York

Providence, 1971
dye transfer print
7 $^{3}/_{8}$ x 7 $^{3}/_{16}$
Courtesy LIGHT Gallery, New York

Providence, 1962
dye transfer print
6 x 9
Courtesy LIGHT Gallery, New York

Paul Caponigro, born 1932
Branches, 1966
silver gelatin print from Polaroid negative
6 $^{1}/_{8}$ x 7 $^{7}/_{8}$
Courtesy The Polaroid Collections

Branches in Ice, Wingdale, New York, c. 1962
silver gelatin print from Polaroid negative
9 $^{1}/_{2}$ x 7 $^{5}/_{8}$
Courtesy The Polaroid Collections

Fungus, Ipswich, Massachusetts, 1962
silver gelatin print from Polaroid negative
7 $^{3}/_{8}$ x 9
Courtesy The Polaroid Collections

New York City, 1962
silver gelatin print from Polaroid negative
7 $^{1}/_{2}$ x 8
Courtesy The Polaroid Collections

West Hartford, Connecticut, 1959
silver gelatin print
7 $^{1}/_{2}$ x 9 $^{3}/_{8}$
Courtesy The Polaroid Collections

Carl Chiarenza, born 1935
Accabonac (NY) I, 1979
silver gelatin print
13 x 17 $^{1}/_{4}$
Collection of DeCordova Museum and Sculpture Park,
NEA Museum Purchase Plan 1980.67

Menotomy 322, 1983
silver gelatin print
17 $^{1}/_{2}$ x 13 $^{1}/_{2}$
Courtesy Worcester Art Museum, Worcester, Massachusetts,
Gift of Mr. and Mrs. Hall James Peterson

Sulfite Moonscape, 1962
silver gelatin print
7 $^{11}/_{16}$ x 9 $^{5}/_{8}$
Collection of Jude Peterson

Untitled (AX63), 1964
silver gelatin print
11 x 14
Collection of Jude Peterson

William Clift, born 1944
Barbara's Table, Boston, Massachusetts, 1956
platinum print (made from copy negative taken of
Polaroid original)
2 $^{13}/_{16}$ x 2 $^{1}/_{8}$

**Kings Chapel Burial Ground, Boston*, 1970
silver gelatin print from Polaroid negative
5 x 6 $^{1}/_{4}$

North Pawnal Valley, Vermont, 1968
silver gelatin print
2 $^{1}/_{2}$ x 5 $^{1}/_{4}$

Rocks, Kelp, Bald Head Cliff, Ogunquit, Maine, 1964
silver gelatin print
5 x 6

Marie Cosindas, born 1925
Asparagus Still Life I, 1967
Polaroid Polacolor print
4 x 5

Asparagus Still Life II, 1967
Polaroid Polacolor print
4 x 5

Bruce Pecheur, 1965
dye transfer print
5 x 7

**Ellen*, 1965
dye transfer print
7 x 5

Nicholas Dean, born 1933
**Ice, Route 128*, 1963
silver gelatin print from Polaroid negative
9 $^{3}/_{4}$ x 12 $^{1}/_{2}$
Courtesy The Polaroid Collections

Quarry, Water, Wingdale, 1963
silver gelatin print from Polaroid negative
7 $^{5}/_{8}$ x 9 $^{3}/_{8}$
Courtesy The Polaroid Collections

Skunk Cabbage, 1963
silver gelatin print from Polaroid negative
9 $^{1}/_{2}$ x 7 $^{3}/_{4}$
Courtesy The Polaroid Collections

Snowbed and Sun, Bedford, 1962
silver gelatin print from Polaroid negative
10 $^{1}/_{2}$ x 14 $^{1}/_{2}$
Courtesy The Polaroid Collections

Elsa Dorfman, born 1937
**Allen Ginsberg, Cambridge, Mass., February 7, 1980*
Polaroid Polacolor print
24 x 20
Lent by Harvey A. Silverglate

Allen Ginsberg, Woodstock Weekend, August 18, 1969
silver gelatin print
16 x 20
Lent by Isaac Dorfman Silverglate

Elaine Roundtree on Route 99, 1970
silver gelatin print
11 x 14
Lent by Isaac Dorfman Silverglate

Morris Litsky at the G&G, 1969
silver gelatin print
14 $^{1}/_{2}$ x 17 $^{1}/_{2}$
Lent by Isaac Dorfman Silverglate

**Myself, the Beginning of the Year, March 3, 1973*
silver gelatin print
16 x 20
Lent by Isaac Dorfman Silverglate

Jim Dow, born 1942
**Bar Detail, North Dakota*, 1981
C print
8 x 10

Cactus in Henry French's Backyard, Cashel, North Dakota,
1981
C print
10 x 8

Lunch Counter at Railroad Station, Pueblo, Colorado, 1981
C print
8 x 10

Upstairs Bar, Tootsie's Orchid Lounge, Nashville, Tennessee,
1977
C print
8 x 10

Whitelock's Pub, Leeds, North Yorkshire, U.K., 1983
C print
8 x 10

Zummo's Supermarket, U.S. 61, Metairie, Louisiana, 1979
C print
8 x 10

Harold Edgerton, born 1903, died 1990
Back Dive—Multiflash, 1954
silver gelatin print
14 x 11
Collection of DeCordova Museum and Sculpture Park,
Gift of Daniel and Janet Tassel 1985.63

Baton, 1953
silver gelatin print
11 x 14
Collection of DeCordova Museum and Sculpture Park,
Gift of Daniel and Janet Tassel 1985.57

**Bullet through Balloons*, 1959
silver gelatin print
16 x 20
Collection of DeCordova Museum and Sculpture Park,
Gift of Daniel and Janet Tassel 1985.19

**Milk Drop Coronet on Red Tin*, 1957
dye transfer print
20 x 16
Collection of DeCordova Museum and Sculpture Park,
Gift of Daniel and Janet Tassel 1985.89

Moving Skip Rope—Multiflash, 1952
silver gelatin print
11 x 14
Collection of DeCordova Museum and Sculpture Park,
Gift of Daniel and Janet Tassel 1985.79

Chris Enos, born 1944
**Untitled*, 1980
from the *Flower* series
Polaroid Polacolor print
24 x 20

Untitled, 1979
from the *Flower* series
Polaroid Polacolor print
24 x 20

Untitled, 1979
from the *Gar·baf* series
Polaroid SX-70 print
3 $^{1}/_{4}$ x 3 $^{1}/_{4}$

Untitled, 1979
from the *Gar·baf* series
Polaroid SX-70 print
3 $^{1}/_{4}$ x 3 $^{1}/_{4}$

**Untitled*, 1974
from the *Nude* series
silver gelatin print
7 $^{1}/_{8}$ x 10 $^{5}/_{8}$

Untitled, 1974
from the *Nude* series
silver gelatin print
7 $^{1}/_{8}$ x 10 $^{5}/_{8}$

Len Gittleman, born 1932
Untitled, 1980
color photogram
9 $^{1}/_{2}$ x 7 $^{1}/_{2}$

**Untitled*, c. 1980
color photogram
9 $^{1}/_{2}$ x 7 $^{1}/_{2}$

Untitled, c. 1980
color photogram
9 ¹/₂ x 7 ¹/₂

Untitled, c. 1980
color photogram
9 ¹/₂ x 7 ¹/₂

Nan Goldin, born 1953
Bruce bleaching his eyebrows, Pleasant St., Cambridge,
1975
cibachrome print
40 x 30
Lent by the Artist; Courtesy Matthew Marks Gallery,
New York

**Nan as a dominatrix, Boston*, 1978
cibachrome print
40 x 30
Lent by the Artist; Courtesy Matthew Marks Gallery,
New York

Ryan in the tub, Provincetown, 1976
cibachrome print
20 x 16
Lent by the Artist; Courtesy Matthew Marks Gallery,
New York

Henry Horenstein, born 1947
Groom Applying Bandages, Saratoga Race Course, 1985
from the book *Racing Days*
silver gelatin print
16 x 20

**Jockey's Excuse, Keeneland*, 1985
from the book *Racing Days*
silver gelatin print
16 x 20

Steam Room, Fair Grounds, 1977
from the book *Racing Days*
silver gelatin print
16 x 20

Top of the Stretch, Suffolk Downs, 1986
from the book *Racing Days*
silver gelatin print
16 x 20

Lotte Jacobi, born 1898, died 1986
**Berenice Abbott, New York City,* c. 1943
silver gelatin print (posthumous print from original
negative)
9 ¹/₄ x 6 ³/₄
Courtesy The Art Gallery, University of New Hampshire,
and the Lotte Jacobi Archive, Dimond Library, University
of New Hampshire

**Minor White, Deering, N.H.,* c. 1962
silver gelatin print (posthumous print from original
negative)
7 ¹/₈ x 5 ¹/₄
Courtesy The Art Gallery, University of New Hampshire,
and the Lotte Jacobi Archive, Dimond Library, University
of New Hampshire

**Paul Caponigro, Deering, N.H.,* c. 1965
silver gelatin print (posthumous print from original
negative)
5 ¹/₄ x 7 ¹/₈
Courtesy The Art Gallery, University of New Hampshire,
and the Lotte Jacobi Archive, Dimond Library, University
of New Hampshire

Lou Jones, born 1945
**Dudley Station*, 1973–1974
C print
20 x 16

Labor, Port-au-Prince, Haiti, May 1977
silver gelatin print
16 x 20

Watermelon Vendor, Acapulco, Mexico, August 1983
C print
16 x 20

Gyorgy Kepes, born 1906

Free Form, 1956
photogram
20 x 16
Courtesy Worcester Art Museum, Worcester, Massachusetts,
Eliza S. Paine Fund

Luminous Spots, 1977
photogram
20 x 16
Courtesy Alpha Gallery, Boston

Photo-Drawing #4, 1957
photogram
10 x 7 $^7/_8$
Courtesy Alpha Gallery, Boston

Untitled, 1978
photogram
19 $^7/_8$ x 16
Courtesy Alpha Gallery, Boston

Untitled, 1957
photogram
15 $^1/_2$ x 11 $^5/_8$
Courtesy Alpha Gallery, Boston

Rodger Kingston, born 1941

Marilyn—Seven Year Itch, Boston, MA, 1983
from the *Marilyn Monroe* series
cibachrome print
29 $^3/_4$ x 38 $^7/_8$
Collection of DeCordova Museum and Sculpture Park,
Gift of Arlette and Gus Kayafas 1994.38

Me and Gene, Cambridge, MA, 1983
from the *American Icons* portfolio
cibachrome print
15 $^3/_8$ x 19 $^3/_8$
Collection of DeCordova Museum and Sculpture Park,
Gift of Arlette and Gus Kayafas 1993.94

Three Penny Opera, Wilmington, DE, 1976
from the *American Icons* portfolio
cibachrome print
17 $^1/_4$ x 15 $^1/_8$
Collection of DeCordova Museum and Sculpture Park,
Gift of Arlette and Gus Kayafas 1993.93

Peter Laytin, born 1949

Cemetery, Manchester, Massachusetts, 1975
silver gelatin print
14 x 11

Entrance to Bath, Kallithea Spa, Rhodes, Greece, 1985
silver gelatin print
11 x 14

Formal Gardens #1, 1978
silver gelatin print
11 x 14

Kallithea Spa, Rhodes, Greece, 1985
silver gelatin print
11 x 14

Jerome Liebling, born 1924

Ed Libman, Handball Player, Miami Beach, Florida, 1977
silver gelatin print
20 x 16

South Bronx, New York City, 1977
silver gelatin print
20 x 16

South Bronx, Charlotte Street, 1977
silver gelatin print
16 x 20

Woman Holding Child, Malaga, Spain, 1966
silver gelatin print
16 x 20

Wendy Snyder MacNeil, born 1943

Adrian Sesto, 1977–1988
platinum and palladium print on vellum
24 x 20

Ezra Sesto, 1977–1988
platinum and palladium print on vellum
24 x 20

Arno Rafael Minkkinen, born 1945

Self-Portrait, Abbayé de Montmajour, Arles, 1983
silver gelatin print
20 x 24

Self-Portrait, Helsinki, Finland, 1976
silver gelatin print from Polaroid negative
16 x 20

Self-Portrait, Narragansett, Rhode Island, 1973
silver gelatin print
20 x 24

Self-Portrait with Daniel, First Noël, Andover, 1979
silver gelatin print
16 x 20

Nicholas Nixon, born 1947
Boston Common, 1978
silver gelatin print
8 x 10

The Brown Sisters, 1985
silver gelatin print
8 x 10

The Brown Sisters, 1975
silver gelatin print
8 x 10

View of Boston from Commercial Wharf, 1978
silver gelatin print
8 x 10

Barbara Norfleet, born 1926
Benefit for the Mt. Vernon Ladies' Association of the Union, Copley Plaza, Boston, MA, 1983
silver gelatin print
16 x 20
Lent by the artist; Courtesy Robert Klein Gallery, Boston

Flying Horse Farm: Hamilton, MA, 1981
silver gelatin print
16 x 20
Lent by the artist; Courtesy Robert Klein Gallery, Boston

Private House: New Providence Island, the Bahamas, 1982
silver gelatin print
16 x 20
Lent by the artist; Courtesy Robert Klein Gallery, Boston

Private House: Sumner, Mississippi, 1984
silver gelatin print
16 x 20
Lent by the artist; Courtesy Robert Klein Gallery, Boston

Starr Ockenga, born 1938
Untitled, 1984
Polaroid Polacolor print
24 x 20

Untitled, 1983
Polaroid Polacolor print
24 x 20

John O'Reilly, born 1930
Guitar Elegy, 1984
silver gelatin print with sepia half-tone montage
$6\,^5/_8$ x $2\,^7/_8$

Victorian Self-Portrait, 1978
silver gelatin print with sepia half-tone montage
$7\,^7/_8$ x $5\,^{15}/_{16}$
Collection of John Pijewski

With My Mother, 1979
silver gelatin print with sepia half-tone montage
$8\,^1/_2$ x $6\,^3/_{16}$
Collection of Arlette and Gus Kayafas

With Olympia, 1984
Polaroid 667 and sepia half-tone montage
$4\,^3/_8$ x $3\,^9/_{16}$

With Whitman, 1981
silver gelatin print with sepia half-tone montage
$4\,^7/_8$ x $5\,^1/_2$

Olivia Parker, born 1941
Cinemechanics, 1984
silver gelatin print
$10\,^1/_2$ x $13\,^1/_2$
Collection of DeCordova Museum and Sculpture Park, Gift of Arlette and Gus Kayafas 1993.9

Cinquefoil, 1975
selenium-toned silver contact print
5 x 4

Miss Appleton's Shoes II, 1976
selenium-toned silver contact print
5 x 4

Under the Lilacs (The Leopard's Garden), 1980
Polaroid Polacolor print
24 x 20
Courtesy The Polaroid Collections

Weighing the Planets, 1984
split-toned silver gelatin print
10 $^1/_2$ x 13 $^1/_2$
Collection of DeCordova Museum and Sculpture Park,
Gift of Arlette and Gus Kayafas 1993.8

Paul Petricone, born 1922, died 1988
Untitled, 1964
silver gelatin print
9 x 7 $^1/_4$
Courtesy Fogg Art Museum, Harvard University Art
Museums, National Endowment for the Arts Grant;
P1972.233

Untitled, 1964
silver gelatin print
7 $^1/_4$ x 5 $^1/_2$
Courtesy Fogg Art Museum, Harvard University Art
Museums, National Endowment for the Arts Grant;
P1972.232

Rosamond Purcell, born 1942
Frank, 1974
silver gelatin print from sandwiched Polaroid negatives
7 x 9

Garden, 1974
silver gelatin print from sandwiched Polaroid negatives
5 $^3/_4$ x 7 $^1/_2$

Malmaison I, 1983
Polaroid Polacolor print
24 x 20
Collection of DeCordova Museum and Sculpture Park,
Gift of the Artist 1999.43

Man Behind the House, late 1970s
silver gelatin print from sandwiched Polaroid negatives
5 $^1/_2$ x 7 $^3/_4$

Mermaid #1, 1970
type 107 Polaroid print
3 $^1/_4$ x 4
Courtesy The Polaroid Collections

Self-Portrait, early 1980s
Type 58 negative transferred onto paper
3 $^3/_4$ x 4 $^3/_4$

The Thinnest Layer, 1979
Polaroid Type 58 print of unfixed Type 52 print
4 $^1/_2$ x 3 $^1/_2$

Daniel Ranalli, born 1946
Bird Fetish #1, 1983
photogram
20 x 16
Lent by the Artist; Courtesy Robert Klein Gallery, Boston

Curved Division #2, 1980
photogram
16 x 20
Lent by the Artist; Courtesy Robert Klein Gallery, Boston

Hanging Lines #2, 1984
photogram
20 x 16
Lent by the Artist; Courtesy Robert Klein Gallery, Boston

Neal Rantoul, born 1946
Boston, 1980
toned silver gelatin print
14 $^1/_2$ x 15

Ipswich, Mass., 1979
toned silver gelatin print
14 $^1/_2$ x 15

Nantucket Sound, 1979
toned silver gelatin print
14 $^1/_2$ x 15

Hakim Raquib, born 1946
Kids from Westminster Place, 1970
silver gelatin print
16 x 20

**Zeigler Street*, 1970
silver gelatin print
15 x 19

Bill Ravanesi, born 1947
**Brothers*, 1982
C print
16 x 20

Coca-Cola, 1982
C print
16 x 20

Coca-Cola, 1980
C print
16 x 20

Untitled, 1982
C print
16 x 20

Eugene Richards, born 1944
First Communion, Dorchester, 1976
silver gelatin print
20 x 24

**Grandy, Lima State Hospital for the Criminally Insane*,
1981
from the *New Works* portfolio
silver gelatin print
8 x 12
Collection of DeCordova Museum and Sculpture Park, Gift
of the Photographic Resource Center, with partial funding
by the Massachusetts Council on the Arts and Humanities
1982.52

Sharecropper, Arkansas, 1971
silver gelatin print
30 x 40

South Boston, 1974
silver gelatin print
20 x 24

Rudolph Robinson, born 1939, died 1987
For Sale, 1983
sepia-toned silver gelatin print
21 x 26 $\frac{1}{4}$
Courtesy The Museum of the National Center of
Afro-American Artists

**Ome*, 1983
sepia-toned silver gelatin print
22 x 25
Courtesy The Museum of the National Center of
Afro-American Artists

Sheron Rupp, born 1943
Billy, Ironton, Ohio, 1985
C print
20 x 24

Millersburg, Ohio, 1984
C print
20 x 24

**New Straitsville, Ohio, 1983*
C print
20 x 24

Dana Salvo, born 1952
**Untitled*, c. 1982–1985
from the *Urban Ruins* series
C print
20 x 16

Untitled, c. 1982–1985
from the *Urban Ruins* series
C print
16 x 20

Untitled, c. 1982–1985
from the *Urban Ruins* series
C print
16 x 20

Melissa Shook, born 1939

May 25, 1980 (left)

June 16, 1980 (right)

diptych; silver gelatin prints

7 x 7 each

October 1982 (left)

January/February 1983 (right)

diptych; silver gelatin prints

7 x 7 each

October 12, 1979 (left)

November 1979 (right)

diptych; silver gelatin prints

7 x 7 each

September 1979 (left)

September 24, 1979 (right)

diptych; silver gelatin prints

7 x 7 each

Irene Shwachman, born 1915, died 1988

Richman Bros., Washington St., November 10, 1961

silver gelatin print

10 $^{15}/_{16}$ x 13 $^3/_4$

Courtesy Boston Public Library, Print Department

Washington St., near Dover, from a Moving Elevated Train,
October 25, 1966

silver gelatin print

13 $^3/_4$ x 10 $^5/_{16}$

Courtesy Boston Public Library, Print Department

Williams Bookstore, Providence St., March 31, 1963

silver gelatin print

10 $^3/_4$ x 10 $^5/_{16}$

Courtesy Boston Public Library, Print Department

Vaughn Sills, born 1946

I Imagined That I Would Be Beautiful . . . , 1984

silver gelatin print with selective toning

16 x 20

Pray for Peace, 1983

toned silver gelatin print

16 x 20

Untitled, 1982–1983

silver gelatin print with selective toning

20 x 16

Untitled (Mother and Self), 1984–1986

silver gelatin print with selective toning

16 x 20

Aaron Siskind, born 1903, died 1991

Bahia, 1984

cibachrome print

36 x 36

Collection of DeCordova Museum and Sculpture Park,

Gift of Pete and Constance Kayafas 1996.94

Lima 89 (Homage to Franz Kline), 1975

silver gelatin print

14 x 14

Collection of DeCordova Museum and Sculpture Park,

Gift of Thomas and Margaret Beling 1989.14

MV 7, 1974

silver gelatin print

10 x 9 $^3/_4$

Collection of DeCordova Museum and Sculpture Park,

Gift of Rodney and Betty Plimpton 1990.7

Providence 15, 1975

silver gelatin print

9 $^3/_4$ x 9 $^7/_8$

Collection of DeCordova Museum and Sculpture Park,

Gift of Rodney and Betty Plimpton 1990.8

Volcano 114, 1980

silver gelatin print

14 x 14

Collection of DeCordova Museum and Sculpture Park,

Gift of Thomas and Margaret Beling 1989.25

Sage Sohier, born 1954

Boston, Massachusetts, 1980
silver gelatin print
14 x 17

Buckhannon, West Virginia, 1982
silver gelatin print
14 x 17

Framingham, Massachusetts, 1981
silver gelatin print
14 x 17

**South Boston*, 1982
silver gelatin print
14 x 17

Sandra Stark, born 1957

**Night Is the Color of a Woman's Arm,* 1981
from the *Light Events* series
C print
16 x 20

Untitled, 1982
from the *Light Events* series
C print
20 x 16

Untitled, 1981
from the *Light Events* series
C print
20 x 16

Jim Stone, born 1947

Ada MacGregor and Her Squash: Lacrosse, Wisconsin, 1984
silver gelatin print from Polaroid negative
20 x 24

Heidi Guarding the Beauty Rings: Old Town, Florida, 1984
silver gelatin print from Polaroid negative
20 x 24

**950 Hats, Don's Bar: Memphis, Nebraska*, 1983
silver gelatin print from Polaroid negative
20 x 24

Retired Upholsterer Who Covered His House with Beer Cans, on His 71st Birthday: Houston, Texas, 1983
silver gelatin print from Polaroid negative
20 x 24

Shellburne Thurber, born 1949

Barry, 1983
silver gelatin print from Polaroid negative
24 x 20
Lent by the Artist; Courtesy Elias Fine Art

Doorway with Two Dogs, 1976
silver gelatin print
20 x 20
Lent by the Artist; Courtesy Elias Fine Art

**Grandfather's Bed*, 1976
silver gelatin print
20 x 20
Lent by the Artist; Courtesy Elias Fine Art

Mary, 1983
silver gelatin print from Polaroid negative
24 x 20
Lent by the Artist; Courtesy Elias Fine Art

Willard Traub, born 1942

Chenonceau, 1985
C print
15 x 15

**Quai de Bercy 1*, 1983
C print
15 x 15

Quai de Bercy 3, 1983
C print
15 x 15

Steven Trefonides, born 1926

Bunker Hill, 1974
silver gelatin print
8 $^3/_4$ x 13 $^3/_8$
Courtesy Boston Public Library, Print Department

Gas Station, Columbus Avenue, 1973
silver gelatin print
9 x 13 ³/₄
Courtesy Boston Public Library, Print Department

**Washington Street*, 1974
silver gelatin print
9 ¹/₂ x 13 ³/₄
Courtesy Boston Public Library, Print Department

Jane Tuckerman, born 1947
Untitled, Benares, India, 1985
silver gelatin print
20 x 24

**Untitled, Benares, India (Morning Bathing)*, 1985
silver gelatin print
20 x 24

Bradford Washburn, born 1910
**McKinley's Great Shadow Stretches Eastward for Nearly a
Hundred Miles across a Sea of Icy Clouds—Seen from a
Flight Altitude of 24,000 ft.—30 Degrees below Zero—
Twenty Minutes before Sunset, October 3, 1964*
silver gelatin print
20 x 24
Collection of DeCordova Museum and Sculpture Park, Gift
of Pete and Constance Kayafas 1988.37

*Mt. Foraker (Left), Mt. Crosson (Left of Center), and
Kahiltna Peaks (Center in the Clouds) and Peak 15840
(Foreground) on the South Buttress of Mt. McKinley, July
16, 1977*
silver gelatin print
14 x 18
Collection of DeCordova Museum and Sculpture Park, Gift
of Arlette and Gus Kayafas 1990.23

William Wegman, born 1943
**Chow*, 1980
diptych; Polaroid Polacolor prints
24 x 20 each
Courtesy The Polaroid Collections

Minor White, born 1908, died 1976
Bush, Wood, and Sand, Eel Creek Dunes, Oregon, 1966
silver gelatin print
6 ¹³/₁₆ x 9 ¹/₂
Courtesy Worcester Art Museum, Worcester, Massachusetts

Dock in Snow, Vermont, 1971
silver gelatin print
12 ¹/₈ x 8 ⁹/₁₀
Anonymous Loan in memory of Davis Pratt, Fogg Art
Museum, Harvard University Art Museums; 56.1994

**Essence of Boat*, 1967
silver gelatin print
16 ⁷/₈ x 13 ³/₄
Collection of Jude Peterson

Untitled, 1967
silver gelatin print
8 ¹⁵/₁₆ x 11 ¹/₁₆
Courtesy Worcester Art Museum, Worcester, Massachusetts

Vicinity of Naples, New York, 1955
silver gelatin print
9 ⁷/₈ x 13
Collection of Jude Peterson

**Windowsill Daydreaming*, 1958
silver gelatin print
11 ³/₄ x 9
Collection of Jude Peterson

Selected Bibliography

Monographs, Artist's Books, and Solo Exhibition Catalogues

Jules Aarons

Aarons, Jules. *The Last Tenement*. Boston: Bostonian Society, 1992.

Aarons, Jules. *Vacation and Travel Photography 1965*. New York: American Photographic Book Publishing Co., 1965.

Into the Streets, 1947–1976: Photographs of Boston by Jules Aarons. Boston: Boston Public Library, 1999.

Jules Aarons: Photographs of Paris, 1953–1968. Boston: French Library and Cultural Center, 1999.

Berenice Abbott

Abbott, Berenice. *Berenice Abbott/Photographs*. New York: Horizon Press, 1970. Reprinted Washington, DC: Smithsonian Institution Press, 1990.

Berenice Abbott: Documentary Photographs of the 1930s. Cleveland: New Gallery of Contemporary Art, 1980.

Berenice Abbott: The Red River Photographs. Provincetown, MA: Fine Arts Work Center, 1979.

McCausland, Elizabeth, and Berenice Abbott. *Changing New York*. New York: E. P. Dutton, 1939. Reprinted as *New York in the Thirties as Photographed by Berenice Abbott*. New York: Dover Publications, 1973.

O'Neal, Hank. *Berenice Abbott: American Photographer*. New York: McGraw-Hill, 1982.

Van Haaften, Julia, ed. *Berenice Abbott, Photographer: A Modern Vision*. New York: New York Public Library, 1989.

David Akiba

Akiba, David. *Will It Burn*. With poetry by Jack Myers. Winthrop, MA: Falcon Publishing, 1974.

David Akiba: Landscape Photographs 1982–1992. Waltham, MA: Brandeis University, 1992.

David Akiba: Photographs from the Collection of the Boston Public Library. Boston: Boston Public Library, 1998.

David Akiba: Photographs from the Emerald Necklace. Boston: Photographic Resource Center, 1987.

Roswell Angier

Angier, Roswell. *A Kind of Life: Conversations in the Combat Zone*. Danbury, NH: Addison House, 1976.

Angier, Roswell. *The Patriot Game*. Boston: David R. Godine Press, 1975.

David Armstrong

Armstrong, David. *The Silver Cord*. Zurich and New York: Scalo Publishers, 1997.

Goldin, Nan, and David Armstrong. *Nan Goldin/David Armstrong: A Double Life*. Zurich and New York: Scalo Publishers, 1994.

Karl Baden

Baden, Karl. *Some Significant Self-Portraits*. Cambridge: Badger Press, 1981.

Jerry Berndt

Berndt, Jerry. *Armenia: Portraits of Survival*. Introduction by Donald E. Miller. N.p., 1994.

Berndt, Jerry. *Missing Persons: The Homeless*. Wollaston, MA: Many Voices Press, 1986.

Berndt, Jerry. *Politics of the Spirit: Portraits of Faith and Community in Los Angeles*. Los Angeles: Center for Religion and Civic Culture, 1997.

John Brook

Brook, John. *A Long the Riverrun*. San Francisco: Scrimshaw Press, 1970.

Brook, John. *Hold Me: Photographs by John Brook*. Buffalo: Aura Publications, 1977.

Bill Burke

Burke, Bill. *Bill Burke: Portraits*. New York: Ecco Press, 1987.

Burke, Bill. *Mine Fields*. Atlanta: Nexus Press, 1995.

Burke, Bill. *They Shall Cast Out Demons*. Atlanta: Nexus Press, 1983.

Harry Callahan

Bunnell, Peter C. *Harry Callahan*. New York: American
 Federation of Arts, 1978.

Callahan, Harry. *Harry Callahan: Color*. Providence: Matrix,
 1980.

Callahan, Harry. *Water's Edge*. Lyme, CT: Callaway
 Editions/Viking Press, 1980.

Callahan in New England. Providence: Brown University,
 1994.

Davis, Keith. *Harry Callahan: New Color, Photographs
 1978–1987*. Kansas City: Hallmark Cards, 1988.

Davis, Keith. *Harry Callahan: Photographs*. Kansas City:
 Hallmark Cards, 1981.

Greenough, Sarah. *Harry Callahan*. Washington, DC:
 National Gallery of Art, 1996.

Photographs: Harry Callahan. Number One in a Monograph
 Series, El Mochuelo Gallery. Santa Barbara, CA: Vin
 Riper & Thompson, 1964.

Shaw, Louise, Virginia Beahan, and John McWilliams. *Harry
 Callahan and His Students: A Study in Influence*.
 Atlanta: Georgia State University Art Gallery, 1983.

Szarkowski, John. *Callahan*. New York: Museum of Modern
 Art, 1976.

Paul Caponigro

Caponigro, Paul. *Megaliths*. Boston: New York Graphic
 Society, 1988.

Caponigro, Paul. *Paul Caponigro: Masterworks from Forty
 Years*. Carmel, CA: Photography West Graphics, 1993.

Caponigro, Paul. *Seasons*. Boston: New York Graphic
 Society, 1988.

Caponigro, Paul. *The Voice of the Print*. Portland, ME: Muse
 Press, 1994.

Fulton, Marianne. *The Wise Silence: Photographs by Paul
 Caponigro*. Boston: New York Graphic Society, 1983.
 Reprinted 1985.

Carl Chiarenza

Chiarenza, Carl. *Chiarenza: Landscapes of the Mind*. With
 essays by Estelle Jussim and Charles Millard. Boston:
 David R. Godine, 1988.

Chiarenza, Carl. *Seven Settings*. With essay by Merry
 Foresta. Tampa: Tampa Museum of Art, 1992.

Carl Chiarenza: Landscapes of the Imagination. Iowa City:
 University of Iowa Museum of Art, 1997.

Carl Chiarenza: Photographs 1984–1997. Atlanta: High
 Museum of Art, 1997.

William Clift

Clift, William. *Certain Places, Photographs by William Clift*.
 Santa Fe: William Clift Editions, 1987.

Clift, William. *A Hudson Landscape, Photographs by William
 Clift*. Santa Fe: William Clift Editions, 1994.

Clift, William. *Old City Hall, Boston*. Boston: Council on
 Arts and Humanities of the Commonwealth of
 Massachusetts, 1970.

McIntyre, Alex McVoy. *Beacon Hill, a Walking Tour*. With
 photographs by William Clift. Boston: Little, Brown,
 1975.

Marie Cosindas

Cosindas, Marie. *Marie Cosindas: Color Photographs*. With
 essay by Tom Wolfe. Boston: New York Graphic Society,
 1978.

Cosindas, Marie. *Polaroid Color Photographs*. New York:
 Museum of Modern Art; Boston: Museum of Fine Arts;
 Chicago: Art Institute of Chicago, 1966.

Nicholas Dean

Dean, Nicholas. *Lubec*. Introduction by Ansel Adams.
 Cambridge: Identity Press, 1967.

Dean, Nicholas, and Jonathan Williams. *Blues and
 Roots/Rue and Bluets*. New York: Grossman, 1972.

Elsa Dorfman

Dorfman, Elsa. *Elsa's Housebook—A Woman's Photojournal*.
 Boston: David R. Godine, 1974.

Dorfman, Elsa. *En Famille*. With poetry by Robert Creeley.
 New York: Granary Press, 1999.

Dorfman, Elsa, and Robert Creeley. *His Idea*. Toronto:
 Coach House Press, 1973.

John O'Reilly

John O'Reilly: Occupied Territories, Works from 1967–1979. Boston: Howard Yezerski Gallery, 1999.

O'Reilly, John. *John O'Reilly: Self-Portraits 1977–1995.* Boston: Howard Yezerski Gallery, 1996.

Starr Ockenga

Ockenga, Starr, and Eileen Doolittle. *The Ark in the Attic: An Alphabet Adventure.* Boston: David R. Godine, 1987.

Ockenga, Starr, and Eileen Doolittle. *A Book of Days: Then and Now.* Boston: Houghton Mifflin, 1990.

Ockenga, Starr, and Eileen Doolittle. *World of Wonders: A Trip through Numbers.* Boston: Houghton Mifflin, 1988.

Olivia Parker

Parker, Olivia. *Signs of Life.* Boston: David R. Godine, 1978.

Parker, Olivia. *Under the Looking Glass: Color Photographs by Olivia Parker.* Boston: New York Graphic Society, 1983.

Parker, Olivia. *Weighing the Planets.* Boston: New York Graphic Society, 1987.

Paul Petricone

Paul Petricone Remembered. Medford, MA: Gallery Eleven, Tufts University, 1989.

Rosamond Purcell

Crussi, Dr. F. Gonzalez. *Suspended Animation.* With photographs by Rosamond Purcell. New York: Harcourt Brace, 1995.

Purcell, Rosamond. *A Collector's Catalogue.* Limited edition artist's book. Cambridge: Bow and Arrow Press, 1991.

Purcell, Rosamond. *Finders Keepers: Eight Collectors.* New York: W. W. Norton, 1992.

Purcell, Rosamond. *Half Life.* Boston: David R. Godine, 1980.

Purcell, Rosamond. *Illuminations, a Bestiary.* New York: W. W. Norton, 1986.

Purcell, Rosamond. *A Matter of Time.* Boston: David R. Godine, 1975.

Purcell, Rosamond. *Naturalezas.* Madrid: Museo Nacional de Ciencias Naturales, 1991.

Bill Ravanesi

Ravanesi, Bill, ed. *Breath Taken: The Landscape and Biography of Asbestos.* Boston: Center for Visual Arts in the Public Interest, 1991.

Eugene Richards

Richards, Eugene. *50 Hours: The Birth of Henry Harry.* Wollaston, MA: Many Voices Press, 1983.

Richards, Eugene. *Americans We.* New York: Aperture, 1994.

Richards, Eugene. *Below the Line: Living Poor in America.* New York: Consumer Reports Books, 1987.

Richards, Eugene. *Cocaine True, Cocaine Blue.* New York: Aperture, 1994.

Richards, Eugene. *Dorchester Days.* Wollaston, MA: Many Voices Press, 1978.

Richards, Eugene. *Exploding into Life.* New York: Aperture, 1986.

Richards, Eugene. *Few Comforts or Surprises: The Arkansas Delta.* Cambridge: MIT Press, 1973.

Richards, Eugene. *The Knife and Gun Club: Scenes from an Emergency Room.* New York: Atlantic Monthly Press, 1989.

Dana Salvo

Salvo, Dana. *Home Altars of Mexico.* Albuquerque: University of New Mexico Press, 1997.

Irene Shwachman

Shwachman, Irene. *Now You Know: This Is Serious Photography.* N.p., 1987.

Shwachman, Irene. *We Grew Up in Manhattan: Notes for an Autobiography.* Boston: Photographic Resource Center, 1977.

Aaron Siskind

Aaron Siskind: Photographs 1932–1978. Introduction by Peter Turner. Oxford: Museum of Modern Art, 1979.

Chiarenza, Carl. *Aaron Siskind: Pleasures and Terrors*.
Boston: New York Graphic Society, 1982.

Kao, Deborah Martin, and Charles A. Meyer, eds. *Aaron
Siskind: Toward a Personal Vision 1935–1955*. Chestnut
Hill, MA: Boston College Museum of Art, 1994.

Lyons, Nathan, ed. *Aaron Siskind: Photographer*.
Rochester: George Eastman House, 1965.

Places: Aaron Siskind Photographs. Introduction by Thomas
B. Hess. New York: Light Gallery/Farrar, Straus and
Giroux, 1976.

Siskind, Aaron. *Aaron Siskind: Photographs*. Introduction
by Harold Rosenberg. New York: Horizon, 1959.

Traub, Charles, ed. *Harlem Document, Photographs
1932–1940: Aaron Siskind*. Providence: Matrix
Publications, 1981.

Sage Sohier

Sohier, Sage. *At Home with Themselves: Photographs and
Interviews with Gay and Lesbian Couples*. Andover, MA:
Addison Gallery of American Art, 1990.

Jim Stone

Stone, Jim. *Darkroom Dynamics: A Guide to Creative
Photography Techniques*. Boston: Focal Press, 1979.

Stone, Jim. *Stranger Than Fiction*. Syracuse, NY: Light
Work, 1993.

Stone, Jim. *A User's Guide to the View Camera*. New York:
Harper Collins, 1987.

Stone, Jim, and Barbara London. *A Short Course in
Photography*. 3d ed. New York: Addison Wesley
Longman, 1996.

Steven Trefonides

Trefonides, Steven. *India*. New York: Grossman-Viking,
1968.

Bradford Washburn

Decaneas, Antony. *Bradford Washburn: Mountain
Photographs*. Seattle: Mountaineers, 1999.

Washburn, Bradford. *Among the Alps with Bradford*. New
York: Putnam, 1927.

Washburn, Bradford. *Mt. McKinley: The Conquest of Denali*.
New York: Harry N. Abrams, 1991.

William Wegman

Kunz, Martin, ed. *William Wegman: Paintings, Drawings,
Photographs, Videotapes*. New York: Harry N. Abrams,
1990.

Livingston, Jane. *William Wegman*. Los Angeles: Los
Angeles County Museum of Art, 1973.

Lyons, Lisa, and Kim Levin. *Wegman's World*. Minneapolis:
Walker Art Center, 1982.

Paul, Frederick. *William Wegman*. Limoges, France: Fonds
Régional d'Art Contemporain, 1991.

Wegman, William, and Laurence Wieder. *Man's Best Friend*.
New York: Harry N. Abrams, 1982.

Minor White

Bunnell, Peter C. *Minor White: The Eye That Shapes*.
Princeton: The Art Museum, Princeton University, 1989.

White, Minor. *Minor White: Rites & Passages*. With essay by
James Baker Hall. New York: Aperture, 1978.

White, Minor. *Mirrors, Messages, Manifestations*. New York:
Aperture, 1969. Reprinted Millerton, NY: Aperture,
1982.

White, Minor. *Zone System Manual: How to Previsualize
Your Pictures*. 3d ed. Hastings-on-Hudson, NY: Morgan
& Morgan, 1967.

**Selected Group Exhibition Catalogues and General
Photography Books**

Ackley, Clifford S. *Photographic Viewpoints: Selections from
the Collection*. Boston: Museum of Fine Arts, 1984.
Includes Harry Callahan and William Clift.

Ackley, Clifford S. *Private Realities: Recent American
Photography*. Boston: Museum of Fine Arts, 1974.

*Between Home and Heaven: Contemporary American
Landscape Photography*. Washington, DC: Smithsonian
Institution Press, in association with University of New
Mexico Press, 1992. Includes Jim Stone.

Boston Now: Photography. Boston: Institute of
Contemporary Art, 1985. Includes Roswell Angier, Karl

Baden, Judith Black, Bill Burke, Carl Chiarenza, Marie Cosindas, Jim Dow, Chris Enos, Wendy Snyder MacNeil, Barbara Norfleet, Olivia Parker, Rudolph Robinson, Sage Sohier, Jim Stone, Shellburne Thurber, and Jane Tuckerman.

Channing, Susan R., ed. *Art of the State: Massachusetts Photographers, 1975–1977*. Boston: Massachusetts Arts and Humanities Foundation, 1978. Includes Carl Chiarenza, Chris Enos, Jerome Liebling, Wendy Snyder MacNeil, and Jim Stone.

Channing, Susan R., ed. *The Leather District and the Fort Point Channel: The Boston Photo-Documentary Project*. Boston: Artists Foundation, 1982. Includes Chris Enos, Eugene Richards, Sage Sohier, and Jim Stone.

Coke, Van Deren, and Diana C. DuPont. *Photography: A Facet of Modernism*. New York: Hudson Hills Press, in association with the San Francisco Museum of Modern Art, 1986. Includes Paul Caponigro, Gyorgy Kepes, Aaron Siskind, and Minor White.

Coleman, A. D. *Depth of Field: Essays on Photography, Mass Media and Lens Culture*. Albuquerque: University of New Mexico Press, 1998.

Coleman, A. D. *Light Readings: A Photography Critic's Writings, 1968–1978*. London: Oxford University Press, 1978. Reprinted Albuquerque: University of New Mexico Press, 1998.

Coleman, A. D. *Tarnished Silver: After the Photo Boom, Essays and Lectures 1979–1989*. New York: Midmarch Arts Press, 1996.

Contemporary Photographers: Toward a Social Landscape. Rochester, NY: Horizon Press/George Eastman House, 1966.

Coppola, Regina. *Beyond Light: Infrared Photography by Six New England Artists*. Amherst: University Gallery, University of Massachusetts, 1987. Includes Peter Laytin and Jane Tuckerman.

Criticism of Photography: Eleven Contemporary Photographers. Amherst: University Gallery, University of Massachusetts, 1978. Includes Elsa Dorfman, Jane Tuckerman, and Irene Shwachman.

Cross Currents/Cross Country: Recent Photography from the Bay Area and Massachusetts. San Francisco: SF

Camerawork; Boston: Photographic Resource Center, 1988. Includes Jerry Berndt, Jim Dow, Chris Enos, Wendy Snyder MacNeil, Sheron Rupp, and Dana Salvo.

Davis, Keith. *An American Century of Photography: From Dry-Plate to Digital*. Kansas City: Hallmark Cards, 1995. 2d ed. 1999. Includes Harry Callahan, Carl Chiarenza, Harold Edgerton, Lotte Jacobi, Gyorgy Kepes, Jerome Liebling, Wendy Snyder MacNeil, Nicholas Nixon, and Aaron Siskind.

Eauclaire, Sally. *New Color/New Work: Eighteen Photographic Essays*. New York: Abbeville Press, 1984. Includes Jim Dow and Bill Ravanesi.

Foresta, Merry Amanda. *Exposed and Developed: Photography Sponsored by the National Endowment for the Arts*. Washington, DC: Smithsonian Institution Press, 1984. Includes Bill Burke, Paul Caponigro, William Clift, Jerome Liebling, and Aaron Siskind.

14 New England Photographers. Boston: Museum of Fine Arts, 1978. Includes Roswell Angier, Elsa Dorfman, Jim Dow, Lotte Jacobi, Gyorgy Kepes, Jerome Liebling, Wendy Snyder MacNeil, Nicholas Nixon, Olivia Parker, Eugene Richards, and Irene Shwachman.

Galassi, Peter. *Pleasures and Terrors of Domestic Comfort*. New York: Museum of Modern Art, 1991. Includes Judith Black, Nan Goldin, Nicholas Nixon, Sheron Rupp, and Sage Sohier.

Gangitano, Lia, ed. *Boston School*. Boston: Institute of Contemporary Art, 1995. Includes David Armstrong, Nan Goldin, and Shellburne Thurber.

Gibson, Ralph, ed. *SX-70 Art*. New York: Lustrum Press, 1979. Includes Chris Enos, Rosamond Purcell, and Jane Tuckerman.

Green, Jonathan. *American Photography: A Critical History, 1945 to the Present*. New York: Harry N. Abrams, 1984.

Grundberg, Andy. *Crisis of the Real: Writings on Photography, 1974–1989*. New York: Aperture, 1990.

Hulick, Diana Emery, and Joseph Marchall, eds. *Photography 1900 to the Present*. Upper Saddle River, NJ: Prentice Hall, 1998.

Image of New England 1839–1989: 150 Years of Photography. Springfield, VA: Society for Imaging Science and Technology; Boston: Photographic

Historical Society of New England, 1989. Includes
Harold Edgerton and Bradford Washburn.

Innovation/Imagination: 50 Years of Polaroid Photography.
New York: Harry N. Abrams, 1999. Includes Paul
Caponigro, Olivia Parker, Rosamond Purcell, Eugene
Richards, Jim Stone, William Wegman, and Minor
White.

Into the Eighties: New England Photography. Keene, NH:
Thorne-Sagendorph Art Gallery, Keene State College,
1980. Includes Karl Baden, Jim Dow, Arno Rafael
Minkkinen, and Daniel Ranalli.

Janis, Eugenia Parry, and Wendy MacNeil, eds. *Photography
within the Humanities*. Danbury, NH: Addison House
Publishers, 1977.

Jussim, Estelle, and Elizabeth Lindquist-Cock. *Landscape
as Photograph*. New Haven: Yale University Press,
1985. Includes Harry Callahan, Paul Caponigro, Carl
Chiarenza, William Clift, Chris Enos, and Minor White.

Lahs-Gonzales, Olivia, and Lucy Lippard. *Defining Eye:
Women Photographers of the 20th Century*. St. Louis:
Saint Louis Art Museum, 1997. Includes Berenice
Abbott, Marie Cosindas, Nan Goldin, Lotte Jacobi,
Barbara Norfleet, and Olivia Parker.

McElheny, Victor K. *Insisting on the Impossible: The Life of
Edwin Land*. Reading, MA: Perseus Books, 1998.

Minkkinen, Arno Rafael, ed. *New American Nudes: Recent
Trends and Attitudes*. Dobbs Ferry, NY: Morgan &
Morgan, 1981. Includes Judith Black.

Naef, Weston. *Counterparts: Form and Emotion in
Photographs*. New York: Metropolitan Museum of Art,
1982. Includes Harry Callahan, William Clift, Lotte
Jacobi, Wendy Snyder MacNeil, and Rosamond Purcell.

The New Face of the Portrait. Brockton, MA: Fuller Museum
of Art, 1995. Includes Marie Cosindas and Elsa
Dorfman.

Newhall, Beaumont. *Latent Image: The Discovery of
Photography*. Garden City, NY: Doubleday, 1967.

Newhall, Beaumont, ed. *Photography: Essays & Images,
Illustrated Readings in the History of Photography*. New
York: Museum of Modern Art, 1980.

*The New Vision: Forty Years of Photography at the Institute
of Art and Design*. Millerton, NY: Aperture, 1982.

Nine Masters. Boston: Photographic Resource Center, 1987.
Includes Berenice Abbott, Harry Callahan, Harold
Edgerton, Lotte Jacobi, Gyorgy Kepes, Aaron Siskind,
Bradford Washburn, and Minor White.

A Photographic Patron: The Carl Siembab Gallery. Boston:
Institute of Contemporary Art, 1981. Includes Harry
Callahan, Paul Caponigro, Chris Enos, Peter Laytin,
Daniel Ranalli, Aaron Siskind, Jane Tuckerman, and
Minor White.

Photography: Current Perspectives. Rochester: Light
Impressions Corporation, 1978.

Photography, U.S.A. Lincoln, MA: DeCordova Museum,
1968. Includes Jules Aarons, John Brook, Carl
Chiarenza, Nicholas Dean, Len Gittleman, Lotte Jacobi,
Paul Petricone, and Minor White.

Photojournalism in the 80s. Greenvale, NY: Hillwood Art
Gallery, Long Island University, 1985. Includes Eugene
Richards.

PLACE: New England Perambulations. Andover, MA: Addison
Gallery of American Art, 1982. Includes Jerome
Liebling and Sage Sohier.

Robinson, William. *A Certain Slant of Light: New England
Photography's First Hundred Years*. Boston: New York
Graphic Society, 1979.

Rosenblum, Naomi. *A History of Women Photographers*.
New York: Abbeville Press, 1994. Includes Marie
Cosindas, Nan Goldin, Lotte Jacobi, Wendy Snyder
MacNeil, Barbara Norfleet, Starr Ockenga, Olivia Parker,
and Rosamond Purcell.

Rosenblum, Naomi. *World History of Photography*. New
York: Abbeville Press, 1987. Includes Olivia Parker and
Eugene Richards.

Sheldon, James. *Aspects of the 70s: Photography, Recent
Directions*. Lincoln, MA: DeCordova Museum, 1980.
Includes Roswell Angier, Harry Callahan, Paul
Caponigro, Carl Chiarenza, William Clift, Wendy Snyder
MacNeil, Nicholas Nixon, Olivia Parker, Eugene
Richards, Aaron Siskind, William Wegman, and Minor
White.

Sichel, Kim. *Black Boston: Documentary Photography and
the African American Experience*. Boston: Boston
University Art Gallery, 1994. Includes Jules Aarons,
Lou Jones, Hakim Raquib, and Irene Shwachman.

Index